Information Services Management Series

Series Editor: Guy St Clair

Susan Henczel

The Information Audit

A Practical Guide

K · G · Saur München 2001

Die Deutsche Bibliothek – CIP-Einheitsaufnahme

Henczel, Susan:
The information audit: a practical guide
/ Susan Henczel. - München : Saur, 2001
ISBN 3-598-24367-7

Printed on acid-free paper

Cover design by Juan Hayward

Typesetting by Florence Production Ltd., Stoodleigh, Devon

Printed and Bound in Great Britain by Antony Rowe Ltd., Chippenham, Wiltshire
ISBN 3-598-24367-7

The author

Susan Henczel has extensive experience in library and information work in Australia. Susan has worked in special libraries, academic libraries and public libraries. She currently works as Educational Services Manager with CAVAL, a university co-operative. In 1998 Susan attained a Masters degree in Business (Information Technology) at RMIT University in Melbourne, Australia and her specialist research was entitled *Evaluating the effective ness of an information audit in a corporate environment.*

This book is dedicated to a special man who provided inspiration, support and love, and who passed away before the book was finished – my father, Bill Parker.

Introduction to the series

A broader management perspective for information services

For several years – decades, it seems – librarians and other information services professionals have lamented the fact that there is not enough emphasis on management in their training. They learn their subjects, and librarians especially connect very early on in their training to the concepts of service and the organization of information. Management skills, however, are frequently neglected or given minimal attention, and many information services professionals find themselves working in the corporate environment, research and technology organizations, government information units, or community/public administration organizations where management skills are needed. Much of what they need they learn on the job; other approaches, such as continuing education programmes, are utilized by those who have the initiative to recognize that they must do something to educate themselves to be managers. Some of it works and some of it does not.

Bowker's *Information Management Series*, for which I serve as Series Editor, seeks to address this need in the information services community. For this series (and indeed, since the entire field of information management is strongly predicted by many to be going in this direction), the concept of information services is being defined very broadly. The time has come, it seems to me, to recognize that the various constituent units of our society concerned with information have many of the same goals and objectives, and, not surprisingly, many of the same concerns. The practice of management is one of these, and for our purposes it does not matter if the reader is employed as an information manager, information provider, information specialist, or indeed, as an information counsellor (as these information workers have been described by one of the leaders of business and industry). In fact, it does not matter whether the reader is employed in information technology,

telecommunications, traditional librarianship, specialist librarianship, records management, corporate or organizational archives, the information brokerage field, publishing, consulting, or any of the myriad branches of information services (including service to the information community and the many vendors who make up that branch of the profession). These new titles on the management of information services have been chosen specifically for their value to all who are part of this community of information workers.

Although much work is being done in these various disciplines, little of it concentrates on management, and that which is done generally concentrates on one or another of the specific subgroups in the field. This series seeks to unite management concepts throughout information services, and whereas some of the titles will be directed to a specific group, most will be broad-based and will attempt to address issues of concern to all information services employees. For example, one book in the series deals with entrepreneurial librarianship, which would seem to be limited to the library profession but in fact offers information and guidance to anyone working in the information services field who is willing to incorporate entrepreneurial thinking into his or her work. Another title looks at corporate memory from the perspective of data and records management, and would seem to be limited to those who are practising the discipline of records management. In fact, the book has been specifically structured to be of value to anyone who is working in the information services field, that 'umbrella' concept of information services described above.

As we attempt to bring general management practices into the realm of information services, it will be pointed out that the practice of management is addressed within the organizations or communities that employ information workers. This is true, and certainly in the corporate world (and, arguably, in the public and academic library communities as well), there are plenty of occasions for information services employees to participate in management training as provided in-house. There is nothing wrong with that approach and in many organizations it works very well, but the training does not proceed from an information services point of view, thus forcing the information worker to adapt, as best he or she can, the management practices of the organization to the management practices needed for the best provision of information services. The titles of the Bowker *Information Services Management Series* will enable the information worker to relate *information* management to *organizational* management, thus putting the information workers (especially the information executive) in a position of considerable strength in the organization or community where he or she is employed. By understanding management principles (admittedly, as frequently 'borrowed' from the general practice of management) and relating them to the way the information services unit is organized, not only does the information services employee position him or herself for the better

provision of information services, but the entire information services unit is positioned as a respectable participant in organizational or community operations.

This last point perhaps needs some elaboration, for it should be made clear that the books in the series are not intended exclusively for the corporate or specialized information services field. It is our intention to provide useful management criteria for all kinds of information services, including those connected to public, academic or other publicly supported libraries. Our basic thesis is that quality management leads to quality services, regardless of whether the information services activity is privately or publicly funded, whether it is connected with a private research or public government agency, or indeed, whether it is a temporary information unit or whether it is part of a permanently funded and staffed operation. Writing for this series will be authors who, I am sure, will challenge some of the usual barriers to effective management practices in this or that type of library or information services unit, and certainly there will be librarians, records managers, archivists and others who will be able to relate some of their management practices in such a way that CIOs and computer services managers will benefit from the telling. In other words, our attempt here is to clear away the usual preconceptions about management within the various branches of information services, to do away with the concept of 'well-that-might-work-for-you-but-it-won't-work-for-me' kind of thinking. We can no longer afford to fight turf battles about whether or not management is 'appropriate' in one or other of the various subunits of information provision. What we must do, and what the *Information Services Management Series* expects to do, is to bring together the best of all of us, and to share our management expertise so that we all benefit.

Guy St Clair
Series Editor

Contents

List of figures

List of tables

Acknowledgements

I would like to thank the many friends and colleagues who contributed to this book by giving generously of their professional advice and their personal support – it would not have been possible without them.

I would like to firstly thank the group of proof-readers and critics who helped shape my early drafts into a viable product: Rosemary Dearman (CAVAL), Allan McLay (RMIT) and Ann Ritchie (AIMA) – they helped create order from chaos!

Secondly I would like to formally thank the librarians and consultants who assisted in the preparation of the case studies: Majella Pugh, Susan Rigney, Yvonne Butler, Ann Ritchie, Brenda McConchie and Keith Parrot.

On a personal note I would like to thank my daughters Lisa, Renee and Amanda for being patient and encouraging.

Finally, and also on a personal note, I would like to thank Ralph Godau for his inspiration and unwavering encouragement and support and for the many hours he spent reviewing and proof-reading the drafts. His help with the diagrams and with the structuring of the book were invaluable as was his interest in the project and his desire to share it with me.

Introduction

Information is universally recognized as the most important strategic asset that an organization can own. Despite this recognition, however, many information units are being closed or downsized and organizations are encouraging information users to acquire, control and manage their own information resources. The information used by an organization as it conducts its business can no longer be physically restricted to the library or information unit as advances in electronic delivery methods have allowed the delivery of information directly to employees' desktops. Controlling the acquisition of, and access to, information resources is becoming increasingly difficult as vendors bypass the information professionals and market directly to the end-user. Compounding this problem is the availability of information in a multitude of formats and the exponential growth in the number of products available. This necessitates a higher level of evaluation and control to ensure that quality information is available to those who need it.

Because of this proliferation of information products and delivery methods, information users are suffering from 'information overload' and in many cases are using a variety of resources to gather their information, some of which may be not be the most efficient or effective for their needs. Many organizations are structured in such a way that the strategic business units operate independently of one another, yet they rely on similar information resources. Some operate without the resources they need because they do not know where to find them, while others engage in 'information overkill' and purchase anything that looks likely to be relevant. Consequently there are often significant gaps and duplications in information resources within an organization. This leads to high-level reports and documents that are based on a multitude of sources, the quality and authority of which may be inconsistent.

There must be a clear and visible alignment of the information that is acquired by the information users with the objectives of the business unit to which they belong. The challenge is to identify the information that is

needed to optimize the achievement of organizational objectives, who needs it, how it will be used, its source and how it flows through the organization and between the organization and its external environment. The information audit is an established management methodology that will address all of these issues.

Many definitions of the information audit have emerged over the past two decades and still there is no universally accepted definition. In her 1991 definition Sharon LaRosa (1991, p.7) takes a stakeholder perspective and defines the information audit as:

> '. . . a systematic method of exploring and analysing where a library's various publics are going strategically, and of determining the challenges and obstacles facing those publics. The audit, which raises questions about where and how these publics find and use information, gives the library a better understanding of the present and future needs of its constituents, which in turn helps the library determine its own most appropriate strategic direction'.

Possibly the simplest and most popular definition is that developed by Guy St. Clair (1997, p.5) who defines an information audit as:

> 'a process that examines how well the organization's information needs and deliverables connect to the organizational mission, goals and objectives'.

In the second edition of her definitive book *Practical Information Policies* (1999, p.69), Elizabeth Orna suggests the definition developed by the Information Resources Management Network of Aslib as one that is commonly used in the UK today:

> 'a systematic evaluation of information use, resources and flows, with a verification by reference to both people and existing documents, in order to establish the extent to which they are contributing to an organization's objectives'.

No matter which definition one favours, the information audit is a process that will evaluate effectively the current information environment. It identifies firstly the information that is required to meet the needs of the organization and secondly the information that is currently supplied. It then allows a matching of the two to identify gaps, inconsistencies and duplications. The process will also facilitate the mapping of information flows throughout the organization and between the organization and its external environment to enable the identification of bottlenecks and other inefficiencies.

A successful information audit will provide strategic direction and guidelines for the management of an organization's information resources and form the basis for the development of a formal information policy. When conducted over an entire organization it forms the basis for a comprehensive strategically-based knowledge management policy.

Just as there is no universally accepted definition of an information audit, there is also no universally accepted model for the information audit process because of the dramatically varying structures, natures and circumstances of the organizations in which they are conducted. Regardless of the method chosen for a particular audit or the scope of the audit itself, there are a number stages that must be worked through to ensure the success of the process.

This book will introduce you to the seven-stage information audit model and take you through the information audit process stage by stage, highlighting those aspects of the process that are critical to its success and the issues that you may face which can affect the value of your outcomes. The model is not a highly structured and controlled process that operates in a tightly defined manner. Rather it is a structured framework that is flexible and can 'bend' to meet the varying conditions and constraints of an organization. The components can be 'tailored' to suit to the size, structure and objectives of the organization and the resources available.

The scope of this book and its objectives

This book is aimed at librarians, library managers, information managers, knowledge managers and other information professionals who want a step-by-step guide that can be used to work through the information audit process. It is also aimed at the other key players within organizations who recognize the importance of information to the success of their business and who wish to know more about the process that can potentially move their organization towards the strategic management of information and into knowledge management.

Many of the articles, papers, chapters and book sections that have been written about the information audit process have included within the scope of the audits the organization's computer systems (both hardware and software). I have purposely excluded them from the process described in this book as they are the delivery mechanisms rather than the information resources. Once an initial information audit has been completed and recommendations formulated from the findings, then it is appropriate to conduct a *systems audit*. The *systems audit* will identify the delivery mechanisms and the hardware and software (including networks and telecommunications) that are required to deliver those information resources which have been identified as having strategic value to the employees who need them.

References

LaRosa, S. (1991) The corporate information audit. *Library Management Quarterly*, **14**(2), 7–9

Orna, E. (1999) *Practical information policies*, 2nd edn. Aldershot: Gower

St. Clair, G. (1997) The information audit I: defining the process. *InfoManage*, 4(6), 5–6

The changing role of the corporate information unit

The changing external environment is making an impact upon every organization, whether it is a corporate enterprise, academic institution, government authority or a non-profit concern. Political, economic, social and technological influences are forcing changes to internal processes and functions so that the organization can continue to conduct its business and remain in sync with its external environment. The ways in which these changes are handled within an organization will depend upon the culture of the organization and the nature of the internal political environment. Some changes are significant and require the re-education of employees, the introduction of implementation strategies and explicit changes to internal procedures and work practices. Others are incremental changes that happen so slowly that they are incorporated smoothly into existing procedures and work practices without sudden upheaval. Any period of change presents management with an opportunity to evaluate the various functions of the organization in terms of their adaptability and flexibility. The role of the corporate information unit is no different from that of any other department where traditional conventions are being challenged. If the information unit is to perform well and contribute to the success of the organization, it also must adapt continually to the changing information environments in order to provide the resources and services which the organization needs to achieve its goals and objectives.

The external environment determines the resources and services that are available (other than those produced from within the organization). The external political, economic, social and technological influences combined with the technological systems within the organization (the technological interface) determine which resources and services will be available for use by the information users within the organization and how they can be used. Figure 1.1 shows these external influences and also the influences from within the organization itself that affect the provision of information. The information strategy that is (or is not) in place and the political and cultural environment have an impact on how the resources

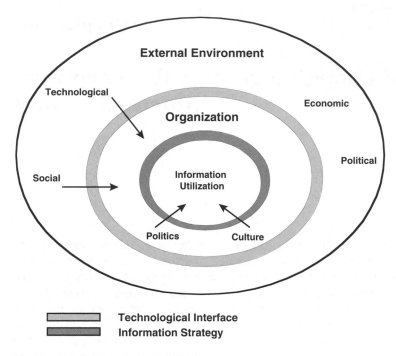

Figure 1.1 Environmental situation

are valued and shared within the organization and how the services are delivered. All of these influences, both internal and external, affect the resources and services that are available for use by the organization, how they are provided and how they are used.

The external environment

Political

The external political environment, which includes the legislative environment, can impact significantly on how an organization deals with information. Some examples that come to mind are the issues of the licencing of electronic products, copyright and the ownership of intellectual property. The complicated issue of how electronic products are licenced influences which product is purchased, how it is purchased (subscription or transaction-based) and what restrictions must be placed on the use of the product within the organization: for example, the number of simultaneous users that are permitted, when and where the product can be accessed, and whether or not printing/copying is allowed. The information professional must negotiate with the vendor for the type of use that best suits the organization, at a reasonable price.

Legislation determines what proportion of a document can be legally copied, by whom and for what purpose. The copyright issue therefore determines how a product can be distributed throughout an organization (for example whether it can be copied for distribution or placed in electronic form on the corporate intranet) and whether or not it can be made available to information seekers outside the organization. The copyright dilemma also influences the decisions that an organization makes regarding the dissemination of its own publications. Reports and other documents that detail the work of the organization are often managed differently from other more general publications.

The generation of internal knowledge in the form of reports and other documents leads to the issue of the ownership of intellectual property. More and more organizations are claiming legal ownership of the knowledge that is generated by their employees, while employees are often claiming that it belongs to them. From an information management perspective this means that tight control over internally produced documents and reports is critical – as is the knowledge of who is producing information, what it is being used for and to whom it is being passed on.

These are just a few of the many examples of how the external political environment impacts on an organization and influences its internal processes and work practices.

Economic and social

The economic environment in which an organization operates influences many of its business activities. National and international economic pressures during the 1990s have resulted in dramatic changes to many organizations. Economic rationalism and the introduction of competition have forced managers to analyse the structure of their organizations, their staffing levels and profit-making capabilities. Organizations have been, and continue to be, downsized, restructured and re-engineered in order to become more streamlined and potentially more competitive. All departments within an organization must be able to demonstrate how their outputs add value and contribute to organizational success, with the critical factor not being how the department itself values its outputs but how management perceives their value and their importance to the business operations (Kennedy, 1996). Consequently the value of information is determined by how important it *is perceived to be* to the processes that lead to decision-making.

The physical size and scope of a corporate information unit can no longer be a measure of its efficiency or value to the organization. The Australian Library and Information Association (ALIA) Market Research Report (Rundle-Thiele, 1997) looked at the value placed on libraries in the top 100 Australian corporations and found that many senior executives regarded their libraries as having no value at policy level. An earlier

survey of 103 top managers in the USA by Matarazzo and Prusak in 1995 suggested that some managers were under the impression that all one needs to access the knowledge of the world is a computer and modem.

The perception that all the information needed by an organization is freely available via the Internet or online databases presents both threats and opportunities for the information professional in today's corporate environment. They are forced to rethink their role as information providers and to seek out opportunities to become players in the overall process of corporate change and renewal (Martin, 1996). They must be able to give up some of the more traditional services that may be unprofitable or not aligned with the organization's strategic objectives and identify those services that save employees' time, add value to the business and provide the information necessary to support the major tasks on which organizational success depends. To do this they need to know not only who is using the information but also how that information is being used and how it aligns with organizational goals and objectives.

One of the key findings of the ALIA Market Research Report was that many of the top 100 Australian organizations do not have corporate libraries and those that do are unlikely to increase the funding for those libraries in the foreseeable future. This declining funding, combined with the increasing demand for more costly information services such as access to electronic resources means that information services must be rationalized and prioritized according to an organization's needs. Dubois (1995) suggests that as long as information services are considered to be a nonproductive overhead they will continue to be under threat when policy decisions to cut costs are made unless they can be seen to be contributing to the productivity of the organization.

Organizations across all sectors are experiencing dramatic reductions in staffing levels. Many are being restructured in an attempt to increase efficiency and effectiveness and employees are being forced to do more with fewer human, financial and physical resources. This has consequences for the decision-makers within the organization and consequently for the organization itself. In many cases they are paying more for their information, but at the same time they do not have the exact information they need to make decisions.

The restructuring of organizations has also led to dramatic changes in work practices. The decentralization of departments and the introduction of telecommuting means that the information required by employees must be deliverable beyond the previous constraint of the physical boundaries of the organization. The information needed by employees must be accessible to them regardless of their physical location.

The boundaries of organizations are also shifting on a global scale. Internet and intranet technologies have enabled communication networks to be established to facilitate the local, national and international sharing of information and information resources. The efficiency of the

communication networks is contributing to the problem of 'information overload' as there are often no filtering processes in place to ensure that all of the information distributed by these methods is useful and/or necessary. Vast quantities of information are being distributed but only a relatively small proportion contributes directly to the decision-making processes.

Technological

All organizations are affected both negatively and positively by changes in the external technological environment. Advances in communications and computer technology facilitate the efficient and effective storage and distribution of huge quantities of information. The role of the information professional has also changed in that he or she is no longer the 'keeper of the information' but the coordinator, manager, evaluator and disseminator of information resources. Evaluating the resources and choosing those that are the most appropriate for the purpose for which they will be used has become a key responsibility for the information professional and one which will impact on how effectively and efficiently the organizational goals and objectives are achieved. Unfortunately many organizations either do not have a person filling this role, or they do not allow their information manager to take on this responsibility. Upper management in these organizations then wonder why their information resources are costing them so much, why they have too much information to wade through to find what they need and why they never seem to have the right information when they need it.

Advances in technology have resulted in changes to the information-seeking behaviour of many information users. Print-based products are often no longer the first step in the information-seeking process, with many information users having a higher regard for the currency and searchability of electronic resources. The exponential growth in electronic products in recent years and the continually changing delivery options exacerbate problems such as resource duplication, rationalization and the control of subscriptions and licences. Products and resources are available directly to the desktop of the individual using the data without the need of an information professional as intermediary. Unmediated access to the Internet and World Wide Web, online databases and other electronic resources expedites the rapid supply of vast quantities of information and places the onus for evaluating the quality and validity of the information on the user who is confronted by a myriad of seemingly similar resources. To compound this problem, vendors bypass the information professional and target the end-user when marketing their products. Without some means of central coordination this can result in the purchase of substandard or unsuitable products, unnecessary duplications and expensive single-user licences for electronic products.

Impact on the internal environment

The nature of external economic, technological, social and political influences makes the need for a comprehensive internal information management strategy vital to the success of an organization. As the organization constantly changes to remain in sync with its external environment, goals and objectives must be reassessed. This assessment must include strategies to achieve the redefined goals and objectives and the resources to achieve them effectively and efficiently. This impacts on the information manager who must maintain the alignment of information resources and services with the changing organizational goals and objectives.

The internal environment

As illustrated in Figure 1.1, the changes in an organization's external environment influence its internal environment (how things are done within the organization). The way in which these changes are handled relies to a large extent on the cultural and political environment within the organization.

As organizations change, so do the cultures within them. At one extreme organizations become fragmented and decentralized with regard to information management and more people find themselves working in isolation. Insecurities can increase as people struggle with changes, increased responsibility and accountability and the decline of support services. Downsizing and decentralization break down the formal and informal networks that employees have built up over time and change the ways in which information is used. Employees who are insecure and who are feeling threatened see information as power and become protective of the information that they produce and the products that they use to source their data. This reduction in the willingness to share information can lead to duplications in information resources acquired by the organization as well as a general lack of understanding of the exact information required to perform a particular function. This issue is exacerbated by political issues such as secrecy between departments, the introduction of internal competition and lack of understanding about who actually 'owns' the information acquired and produced by the organization.

On the other hand, changes in the external environment are stimulating many organizations to develop an 'information culture'. In these organizations from the CEO down, employees are aware of the value of information and its impact on the organization's success and the quality of work which they produce. There is very little political activity and competition amongst employees – rather a general willingness to share information (Skryme, 1992). Adequate resources are allocated to the management of information. Organizations such as these are more likely

to have developed and implemented formal information policies and infor-
mation management strategies.

As organizational structures become flatter, employees at lower levels
in the structure are being asked to make routine and non-routine deci-
sions that would previously have been made further up the management
ladder. Where there are clear information policies and information
management strategies, the decisions made by employees are more likely
to be aligned with the organizational goals. The information manager must
understand who is making the key decisions in the organization, what
information resources they need and how those information resources
support the decision-making process.

The value of the information received by decision makers is not only
dependent on the quality and relevance of the source, but also on how
the information has been filtered before being passed on up and through
the organization. Information is acquired by employees and departments
at all levels of an organization from sources both inside and outside the
organization. The information is manipulated, used and filtered and then
passed up the organizational hierarchy. Senior managers are dependent
on this information for their decision-making at a strategic level. Figure
1.2 shows information flowing into the organization at all levels from the
top level (level 1), which is the strategic level, through to level 4 which
is the 'coal face' where employees interact with customers or clients. It
also shows how information flows within the organization – up and down
the hierarchy and within each of the levels.

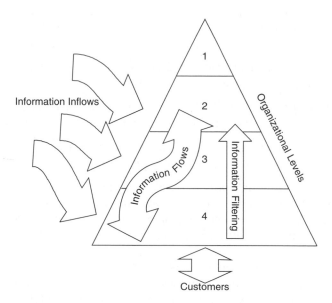

Figure 1.2 Information filtering up through the organizational hierarchy

It is critical that data sources are validated and information flows are understood to ensure that the best possible sources are available where they are needed (Figure 1.3). It is also important to examine how the information is used (manipulated and filtered) before being passed on in the form of reports, databases and other products which become the basis for decision-making at all levels within an organization.

These changes in the internal environment together with the acknowledgement that information can influence the level of success of an organization impact significantly on their changing information environments.

The information environment

As internal environments change in response to the influences of their external environment, the information environment must also change. This creates a constantly changing information environment which has to be managed. How this is achieved will depend on the culture of the organization and the resources that are allocated for information resources and services and their management. How *well* this is achieved will depend on how efficiently and effectively the information manager is able to identify the changing needs and adapt the resources and services to meet them.

The successful management of the information resources and services within an organization depends on:

- understanding how the external environment in which the organization operates influences internal processes and procedures, and consequently the way in which information may be acquired, accessed and managed

- how well the information services and resources are aligned with the strategic goals and objectives of the organization

- continual assessment of how well the information services and resources are supporting the strategic goals and objectives

- understanding how information flows within the organization and between the organization and its external environment

- understanding how the internal political and cultural environment impacts on the implementation of changes within the organization so that the changes required in the way that information is coordinated and managed can be implemented efficiently.

It is essential that the information manager takes a holistic view of the organization and understands how the components of the organization interrelate, and how the information service interrelates with all of the individual components of the organization. This will ensure that he or she

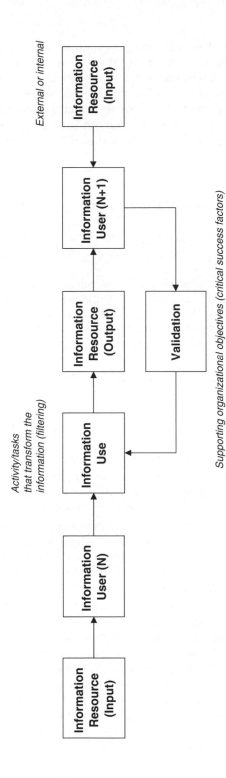

Figure 1.3 Mapping information flow

maintains an awareness of the changing nature of the organization and is thus in a better position to anticipate major changes in information needs that will affect the resources and services provided. The alignment of information services and resources with the strategic goals of the organization requires a clear understanding of how the organization works, both internally and in relation to its external environment. The establishment of these relationships paves the way for strategic information management and effective knowledge management.

Strategic information management

Strategic information management, or information strategy, is defined by Orna (1999, p.10) as:

> '. . . the detailed expression of information policy in terms of objectives, targets and actions to achieve them, for a defined period ahead. Information strategy provides the framework for the management of information. Information strategy, contained within the framework of an organizational information policy for information and supported by appropriate systems and technology, is the 'engine' for:
>
> – maintaining, managing and applying the organization's information resources;
>
> – supporting its essential knowledge base and all who contribute to it, with strategic intelligence, for achieving its key business objectives.'

The strategic management of information is not a new concept. In today's rapidly changing and increasingly competitive business environment there is a growing recognition by both company managers and information professionals that the effective use of information can affect the productivity of an organization. Koenig's work (1992) on the relationship between information services and organizational productivity highlights the difficulties involved in assessing the contribution of information to productivity. These include assigning a strategic value to information and overcoming the perception that information is a costly overhead that is unrelated to organizational goals. However his research shows the emerging consistent theme that productive organizations are more likely to have information policies and a high regard for information resources.

The recognition that information is a strategic resource and should be managed as such is discussed widely in works by information professionals as they reflect on their changing roles within their organizations. Weitzel (1987), Burk and Horton (1988), Worlock (1987), Griffiths and King (1993), Orna (1990; 1999) and Brache and Rummler (1997) all discuss strategic information management as the solution to enable an organization to become fully competitive in the global marketplace and to achieve

its organizational objectives of competitive power, position, growth and financial advantage.

The basis of an information strategy is an organizational information policy, which is best described by Orna (1999, p.9) when she says it defines:

- 'the objectives of information use in the organization and the priorities among them
- what 'information' means in the context of what the organization is in business for
- the principles on which it will manage information
- the principles for the use of human resources in managing information
- the principles for the use of technology to support information management
- the principles it will apply in relation to establishing the cost-effectiveness of information and knowledge.

An information policy is a dynamic tool which can be used:

- as the basis for developing an organization information strategy
- to relate everything that is done with information to the organization's overall objectives
- to enable effective decisions on resource allocation
- to promote interaction, communication and mutual support between all parts of the organization, and between the organization and its 'customers' or 'public'
- to provide objective criteria for assessing the results of information-based activities
- to give feedback to the process of developing corporate policies.'

An information policy provides the guidelines for both the information manager and the information user. It provides the information manager with a framework within which to work. It details the organizational principles in relation to information, its use and its management. As well as this it guarantees the necessary allocation of resources for the ongoing management of information. From the information user's perspective, an information policy is an assurance that the organization has a commitment to provide the information that he or she requires to do their job.

The information policy is, however, an evolving entity. Constant re-assessment is necessary to ensure that the information priorities change as the organization itself changes and its information needs change. Regularly conducting an information audit is an effective way to ensure that an organizational information or knowledge management policy accurately reflects

the information needs of an organization. The concept of the information audit as a continuum is discussed further in Chapter 8.

Figure 1.4 illustrates the process by which the information audit can form the basis for an organizational information policy that provides the framework in which information can be managed strategically. The information policy can then be used to form the basis for the development of a comprehensive knowledge management system.

Many works discuss the benefits of information resources management and the difficulties associated with developing an information strategy. Worlock (1987) and Skyrme (1995) recognize that rapidly changing technology has made the management of information resources simultaneously easier and more difficult. On the one hand the technology is available to manage information resources effectively and efficiently while ensuring that the right information is available to the right people. On the other hand the number of information sources is growing exponentially and decisions must be made as to which resources will be used.

Skyrme (1995) discusses the current dilemma facing today's company managers where they are subject to information overload yet they complain about the shortage of information needed to make vital decisions. He presents a model for the effective management of information resources that includes the information audit as a key process. Worlock, an information specialist, also discusses the dilemma facing managers of the multiplicity of sources brought about by improvements in technology and a lack of market recognition for the value of information. He suggests that information

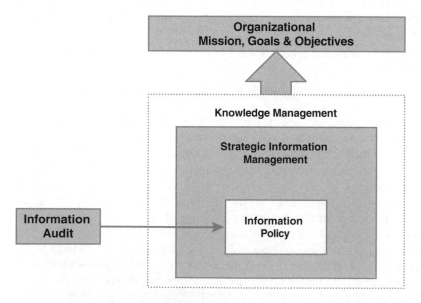

Figure 1.4 From information audit to knowledge management

that is produced by an organization and information that is acquired from external sources and brought into an organization must be managed effectively to avoid duplication and gaps. He discusses the concept of information 'systems' and suggests ways in which they must be related to the behaviours of the information users to optimize their value.

There is an opportunity for the information professional to demonstrate that the management of information at an organizational level will ensure that the right information is available where it is needed. Being able to diagnose information needs as well as to map information flows within an organization, and to relate those flows to the strategic objectives of the organization, ensures that the information professional knows what information is coming into the organization. It also ensures that they know who is using it, as well as how internal information is moving throughout the organization (Burk and Horton, 1988).

The role of the information audit as a component of strategic information management

As stated in the introduction to this book, there is no one universally accepted definition for the information audit. Nor is there a universally accepted methodology for conducting one. There is, however, a consensus amongst professional information managers around the world that the information audit is a firm basis for developing an information policy on which a sound information management strategy can be based.

Guy St. Clair (1997, p.21) says of the information audit:

> 'It assists in the establishment of accountability and responsibility and on determining which components of the information function are 'mission-critical'. By determining how people use information, the audit enables management to set up standards of service based on real needs and it acknowledges competition that might provide the same information differently.'

The information audit is promoted by Orna and St. Clair in their many works as an integral component of information policy development which is therefore vital to the establishment of an information strategy. The information audit process is described as an effective way of identifying organizational information needs, charting internal and external information flows, improving communication between information professionals and employees, marketing information services and enhancing the profile of the library within the organization. The information audit process is promoted as one that can be adapted according to the resources available and the organization's objectives.

Orna's definitive works on the development of information policies (1990; 1999) are particularly important. They establish that the information

policy is an integral component of information resources management, and that the information audit is an integral component of information policy development. It is on the basis of Orna's work that St. Clair and others promote the information audit as an effective means of aligning an information service with the objectives of an organization.

Orna, St. Clair and others emphasize the importance of ensuring that an information service is strategically placed within an organization to enable the resources and services to be acknowledged as contributing to the organizational objectives. They discuss the importance of matching services to needs and the maintenance of focus on the strategic direction of the organization. The information professional must become proactive and entrepreneurial in order to become a strategic player within the organization and to maximize the benefits of the information resources.

Needs analyses and surveys for diagnosing information needs, evaluating services, measuring user satisfaction and marketing information services have been developed as methods for matching information resources and services to user needs. These processes can be used individually or in conjunction with one another to justify existing services, identify unfilled needs and initiate the establishment of new services, demonstrate cost-effectiveness and user satisfaction and market new or existing information services to users and non-users. None of these processes, however, allows a comprehensive map of the information resources of an organization to be produced or charts the flows of information throughout an organization. They do not identify how the recipients are using the information and consequently they are not able to identify information that is of strategic value to the organization.

Needs analysis versus information audit

Although the needs analysis is not the focus of this book, I thought it was important to mention it here because of the widespread confusion between the two terms: 'needs analysis' and 'information audit'. An information audit is not a needs analysis and a needs analysis is not an information audit although the terms are often used interchangeably. The comparison of the characteristics of the two processes in Table 1.1 is taken primarily from St. Clair's book *Customer Service* (1993). A needs analysis is most commonly a survey questionnaire that asks simple questions concerning the resources and services that people need to do their work and how they find them. The information audit, on the other hand, examines not only the services and resources that are used, and by whom, but also looks at how they are used. Its purpose is to describe the current information situation as objectively as possible: what resources and services are used within the organization (whether provided by the information unit or not); where they come from; how the resources and services are used to support the achievement of objectives and by whom; and to whom the information is directly or indirectly passed.

Table 1.1 Characteristics of the needs analysis and information audit

Needs Analysis	Information Audit
Does not require that a service be in place	An examination of what already exists – seeks to describe the current information situation as objectively as possible
Asks simple questions	Seeks useable information using subjective and objective questions
Reactive	Proactive
Seeks definite and specific responses	Seeks to elicit trends and concepts from potential users as well as determining specific requirements for success in performance of specific tasks
Can be conducted by in-house staff	Best conducted using consultants in conjunction with in-house staff

From information management to knowledge management

It is beyond the focus of this book to discuss knowledge management in detail, as there are other texts that focus on this topic. The relationship between information management and knowledge management does however need to be clarified and simplified to eliminate much of the mystique which surrounds it. The concept also needs clarification from an information manager's perspective, rather than from the perspective of the computer technologist.

The term knowledge management is one that appears to mean different things to different people. Many see it as an extension of the records management processes within an organization, while others see it as a database, or a series of databases, that stores details of the knowledge within the organization (a computerized version of the 'index of expertise', an index to the various kinds of specialist knowledge and skill available within the organization (Orna, 1999, p.10)). Those who are more 'information technology'-focused regard knowledge management as the technology that stores and delivers details of an organization's knowledge assets to those who need them. There are many comprehensive texts available on knowledge management that describe its processes and functions, but not one of them defines clearly what knowledge management is, where its boundaries sit and where it fits in relation to information management within an organization. I would like to suggest that knowledge management is the extension of information management to incorporate an organization's knowledge assets, which include specialist knowledge held by employees, business process information, market and

customer information, management and human resources information, shareholder information, case data and product information.

The Hawley Committee's 1995 report *Information as an Asset* defined these components as 'information'. Many would agree that this definition takes us beyond the traditional definition of information and into what is now seen as knowledge management. It seems that there are shifting boundaries, with individual organizations choosing those that suit them best. For the information managers within those organizations these involve a blurring of the traditional boundaries between records management, information management and human resources management and their convergence in the new concept of knowledge management.

Records Managers and Library Managers are being renamed Knowledge Managers and Chief Knowledge Officers as their roles broaden to cover knowledge assets. Their primary responsibilities, however, remain the same – to acquire, synthesize/filter, disseminate, control, manage and coordinate the information resources that are required by employees to do their jobs. Within these extended roles, information managers must take a holistic view of their organizations. They must ensure that policies (whether they are called 'information' policies or 'knowledge' policies is largely irrelevant) are developed to acquire, manage, control, coordinate and disseminate consistently whatever information is needed by the organization and its employees as well as that produced by the organization as it conducts its business.

An information audit is one of the critical first steps of any knowledge management programme (see Figure 1.4). Conducting an information audit provides the necessary snapshot of an organization's current use of information and also provides details of what would be required in an 'ideal' situation. Decisions can then be made with regard to eliminating the gaps in information provision and addressing other inefficiencies.

In summary, the information audit is a means by which the information resources and services can be identified and aligned with organizational goals. The outcomes of the information audit can be used to develop a comprehensive information policy or knowledge management policy which can then be used to develop processes by which information (and knowledge assets) can be strategically managed. As well as these primary benefits, conducting an information audit can result in many ancillary benefits for the organization, the information unit and the information professional, and these are discussed in Chapter 9.

At this point I would like to introduce the seven-stage information audit model that forms the basis for the remaining chapters of this book.

Introducing the seven-stage information audit model

A research project conducted on information audits in 1997 (Henczel, 1998) confirmed that a standard process is used by information profes-

sionals who conduct information audits, but that they tailor the process according to the type of organization to which they belong, the resources that are available and their reasons for conducting the information audit. The results of this research have been used to develop the seven-stage model. Each stage follows on from the previous one, and within each stage alternative methodologies are discussed in terms of how they can be adapted to suit the physical, financial, technical and human resources that are available. By following this model, you will be forced to determine your objectives prior to conducting the audit so that your expectations are realistic and so that you follow an appropriate methodology for your organization.

Figure 1.5 illustrates the seven stages of the information audit process and the order in which they are conducted. It also illustrates that the information audit process is not an isolated activity and must result in the establishment of an audit cycle for the continual matching of services and resources with organizational needs.

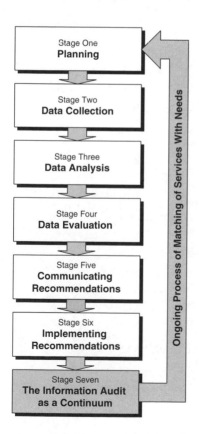

Figure 1.5 The seven-stage information audit model

Each of the stages is listed below, with details of the tasks and activities that are involved.

Stage One: Planning

- Develop clear objectives
 - know what you want to achieve
 - know the organization
 - identify the stakeholders.
- Determine scope and resource allocation
 - physical scope
 - information scope
 - human, financial, technical and physical resource allocation
 - the insource/outsource option.
- Choose a methodology
 - data collection
 - data analysis
 - data evaluation
 - presentation of findings and recommendations
 - action plan for implementing the recommendations.
- Develop a communication strategy
 - before the audit
 - during the audit
 - after the audit.
- Enlist management support
 - develop a business case
 - find a sponsor.

Stage Two: Data Collection

- Development of an information resources database
- Preparing for data collection
- Questionnaire
- Focus group interviews
- Personal interviews.

Stage Three: Data Analysis

- Data preparation
- Methods of analysis.

Stage Four: Data Evaluation

- Evaluate any gaps and duplications
- Interpret information flows
- Evaluate the problems
- Formulate recommendations
- Develop an action plan for change.

Stage Five: Communicating Recommendations

- Written report
- Oral presentations and seminars
- Corporate intranet/web site
- Personal feedback to participants and stakeholders.

Stage Six: Implementing Recommendations

- Develop an implementation programme
- Incorporate the changes into formal plans (marketing, business, strategic)
- Develop a post-implementation strategy
- Develop an information policy.

Stage Seven: The Information Audit as a Continuum

- Measure and assess the changes
- Plan a regular information audit cycle.

How to use this book

Chapters 2 to 8 of this book each cover one stage of the information audit process. Chapter 9 *(Bringing it all together)* summarizes the process. (Skip straight to this chapter if you want a short overview of the seven-stage information audit model and the components within each stage).

Chapter 2: Planning explains how to begin planning for the information audit. This stage is the most crucial of the process and can make the

difference between success and failure. This chapter takes you through the five planning steps: (i) developing clear objectives; (ii) determining the scope of the audit and resource allocation; (iii) choosing a methodology; (iv) developing a communication strategy; and (v) enlisting management support (including the preparation of a business case). With the help of comprehensive checklists, this chapter identifies many of the decisions that need to be made before the process begins.

Chapter 3: Data Collection describes how to develop an information resources database. It then examines three survey methods of data collection: questionnaire, focus group interviews and personal interviews. It looks at the differences between each of the methods and suggests how to use each one to collect relevant data. A sample questionnaire and suggested structures for focus group and personal interviews are provided.

Chapter 4: Data Analysis looks at the three types of analyses that are necessary. The first is the analysis of the data contained in the information resources database. The second is the mapping of information flows and the third is the analysis of the additional survey. It covers the preparation of the data, data entry and editing and the various ways in which the data can be coded to facilitate analysis. It suggests ways in which the data can be analysed and introduces software that can assist with both qualitative and quantitative analysis.

Chapter 5: Data Evaluation discusses the evaluation and interpretation of the data within the context of the organization and suggests ways in which the findings can be used to develop strategies and to formulate recommendations.

Chapter 6: Communicating the Findings and Recommendations examines the all-important issue of communicating the recommendations to stakeholders. It looks at the various options available for presenting the audit findings and recommendations.

Chapter 7: Implementing the Recommendations deals with the implementation of the recommendations and suggests ways to increase your chances of successful implementation. It introduces the information policy as a means of coordinating how information is managed within the organization.

Chapter 8: The Information Audit as a Continuum looks at how the information audit process can be conducted regularly to keep up with the rapidly changing information needs of an organization and to maintain an up-to-date organizational information or knowledge policy. It introduces the model as a continuum and discusses how to plan and schedule 2nd generation and 3rd generation information audits. It also examines how the process can be tailored to suit the needs of individual organizations at the various stages of the information audit continuum.

Chapter 9: Bringing it all Together summarizes the components of the processes that are discussed in earlier chapters. It takes a look at ancillary benefits gained by working through the information audit process.

Chapter 10: Case Studies presents selected case studies. These are examples of information audits that have been conducted and include details of the process used and the outcomes.

Checklists are provided for the planning, data collection and evaluation stages to assist in decision-making and to ensure that all relevant issues have been addressed.

Appendix A In 1997, in partial fulfilment of my Master of Business (Information Technology) degree at RMIT University in Melbourne, Australia, I completed a study into the effectiveness of an information audit in a corporate environment (Henczel, 1998). My research examined the methods used by both information professionals within organizations and consultants who are brought into organizations to conduct information audits on their behalf. Two extracts from my study are included as Appendix A – one is an extract of the study of the consultants and the other is an extract of the study of the information professionals. These extracts may be of interest to those who have to choose between conducting an information audit using in-house resources or outsourcing it to consultants.

References

Brache, A.P. and Rummler, G.A. (1997) Managing an organization as a system. *Training*, **34**(2), 68–74

Burk, C.F. and Horton, F.W. (1988) *InfoMap: a complete guide to discovering corporate information resources*. Englewood Cliffs, NJ: Prentice Hall

Dubois, C.P.R. (1995) The information audit: its contribution to decision making. *Library Management*, **16**(7), 20–24

Griffiths, J.M. and King, D. (1993) *Special libraries: increasing the information edge*. Washington, DC: Special Libraries Association

Hawley Committee (1995) *Information as an asset: the board agenda: a consultative report*. London: KPMG IMPACT

Henczel, S.M. (1998) *Evaluating the effectiveness of an information audit in a corporate environment*. Minor Thesis, Faculty of Business, RMIT University, Melbourne

Kennedy, M.L. (1996) Positioning strategic information: partnering for the information advantage. *Special Libraries*, **87**(2), 120–131

Koenig, M. (1992) The importance of information services for productivity 'under-recognized' and under-invested. *Special Libraries*, **83**(4), 199–210

Martin, B. (1996) Corporate libraries in the digital age: threats and opportunities. *Vic Specials*, **13**(2), 4

Matarazzo, J.M. and Prusak, L. (1995) *The value of corporate libraries: findings from a 1995 survey of senior management.* Washington DC: Special Libraries Association

Orna, E. (1990) *Practical information policies: how to manage information flow in organizations.* Aldershot: Gower

Orna, E. (1999) *Practical information policies*, 2nd edn. Aldershot: Gower

Rundle-Thiele, S. (1997) *ALIA market research report.* Adelaide: University of South Australia

Skyrme, D. (1992) Knowledge networking: creating wealth through people and technology. *The Intelligent Enterprise*, **1**(11/12), 9–15

Skyrme, D. (1995) Information resources management (IRM). *Management Insight*, (8). Available at www.skyrme.com/insights/8irm.htm

St. Clair, G. (1993) Customer service in the information environment. In: *Information Services Management*, ed. G. St. Clair. London: Bowker-Saur

St. Clair, G. (1997) Matching information to needs. *Information World Review*, **123**(March), 20

Weitzel, J.R. (1987) Strategic information management: targeting information for organizational performance. *Information Management Review*, **3**(1), 9–19

Worlock, D. (1987) Implementing the information audit. *Aslib Proceedings*, **39**(9), 255–260

Planning

Figure 2.1 Stage One – Planning

Planning is the first stage of the seven-stage information audit process (Figure 2.1). As with any major project, proper planning can minimize the risks and result in a more focused process with more significant outcomes. Undertaking an information audit is no different, as the success or failure of the entire process can rest on how well it was planned in the initial stages. Giving thought to how the process will be conducted, how it will be resourced, its scope and timescale and communication issues prior to the commencement of the project will enable many of the potential risks and problems to be considered before they happen.

This chapter introduces the five-step planning process and helps to identify some of the major issues that you are likely to face when conducting an information audit. It also looks at some of the significant decisions that have to be made when planning how the audit will be conducted and what resources will be used. Steps 1 to 4 have checklists that allow you to document the information that you gather as you work through each step. In step 5 the consolidation of the information in the checklists forms the basis for your business case.

The five-step planning process

The five-step planning process will lead you through all of the important issues associated with the information audit process (Figure 2.2). Each step

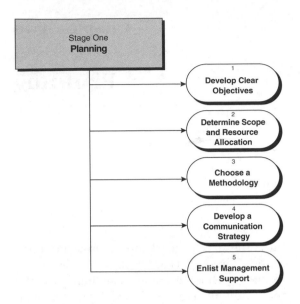

Figure 2.2 The 5-step planning process

addresses a major issue that, once examined, will lead you one step closer to a successful information audit.

Step 1 makes you define your reasons for conducting the information audit and asks you to consider what you might hope to achieve. It emphasizes the importance of knowing how your organization works and how the organizational structure and culture impact on information use and flows.

Step 2 explains the options available for determining the scope of the information audit and what resources will be required to conduct it. It covers human, physical, financial and technical resources, and discusses the insource/outsource options.

Step 3 describes the various ways in which an information audit can be conducted and helps you to choose an appropriate method of data collection, analysis and evaluation, and appropriate methods of communicating the audit findings and recommendations.

Step 4 explains the importance of communication before, during and after the information audit. It discusses the advantages of the various methods of communication to assist you to choose the most appropriate for your organization.

Step 5 explains the importance of recruiting a sponsor or advocate to act as a liaisor between the auditors and upper management. It stresses the importance of developing a business case that brings together the scope, resources, methodology, timeframe and objectives to persuade management that the information audit will produce short- and long-term benefits for the organization.

Step 1: Develop clear objectives

The first step of the planning process is to develop clear objectives. To do this you must examine your reasons for conducting the information audit and consider carefully what you hope to achieve. Your objectives must be realistic and achievable, as they will form the basis for your expectations of what the outcomes of the process will be. The reasons for conducting an information audit will be different for each organization and consequently the objectives and expectations will also vary.

Before you can develop your objectives it is important that you understand your organization's mission, goals and objectives, and how these are translated into strategic business unit (SBU) objectives, critical success factors (CSFs) and tasks. Understanding the structure of the organization and how it impacts on the transfer of information internally and between the organization and the external environment is also important, as is understanding the culture within the organization.

At the same time you must also identify the various stakeholders who rely on an efficient and effective information service. These are groups and individuals both inside and outside the organization and it is vital that

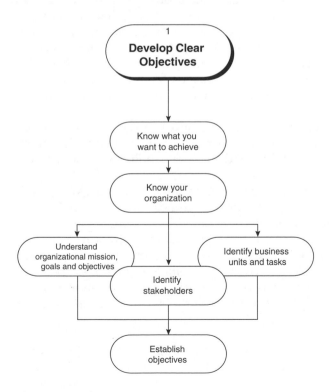

Figure 2.3 Planning – Step 1

you understand who they are and why they are stakeholders. The objectives that you establish prior to conducting the information audit must be compatible with the needs of all stakeholders.

Know what you want to achieve Why are you conducting the audit? What do you hope to achieve? The answers to these questions are critical as they form the basis for expending the time and resources needed to conduct the information audit.

There are many reasons, both strategic and operational, for conducting an information audit. At a strategic level it will identify those resources and services that have strategic value to the organization and form the basis for an organizational information policy or knowledge management policy. At an operational level it can enable cost efficiencies through more streamlined processes and the rationalization of information resources and services. It can enable the information manager to prioritize the acquisition of resources and the provision of services in times of declining budgets and increasing demand for information resources and services. In these times of organizational downsizing and restructuring an information audit can help to justify the existence of the information unit by placing a value on its contribution to the achievement of organizational success. The information manager can initiate the audit to enable him or her to be prepared for the justification process, or it can be sought by upper management. Tables 2.1 and 2.2 list and categorize some of the objectives for conducting an information audit and their associated outcomes. This list is not exhaustive, however, as the reasons for conducting an information audit will vary with the needs of the information unit and the organization.

Any one of these reasons may be the primary objective for conducting the information audit, but the outcome of the audit will address many, if not all of them, to some degree depending on the process chosen.

The development of clear objectives is an important process that will form the basis for the development of the business case in Step 5.

The information audit process has the potential to identify many features and characteristics of information use within an organization. You may choose to concentrate on one or two specific outcomes, or you may decide that you want your audit to cover the complete range of possible outcomes. The most important issue is to understand the audit process and what it can potentially achieve for both the information unit and the organization.

Know your organization It is important that the audit manager and the members of the audit team have a complete understanding of the organization's business. Before establishing your objectives you need to learn as much as you can about your organization, its purpose and how it

Table 2.1 Objectives: to move towards strategic information management
Purpose of the information audit: To move towards strategic information management and knowledge management:

Objective	Outcome
To ensure that information resources and services support organizational goals	Enables a matching of information resources to organizational goals and objectives to determine their value to the organization
To identify the services that contribute to the organization's key business objectives	Enables the rationalization of information services including the cessation or modification of existing services and the introduction of new services
To develop a formal information policy	A formal information policy is the basis for strategic information management and a comprehensive knowledge management policy
To identify the needs of the key information users in the organization	The identification of organizational stakeholders and the information that they need for their work can lead to the fulfilment of their needs and may ensure their support for future projects
To map information flows within the organization and between the organization and its external environment	Highlights any inefficient information flows – can lead to the re-engineering of processes to make flows more efficient and effective
To raise the profile of the information service in the eyes of management by increasing the recognition that information is a strategic asset	Information providers secure a more strategic role in the organization and are seen to be contributing to organizational success
To link information to management processes	Enables the identification of critical information resources. Improves decision-making when faced with competing resources and services. Improves the ability to establish a 'value' for information services
To identify gaps and duplications or areas of over-provision of information resources	Allows gaps to be filled and duplications and over-provisions to be eliminated
To identify the important information resources used by the organization (including those that are not supplied by the information unit)	Facilitates acquisitions and subscription consolidation. Combined with the mapping process can result in a more efficient provision of strategically significant information resources

Table 2.2 Objectives: to improve the efficiency of information provision
Purpose of the information audit: To improve the efficiency of information provision:

Objective	Outcome
To understand better the organization, its mission, its people and how they interact with one another and with the external environment	More effective information provision. Alignment of information provision with organizational objectives. Improved decision-making when faced with competing resources or services
To reduce costs	More efficient use of the resources committed to the provision of information (financial, human, physical, technical). Elimination of duplicate resources. Identification of inefficient information use behaviours
To justify existing services/resources	Shows how existing services contribute to organizational success. Establishes whether the existing information services provide the information that employees need to do their work
To evaluate existing services/resources	Establishes how well the existing services are meeting the information needs of the employees and the organization
To promote existing services/resources	Informs users and non-users about the services and resources provided
To support restructuring of information services	Identifies critical resources and services and paves the way for the elimination or modification of non-critical resources and services
To support a request for additional staff and/or funding for information services/resources	Places a value on the services and resources provided by the information unit which allows further cost-benefit analyses to be done
To improve the efficiency of information services	Creates a map of what is needed where and when, which facilitates the efficient provision of information

works, and to develop a clear understanding of the organization's culture in order to recognize the 'people' issues that need to be considered. The important elements are the:

- organizational mission, goals and objectives

- organizational structure

- organizational culture.

Organizational mission, goals and objectives The information manager has a responsibility to understand how the information which you provide to people in the organization contributes to the achievement of the organizational objectives and in turn the organizational goals and mission. The information audit process will enable you to identify the information resources that contribute to the objectives of the strategic business units which in turn contribute to the organizational objectives and the organizational mission.

The organizational mission statement is a declaration of the organization's purpose and its reason for existence. While the mission statement provides the overall guiding vision for the organization, the goals are the statements that define the strategies and activities which the organization plans to pursue. The objectives are short-term, specific and measurable actions or activities that are pursued in support of the goals (Jacob, 1990). Figure 2.4 illustrates the relationships between the mission, goals and objectives of an organization.

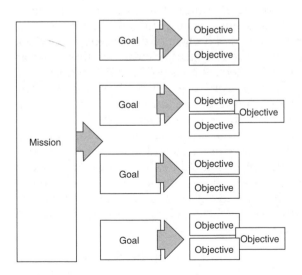

Figure 2.4 Organizational mission, goals and objectives

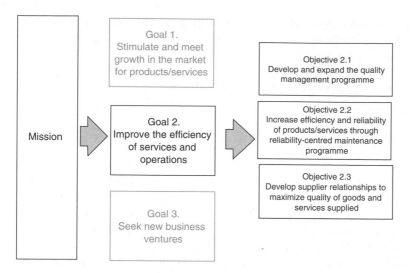

Figure 2.5 Organizational mission, goals and objectives – example

Figure 2.5 shows an example of how the organizational objectives are broken down into specific goals. Details of the organizational mission, goals and objectives are usually found in the annual report, or other key reports produced by the organization.

Strategic business unit objectives, critical success factors and tasks A SBU is a unit within an organization that has a distinct client base, either inside or outside the organization. All business unit managers should have a clear understanding of the organizational mission and goals and how the business unit for which they are responsible contributes to the achievement of the key business objectives. Each business unit within an organization has its own goals and objectives that align with those of the organization. Each business unit objective has critical success factors which are those factors on which the achievement of each objective is dependent. Each critical success factor is made up of tasks that are carried out by the business unit. The identification of the tasks makes it possible then to identify the information resources which are required to meet the objectives successfully. Figure 2.6 illustrates the relationship between the organizational mission and the information resources used in the specific tasks and activities of the business units. In preparation for the information audit it is important that you identify the strategic business units within your organization. This methodology has been adapted (with little change) from the process developed by Steven J. Buchanan which incorporates the development of an information resources database as recommended here.

Organization structure Organization structure is the formal pattern of interactions and coordination designed by management to link the tasks of individuals and groups to achieve organizational goals (Bartol *et al.*, 1995).

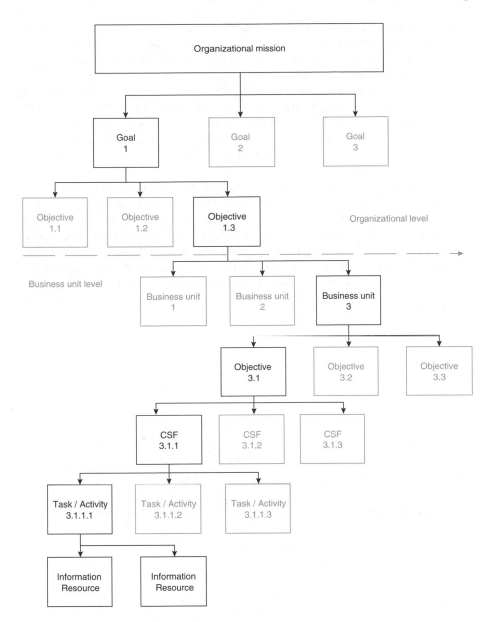

Figure 2.6 From organizational mission to information resources (adapted from Buchanan, 1999)

The tasks and responsibilities necessary for the organization to achieve its objectives determine its structure, rather than the people it employs. An organization chart is a visual representation of the formal organization structure. The structure of an organization is important when faced with the task of analysing the information situation and mapping information flows.

The structure can either impede or facilitate the exchange of information and therefore the flow of information. It can also impede or facilitate the sharing of information resources and services which can result in gaps and/or duplications.

General management texts identify three main types of organization structures – vertical, autonomous groups and network (although in reality there are numerous variations of these and organizations rarely fit neatly into one particular structure). Figure 2.7 illustrates each of these structures to show how they differ. Orna (1999) identifies the different characteristics of each structure.

Vertical structures are the most common, with a fixed chain of command and very little horizontal communication. This affects the information situation by impeding the horizontal exchange of information. The vertical exchange of information is often impeded also as decisions are made centrally with the information being available only to those who make the decisions. More information is held in the upper parts of the organization as there is very little flow down; therefore those lower in the organization are less likely to have the information they need to perform their work effectively.

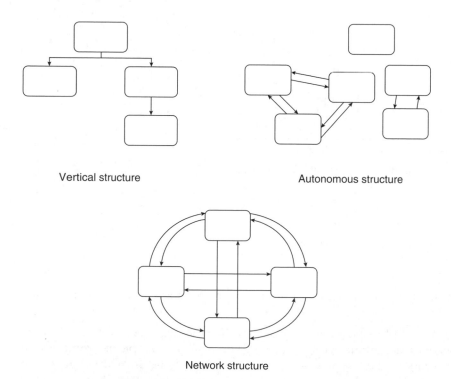

Vertical structure Autonomous structure

Network structure

Figure 2.7 Types of organizational structures (adapted from Orna, 1999, p.61)

Autonomous structures have more decision points with each division making its own decisions. This affects the information situation by impeding the exchange of information between divisions, although information flow within each division can be efficient and effective. There are duplications in the provision of information resources and services as each division wants its own resources.

Network structures are flexible both vertically and horizontally. This structure is the most adaptable to change as it operates as one large group with everyone working towards a common goal. Unfortunately organizations with network structures are uncommon. This structure affects the information situation by facilitating the exchange of information both vertically and horizontally, and the sharing of information resources to avoid duplications and over-provision.

Organizations also have informal structures that are not designed by management but emerge because of common interests or friendships. These groups can have a significant influence on how an organization functions and their importance should never be underestimated when considering how information flows through an organization. The informal structure of an organization will be very different from the formal structure when visually represented since informal groups cross both horizontal and vertical boundaries which are never crossed in the formal structure.

Organizational culture Organizational culture is the system of shared values, assumptions, beliefs and norms held by members of an organization (Bartol *et al.*, 1995). The culture of an organization is important because when a large group of individuals behaves in a certain way it can have a significant impact on organizational effectiveness and has specific and direct influences on the information situation. Culture influences how an organization values information, how information flows and how it is used ,and so will condition the resources that it is prepared to devote to developing information policy and strategy and affect the success of such endeavours (Orna, 1999).

For any project such as the information audit to have a successful outcome, it must be managed in such a way that it is compatible with the organizational culture. The process that you choose must be compatible with how things work in the organization. It is important to recognize where the organization's culture is impacting on information use and reflect carefully on whether this is something that can be changed.

An organization with an 'information-friendly' culture will be an informal organization where communication is open and workers have a strong sense of responsibility. There will be very little political activity and competition. In most cases the CEO will have instilled an information ethos and throughout the organization there will be a general willingness to share information (Skryme, 1992).

Many organizations are undergoing constant change, which causes varying degrees of insecurity amongst employees. Their concerns are very real and their behaviour can have a dramatic effect on organizational success if not recognized by management and counteracted. Insecurity tends to make people possessive and territorial about the information that they generate due to their desire to be 'indispensable' and in control. 'People' issues such as these impact on the information audit process if employees are not open about their information needs and use behaviours. They could possibly view the audit process as a threat to their position and consequently be less than honest about what they use and how. Cultural issues and specific 'people' issues can be minimized, if not overcome, if they are recognized and their impact on information use and flows is understood.

Identify stakeholders Understanding who the stakeholders are within your organization and also outside it is important as it allows you to target the information audit at these specific groups. It also ensures that any recommendations which are formulated as a result of the audit address the needs of all stakeholder groups, and not one group to the detriment of others.

There are various types of stakeholders. An information stakeholder is anyone who is affected by the information services within the organization. Information stakeholders are also organizational stakeholders (those within the organization) and can be external stakeholders as in the case of vendors and publishers who rely on the organization to use their products and services. Table 2.3 lists these stakeholder groups and explains why they are stakeholders.

Table 2.3 Stakeholder groups

Stakeholder Group	Why they are stakeholders
Information customers	They rely on information services and resources to do their jobs
Organizational management	They rely on information services and resources to make quality decisions (either directly from the information unit, or indirectly via information that has been manipulated or filtered by employees)
All employees of the organization	Their job security etc. relies on the success of the organization, which can be affected by the quality of the information service
The information manager	For the assurance that he or she is providing the optimal information service to the organization
Vendors and publishers	They rely on the organization to use their products and services
Shareholders	Their financial returns rely on the success of the organization, which can be affected by the quality of the information service

Once you have a clear understanding of who the stakeholders are and why they are stakeholders, you are in a better position to establish your objectives for conducting an information audit.

Establish objectives Understanding the needs of your stakeholders and of how your organization works (culturally and politically), what is its purpose and how it hopes to achieve that purpose will place you in a good position to define specific objectives for conducting an information audit. When defining your objectives it is also necessary to have a good understanding of the information audit process and what are its limitations. This helps to avoid unrealistic expectations. Once established, these objectives become an important part of the business case that is developed in Step 5.

Step 1 Checklist

The following checklist allows you to consolidate the information that you have gathered as you have worked through Step 1.

STEP 1 CHECKLIST
Develop Clear Objectives
What are your reasons for conducting the information audit?
What do you hope to achieve?
How well do you know and understand your organization?
• What is its mission?
• What are its major goals?
• What are its major objectives?
• What is its structure?
• How does its structure impact on the information situation?
Where does the information unit fit within the structure?
What are the strategic business units within the organization?
What are 'people' issues that might impact on the success of your information audit?
What 'cultural' issues may impact on the success of your information audit and the resultant recommendations for change?

> Who are the key stakeholder groups?
>
> ● Within the organization
>
> ● External to the organization

Step 1 Outputs
The outputs of Step 1 of the planning process are:

1. List of business units
2. Stakeholder list
3. List of objectives
4. Completed Step 1 checklist.

Step 2: Determine scope and resource allocation

In Step 1 you established your objectives for conducting the information audit, identified the stakeholder groups and determined why they are stakeholders and identified the business units within the organization. The purpose of Step 2 is to help you to decide on the scope of your information audit and how it will be resourced. Figure 2.8 shows the two ways in which the information audit project can be scoped: (i) by the type of information and (ii) physically by how much of the organization it covers. It also shows the types of resources that must be allocated to the information audit project. The outputs of Step 1 are used in the decision-making processes in Step 2.

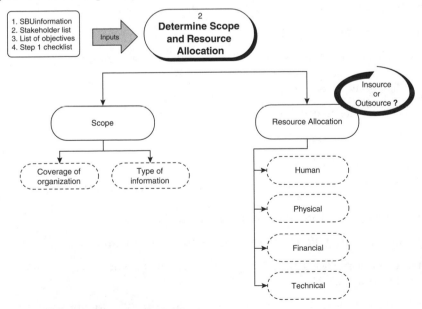

Figure 2.8 Planning – Step 2

Scope (coverage of the organization)

The scope of the information audit can be organization-wide or business-specific. A decision must be made about whether the information audit will cover the entire organization, or concentrate on targeted sections or business units. Targeted sections can be geographical units or divisions based on function or process. Regardless of how you scope your information audit, ensure that boundaries are clearly established, and that exclusions to the scope (and the reasons for their exclusion) are clearly noted.

When considering the scope of your audit the following issues must be taken into account:

- what are your objectives?

- how much will it cost?

- how long will it take in person-days and elapsed time?

- how will it be managed?

- what level of management support is available?

To evaluate fully the information needs of the organization and match them to existing services and resources, and to map information flows, the information audit must be conducted across the entire organization. The scope of an initial (or 1st generation) information audit should definitely be the entire organization. An information audit of a specific business unit can be conducted as a pilot project to try out processes prior to an organization-wide audit. This enables a more accurate estimate to be made of the resources needed for the wider audit, and also validates the processes chosen to collect, analyse and evaluate the data. It allows the auditors to assess the appropriateness of their chosen methodologies and identify potential problems that could impact on the success of the audit. The results of the pilot audit can be used to demonstrate the validity and value of the process when preparing the business case for a more comprehensive information audit.

Although the processes are the same for the wider and more specific audit, the volumes of data can be dramatically different and therefore require the commitment of more human, financial, physical and technical resources, and a greater level of management support. The wider audit will require more intensive planning and management but will result in recommendations that have more strategic value to the organization. See Table 2.4 for a comparison of the different methods.

A third and possibly less common method of scoping the information audit is by limiting it to a specific level of the organization. An audit conducted across an operational or functional level will enable the infor-

mation needs of that level to be defined, and also will give an insight into how information is used at that level.

Most organizations have significantly large pockets of employees who do not have a need for information resources to do their work. These include catering staff, staff in support clerical and administrative roles and some customer service employees. An organization-wide audit can be conducted excluding the groups who are known not to be information users. For example, case study 1 in Chapter 10 looks at an information audit in a hospital medical library that sensibly excluded catering, laundry, clerical and administrative staff.

Table 2.4 Scope by coverage of the organization

Organization-wide information audit	Information audit of a business unit or section
Requires the commitment of financial, human, technical and physical resources from the organization	May be conducted using existing information services resources
Needs intensive planning and management	Needs planning and management
Needs high-level management support	Can be done just with management support from the targeted department or section
Recommendations have strategic value for the organization	Recommendations have value for the department or section and possibly for the organization as a whole
A first audit should always be organization-wide to provide global data to which subsequent audits can be compared and measured	Subsequent audits can be restricted to specific business units or sections of the organization

Scope (type of information)

Consideration must also be given in the planning stage to the type of information resources to be covered by the audit. A comprehensive information audit will be all-encompassing and will cover records management, archives and IT departments as well as traditional information resources. The way you handle this will depend on how the responsibilities for these areas are divided in your organization. If they are all part of the same functional area, then it makes sense to include all types of information in the information audit. Many information managers choose to scope the

information audit to cover only those resources that are, or could be, provided by the information unit. This is a reasonable starting point for a first audit. As subsequent audits are conducted their scope can be increased incrementally to incorporate other types of information and the technological resources necessary to provide and access the information.

Resource allocation

An information audit requires the commitment of human, financial, physical and technical resources. In this part of the planning stage you must estimate the level of resource commitment required to complete the audit successfully. Human and financial resources are the most critical, but you must also consider what is required in the way of physical and technical resources. This is particularly important if additional staff are required and if you plan to make significant use of the technological resources available within the organization.

You must also consider whether in-house or external resources will be used for the various stages of the process. It might be beneficial to undertake some cost comparisons here so that you can use them to support your case for either additional resources from within the organization or authorization to employ external resources.

Human resources Human resources are needed to plan, manage, conduct and evaluate the information audit. The tasks vary with each stage of the process, and there are many decisions to be made about who has the most appropriate skills. The appointment of an audit manager and the recruitment of an audit team must be done with an understanding of what skills and expertise are needed.

Audit Manager. If the audit is to be conducted using in-house staff, the most appropriate person to conduct the audit is the information manager if he or she is an information professional. The skills and expertise that he or she brings to the project are inherent in their professional expertise and should include:

- an understanding of the organization as a whole and how the parts work together

- an understanding of all types of information content

- the ability to organize, codify and categorize knowledge

- the ability to identify inefficient or improper uses of information, whether that problem relates to the quality of the content, appropriate format or access methods

- the ability to comprehend and elaborate on users' information needs (e.g. the skilled 'reference interviewer' is an ideal person to query staff about their day-to-day uses of information – this skill is fundamental to the audit process)
- the ability to improve the value of information by evaluating, filtering, abstracting or providing a broader organizational/industry context.

[from 'The steps to take for conducting an information audit', 1997]

There are disadvantages in using the information manager as the audit manager:

- his or her possible subjective view of existing information services which could result in bias in the data collection and evaluation processes and the formulation of recommendations
- a possible lack of experience in data collection, analysis and evaluation techniques
- a possible inability to commit the appropriate amount of time to the audit project.

Audit Team. The establishment of an audit team spreads the workload and brings in a wider range of skills and expertise. By involving staff from areas other than the information services department the 'ownership' of the audit process is expanded. This has other advantages including:

- improved communication before, during and after the audit (a wider range of formal and informal communication networks is incorporated)
- increased support for implementation of the recommendations resulting from the audit.

There will always be an element of suspicion about any project that asks employees for information about their jobs and involving a wide range of people in the audit process will help to allay fears that the information audit will cause downsizing or job losses.

It is important that members of the audit team are respected within the organization, and that they have the necessary skills and expertise to establish and maintain their credibility in the eyes of all audit participants and stakeholders. When more than one person is involved in the management and administration of the information audit processes, it is important that they each have an understanding of the organization's business and the ability to interact with a wide range of people. They must have consistent expectations of the audit's purpose and understanding of the objectives – why it is being conducted and what it hopes to achieve.

Physical Resources Regardless of whether you conduct your entire survey using in-house resources or whether you outsource selected components you will require physical resources such as office space and furniture as

well as materials such as stationery. If you are bringing consultants into the organization they will need somewhere to work. If you are using existing employees it may not be possible for them to work from their usual location and an alternative location will be needed. This may not be a problem for most, but if space is at a premium in it can become a major dilemma, and one that is often not realized until further into the project. Make sure that sufficient working space is available for all auditors and also those employees who have supporting roles.

The quantities of stationery supplies that will be required must be ordered well in advance to ensure that they are available when the auditors are ready to begin. If questionnaires are to be printed this must also be arranged in advance.

Financial Resources The potential outcomes of an information audit can result in significant cost savings to the organization by rationalizing the acquisition of information resources and services and ensuring that they all support the achievement of organizational objectives. However, regardless of how the audit is conducted, it will be a costly exercise. In addition to direct costs many indirect costs are incurred, such as staff time and the use of physical and technical resources. How you actually cost the data collection and analysis processes will vary according to the practices that are following in your organization. Consideration must be given to staff salaries and on-costs and the costs of materials, communication, training and consultancy. These must be estimated and budgeted for, either from the information unit budget, or from other sources. The business plan should state which costs the information unit will cover and which costs will require funds from elsewhere.

Consider how the use of the technology infrastructure within the organization can reduce costs and speed up the audit process. The use of email or intranet/Internet distribution and collection methods are much less labour-intensive than mail or personal delivery, and the costs of materials are much less (unless everyone decides to print out their copy of the questionnaire!).

Accurate records must be kept of all direct and indirect costs incurred and these should be included in the final report to management. Conducting an information audit is an investment in the future of the organization and the information unit. By recording all costs, and measuring them against potential savings and increases in productivity, the return on investment becomes evident. For example, an outlay of $20 000 to conduct an information audit could lead to streamlined processes that result in savings far in excess of this outlay. Also, the savings are ongoing and cumulative as subsequent audits are conducted.

Technical Resources Technical resources such as computers, printers and photocopiers will be required, as will communications equipment

such as telephones and fax machines. If interviews are to be recorded, recording devices will be needed such as dictaphones or tape recorders.

As well as ensuring that sufficient computers are available, it is important to remember to make sure everyone concerned has the appropriate passwords and logons to allow them access to all relevant sections of the network. The cost of storage space on the server must also be considered if large volumes of survey results are to be stored and manipulated using the organizational computing infrastructure.

Insource/outsource option When determining the resources that are required to conduct an information audit, consideration must be given to whether the resources will be provided by the organization or whether they will be brought in from external sources. The use of external service providers to perform non-core tasks is not new to information units, and in these days of downsizing and re-engineering it is a methodology often used to allow staff to focus on the more strategic activities.

The following questions must be asked when deciding whether to insource or outsource:

1. Is appropriate audit expertise available within the organization, and if so, is it available for use on the information audit? In other words, can staff members be released from their other duties for the time needed to conduct the audit?
2. Are there sufficient resources available to conduct the audit in the timeframe available?
3. Which is more costly – insourcing or outsourcing?
4. What is the organization's policy with regard to outsourcing?

There are benefits of using in-house staff to conduct the information audit. It provides them with an opportunity to broaden their knowledge base about the organization, develop skills in areas such as interviewing techniques, the preparation of survey questionnaires, data analysis and report presentation. It also gives them the opportunity to communicate with employees throughout the organization. This increases their visibility and may raise their profile within the organization. They will have a better overall understanding of the organization, its structure, culture and politics, and they will have existing communication networks within the organization. In addition, there will not be any risk in the handling of sensitive or proprietary data.

There are benefits also in using external consultants to conduct the survey. They are practised surveyors and can be faster and therefore cheaper; they may lend a level of credibility to the survey process and respondents may feel less 'at risk' when talking to 'outsiders'. They are also more objective. However using external human resources impacts on

other resources such as space, equipment, communications, etc. so any decisions that are made to outsource specific components of the project will impact on other areas of resource allocation.

Research has shown that there are benefits associated with using external consultants and with using in-house staff, but that the optimal situation is using a mix of both (Henczel, 1998). There are many ways that this mix can be formulated:

- employ a consultant with information auditing skills from outside the organization and use in-house resources for data collection and analysis

- use in-house auditing expertise and outsource the data collection and analysis

- use external expertise to conduct the entire information audit from the preparation of the business case to the presentation of recommendations

- use in-house resources to collect and analyse data, and use external expertise to evaluate the data and formulate and present the recommendations.

These are just a few of the possibilities, and the mix that you choose will depend on the expertise that is available within the organization, the proposed timeframe and budget, the organizational policy relating to outsourcing and the perceptions of management. It is worthwhile considering whether management will take a project conducted by consultants more seriously than one conducted entirely in-house, no matter how professionally it might have been managed.

In one example an organization used a combination of both internal staff and a consultant. The consultant managed the information audit process while internal staff assisted with preliminary research, interviews and the preparation of reports. This decision was made as it was thought that the organization did not have sufficient expertise in-house to conduct the information audit successfully. This situation benefits in-house staff by allowing them to become involved in the process and build on their knowledge base and skills whilst incorporating the objectivity and professional auditing skills of the consultant.

The research also indicated that consultants have more confidence than information managers in the information audit process as a means of achieving specific objectives. They regard the information audit process as an excellent means of achieving the following list of objectives:

- justifying existing services/resources
- evaluating existing services/resources

- promoting existing services/resources
- maintaining current staffing and funding levels
- supporting requests for additional staff and funding
- identifying user needs
- identifying gaps in service/resource provision
- identifying service/resource duplication and over-provisions
- supporting restructure of information services
- mapping information flows throughout the organization
- ensuring that information services support organizational goals
- raising the profile of information as a strategic asset
- linking information to management processes
- improving the efficiency and effectiveness of information services.

This is due to a number of factors including their auditing experience, their skills in questionnaire design, interviewing techniques and data analysis. It is also due to the higher levels of objectivity that enable them to visualize the potential of an information service.

Table 2.5 lists the advantages and disadvantages of using in-house resources and consultants.

Table 2.5 Comparing the use of in-house staff with consultants

In-house Resources	*Consultants*
Subjective	Objective
Lack of skills in survey design and preparation, interviewing and reporting	Skilled in survey design and preparation, interviewing and reporting – professional auditing skills
Routine tasks and responsibilities may be neglected during the audit process	Minimal impact on day-to-day activities
Confidentiality is assured when dealing with sensitive or proprietary information	Organizational policy may prohibit access to sensitive or proprietary information
In-depth knowledge of the organization	May lack knowledge of the organization
Participants may be guarded in their responses	May instil a greater level of honesty when collecting data

For more information about how consultants conduct information audits and how they rate the information audit process as a means of achieving specific objectives see Appendix A.

Step 2 Checklist

The following checklist allows you to consolidate the information that you have gathered and the decisions that you have made as you have worked through Step 2.

STEP 2 CHECKLIST

Determine Scope and Resource Allocation

What will be the <u>physical</u> scope of the audit?

- The entire organization
- Selected business units/departments/levels/functional groups

What will be the <u>information</u> scope of the audit?

(Provide details of what will be included and excluded)

- All information, regardless of format or source
- Only information provided by the information unit
- Only information acquired from external sources
- Only electronic information resources
- Only print-based information resources

(these are just a few examples of the options available)

What human resources are required?

- Audit manager
- Audit team
- Audit administrator
- Data coders and editors
- Data analysts

What physical resources are required?

- Space (workspace, desks, chairs)
- Materials (stationery, printing)

What technical resources are required?

● Computer equipment, printers, scanners etc.

● Communications equipment (telephones, faxes)

What financial resources are required?

● How much will the audit cost?

● Where will financial support come from?

(what proportion will be funded by the information unit and for what proportion are funds being sought?)

Step 2 Outputs

The output of Step 2 of the planning process is the completed Step 2 Checklist.

Step 3: Choose a methodology

There is no universally accepted methodology for conducting an information audit because each organization is different and requires a different approach. This flexibility has some benefits in that it enables you to choose a methodology that best suits the structure and culture of your organization without being locked into a predefined method. The features that are inherent in all approaches are data collection and data evaluation. Data are collected, analysed and then evaluated. Recommendations are formulated and then reported to management. Once approved by management a plan is developed for their implementation (Figure 2.9).

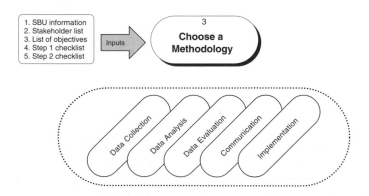

Figure 2.9 Planning – Step 3

The methods chosen for the data collection, analysis and evaluation stages will depend upon the resources that are available, the required timeframe, the structure of the organization, the scope of the audit, the support available from within the organization and what you hope to achieve by conducting the information audit.

Data collection

The most common methods used for the collection of data are survey methods including questionnaires, focus groups and personal interviews. The method of data analysis must be considered prior to the collection of the data so that the right sort of data are collected. All data collected must be useable. The volume of data that is collected must be able to be handled with the resources that are available.

The <u>questionnaire</u> is used primarily to gather quantitative, demographic and attitudinal data using a mix of open and closed questions and rating scales. Designing a survey questionnaire is an art in itself, and how well it is done will influence the quality of the data collected and the time and cost spent in analysing the data. Responses to closed questions including check boxes and multiple choice can be easily coded and therefore are relatively inexpensive to analyse. Open questions require more intensive coding and analysis to extract meaningful data. Software is available to assist in the data analysis, or this process can be outsourced to a specialist.

<u>Focus groups</u> are groups of people who have something in common. They might be groups from specific work areas, or people who share common functions or expertise within the organization. The purpose of a focus group is to facilitate discussion and exploration of particular issues in a non-threatening environment. Questions are posed to the group and the resulting discussions provide the data. Questions can be either structured (set questions for all groups) or unstructured (different questions for each group to match their areas of interests). Data are collected by a 'notetaker' or recorded for later analysis. Most data collected are qualitative.

<u>Personal interviews</u> are used to collect data from individuals within the organization. They can be done on a one-to-one basis or in small groups. As with focus groups they can be structured or unstructured.

Personal interviews and focus groups are generally used to collect data that supplement those collected using the survey questionnaire. If all three methods are used, they are generally conducted in the order (1) survey questionnaire, (2) focus groups, and (3) personal interviews. This allows each set of data to supplement and build upon the data collected previously. However, there are grounds for conducting focus group and personal interviews prior to the primary data collection stage. These preliminary interviews are used as an intelligence-gathering technique to ascertain how to optimize the value of the data collected and reduce the time and costs needed to conduct the information audit. They can be used to identify:

- the key objectives of business units/sections
- the key information users, stakeholders and 'information gatekeepers'
- the optimum scope of the information audit
- potential survey participants.

Chapter 3 includes more detailed descriptions of these three methods of data collection.

Data analysis

The collected data can be analysed manually or using common or specialist software. The method or methods chosen will depend on the types and volume of data collected. They also depend on the skills of the person doing the analysis and whether they are experienced in using the software. If you do not have anyone with the skills needed to analyse the data using specialist software, and you do not wish to outsource this function, then you must only collect data that can be analysed using common database and spreadsheet software. This relates not only to the types but also the volume of data collected.

The data analysis component of the information audit process also involves mapping information flows within the organization and between the organization and its external environment. The mapping of information flows assists in the identification of the gaps, duplications and inefficiencies that hinder effective information provision.

Once analysed the data will identify:

- the resources that are being used to support the strategic aspects of the business unit tasks
- resources and services that are needed but are not being supplied
- duplications in the provision of information resources and services
- supply and flow inefficiencies.

Chapter 4 includes more detailed descriptions of how the data can be analysed.

Data evaluation

Once the data have been analysed, they must then be evaluated and interpreted within the context of the organization. Methods chosen to evaluate the data will vary according to the types of data collected and the results of the data analysis. Data evaluation is a function that can be outsourced to specialists, but may also be done effectively in-house if the appropriate skills are available.

Evaluation and interpretation of the data involves:

- evaluating the problems within the context of the organization to determine whether or not they need to be addressed

- evaluating the opportunities that have been identified to determine whether they can be incorporated into existing strategies

- comparing the existing information situation with the ideal information situation and evaluating the significance of the differences. Gaps, duplications and inefficiencies that have been identified in the data analysis stage can be prioritized and rated according to their significance in terms of the strategic needs of the organization

- interpreting the information flows and determining what needs to be addressed

- identifying efficiencies and determining whether existing strategies are transferable to address inefficiencies elsewhere.

Strategies can then be developed to address the inefficiencies. These might include the modification of existing services, the introduction of new services, a rationalization of resources or changes to delivery and access methods. The strategies can then be used as the basis for the recommendations that will be presented to management as the solution to ensuring the efficient and effective provision of information.

Chapter 5 includes a more detailed description of how the analysed data can be evaluated and strategies developed to address the problems that are identified, and the formulation of recommendations based on the strategies.

Communication of findings and recommendations When the data have been evaluated, findings determined and recommendations formulated, they must be presented to management in such a way that support is received for their implementation. Without this the entire project will have been a waste of time, effort and money.

A <u>written report</u> is the most common means of presenting the results to management. Keeping in mind the importance of this report, it may be worth considering outsourcing its preparation to a specialist, or there maybe a specialist in-house who can produce a professional document. The written report can be made available on the corporate intranet and on the corporate web site, or emailed to managers, survey participants and other stakeholders.

<u>Oral presentations</u> are a popular means of presenting results of a project such as an information audit. A professional presentation incorporating handouts, audiovisual presentation and discussion can be conducted for large or small groups. If the organization is geographically dispersed the presentations can be 'roadshowed' so that all groups are included.

Seminars can be conducted to discuss the audit process and the resultant recommendations. If the audit results in recommendations for changes, the seminars and workshops allow groups to discuss the changes and have an input into how the changes will be managed. This facilitates the change management process.

Chapter 6 includes more detailed descriptions of the communication options that are available and how they are best used.

Implementing the recommendations

How the recommendations will be implemented will depend on what the recommendations are, how much change is involved and the level of support needed from the management and employees. It is important in this planning stage to develop the support and commitment of management for the information audit project in its entirety. It is a major role of your sponsor to ensure that all support gained before and during the audit process follows through to the implementation stage.

Chapter 7 includes details of strategies to use to ensure that the formulated recommendations are implemented.

Step 3 Checklist

The following checklist allows you to consolidate the information that you have gathered and the decisions that you have made as you have worked through Step 3.

STEP 3 CHECKLIST
Choose a Methodology How will the data be collected? ● Questionnaire ● Focus group interviews ● Personal interviews
How will the data be analysed? ● Manually ● Using databases and spreadsheets ● Using specialist data analysis tools Will the data analysis be done in-house or externally?
How will the data be evaluated and recommendations formulated?

How will information flows be mapped?
How will the audit findings and recommendations be communicated?

- To participants
- To key stakeholders (internal and external)
- To management
- To all employees

What method(s) of presentation will be used?

- Written report
- Presentation
- Seminar/workshop
- Intranet/Internet

Step 3 Outputs

The output of Step 3 of the planning process is the completed Step 3 Checklist.

Step 4: Develop a communication strategy

Establishing the appropriate communication channels during Step 4 of the planning stage of the information audit will facilitate effective communication before, during and after the audit. The communication channels chosen will depend on your organization's structure and the methods that are already in place. It is important to begin communication before the information audit has started, continue it throughout the process and maintain it beyond the audit (Figure 2.10).

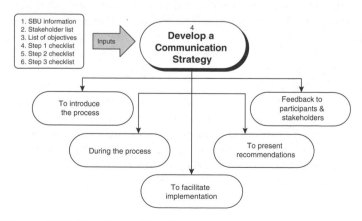

Figure 2.10 Planning – Step 4

Introducing the process

It is important to promote the information audit right from the beginning. This will ensure that everyone understands what it is and why it is being conducted. They will also understand their role in the data collection stage and be better prepared to provide quality data. Communicating throughout the organization at this point also flushes out anyone in the organization who feels strongly about becoming involved and who may have specific skills that can be used during the process.

The use of a corporate intranet is the most effective means of introducing the information audit to all employees prior to its commencement. Ensure that there is a facility for requesting further information or for registering interest in participating. Follow this up with memos to key players, write an article for the corporate newsletter, develop a special issue of the information unit bulletin and print flyers if the budget allows.

If the organization does not have an intranet other methods of communication can be used. Seminars and presentations provide an opportunity for discussion about the audit process and allow employees to ask questions and express their concerns. Flyers, brochures, posters, newsletters and other printed media can be used to inform employees of the audit process, its objectives and the role that the employees will be expected to play. Add a contact name and number to the printed media so that there is a means by which employees can ask questions.

During the process

It is critical to the success of the information audit that effective communication channels are open during the audit. This enables the concerns of employees to be addressed before they become major issues that could potentially have a negative impact on the acceptance of recommendations.

Continue to use the corporate intranet as a means of communicating with the entire organization, but keep in mind that there will undoubtedly be some employees who do not have access to it. Use notice-boards, or manual mailings to reach these people. Establish email distribution lists for dissemination of information electronically and make sure that there is an email address for queries or concerns, particularly during the data collection stage of the audit.

In organizations where there is no intranet or email, use manual methods such as newsletters. Create an 'Information Audit Progress Report' (needs only to be a single page) and issue a new one at significant points during the audit. The newsletter can be mailed to all employees and pinned to notice-boards. Ensure that there are contact names, telephone numbers and fax numbers on all printed material.

Feeding back to participants and stakeholders

Everyone who participates in the information audit needs to be kept informed about what is happening and particularly how useful is their participation. Use email distribution lists, the corporate intranet and other electronic means to provide feedback to audit participants. Many concerns they have will be raised after the data collection stage, and some may wish to provide additional data that was not extracted by the data collection processes used. Provide an email address for questions and make sure that all messages have a prompt reply.

Communicate with stakeholders via the corporate intranet, and use the corporate newsletter to keep them up-to-date with the project. Communicate with external stakeholders using the information unit page on the corporate web site.

Printed newsletters or bulletins, brochures or notice-boards can be used where electronic means are not available.

Presenting recommendations and facilitating implementation

The audit will have been a waste of time if you are unsuccessful in communicating the findings and recommendations to the people who are able to make their implementation possible. Communicate with management while formulating the recommendations. This ensures their 'ownership' of the recommendation and generates support and commitment for the proposed changes. Once the recommendations have been formulated they must be presented to upper management and key players within the organization before they are presented to all employees. This allows management to participate in the development of the implementation programme.

Communicate the final recommendations to employees using the corporate intranet and supplement this with a series of presentations or seminars. The intranet is an effective means of communicating the recommendations in detail, but employees will undoubtedly have questions that relate specifically to how the recommendations and the associated changes will affect them and their work processes. Allowing them to ask questions and discuss their concerns as soon as the recommendations become known minimizes the time they have to develop negative feelings towards the recommended changes. This will provide the opportunity for any opposition to the changes to be addressed and thus streamline the implementation process.

Step 4 Checklist

The following checklist allows you to consolidate the information that you have gathered and the decisions that you have made as you have worked through Step 4.

STEP 4 CHECKLIST

Develop a Communication Strategy

How will the purpose of the information audit be communicated to stakeholders:

- Before the information audit?
- Personally using presentations, seminars, information sessions
- Electronically using Email, intranet/Internet
- Print based – bulletins/newsletters, brochures, notice-boards
- Other _____

- During the information audit?
- Personally using presentations, seminars, information sessions
- Electronically using Email, intranet/Internet
- Print based – bulletins/newsletters, brochures, notice-boards
- Telephone 'hotlines'
- Other _____

- After the information audit?
- Personally using presentations, seminars, information sessions
- Electronically using Email, intranet/Internet
- Print based – bulletins/newsletters, brochures, notice-boards
- Other _____

Step 4 Outputs
The output of Step 4 of the planning process is the completed Step 4 Checklist.

Step 5: Enlist management support

Once clear objectives have been established it is critical to the success of the information audit project that you secure the support of upper management. The managers within the organization are key information stakeholders and as such must be made aware of how the outcomes of the information audit can benefit them and the organization. By recruiting a key player in the organization as a sponsor or advocate of the information audit project you can raise the profile of the project and ensure a higher level of support for the implementation of the recommendations.

A successful information audit requires not only approval to use corporate resources, but also a level of commitment from all employees during the data collection stage and the implementation stage. If management visibly show that they support the project employees will be more likely to develop an appropriate level of commitment. The means of acquiring management support will depend upon the current relationship between the information unit and upper management, and the channels that are in place within your organization to enhance this relationship.

The preparation of a business case that details the objectives, resources, methodology, corporate investment and other relevant issues will ensure that management is aware of what the information audit can potentially achieve. It also helps to justify expenditure, whether it is in the form of staff time or the direct costs incurred. The recruitment of a key player as sponsor establishes a link between the information services unit and upper management which will facilitate communication, ensure an appropriate level of commitment to the project, broaden 'ownership' and streamline any changes that the audit results recommend.

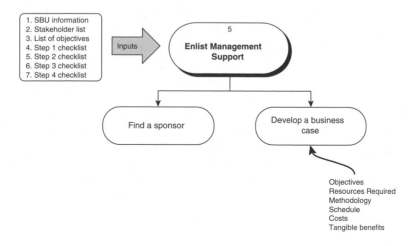

Figure 2.11 Planning – Step 5

Find a sponsor

A sponsor is a key player in the organization who is able to recognize the organizational significance of an idea, help obtain the necessary funding for development of the idea and facilitate its actual implementation. In an information services context a sponsor can be used to 'encourage others to support the work of the information services department and encourage those people to develop relationships which can have a positive influence in the decision-making process for allocating resources for the funding of information services' (St. Clair, 1994). St. Clair also points out that using a sponsor is vital for those situations in which senior management has not yet accepted the validity of information services management as a proper construct in their organizational success. The sponsor raises the awareness in upper management of the value of information services. It is possible to conduct an information audit without a sponsor, but if you are able to find one within your organization it will increase your chances of achieving your objectives.

The recruitment of a sponsor will facilitate many stages of the information audit process. It will improve the chances of obtaining the resources that are needed, open communication channels and facilitate access to decision-makers who would otherwise be uninvolved. He or she may also be able to provide knowledge about, or access to, the 'information gatekeepers' within in the organization. The recruitment of a sponsor creates a link between the information unit and upper management. This is important when seeking approval for the resources to conduct the information audit, for ongoing support during the audit process and when implementing the recommendations.

The sponsor you choose will be someone who is an information user, and who recognizes the value of the information they need for their work as well as the strategic value of information to the organization. He or she will use their influence with upper management to promote the information audit and its potential value to all stakeholders. This type of support will ensure that the information audit is regarded as an important management exercise rather than just an information unit project. It will increase the chances of the recommendations developed in Chapter 7 being accepted by management and also facilitate their implementation.

A successful information audit may result in many changes that will rationalize the information management practices within an organization. This will affect those people or departments who have developed their own methods of acquiring, storing and accessing information, as they will be forced to change. The sponsor must understand the organizational culture, and be able to advise on the appropriate change management techniques to streamline the implementation of the recommendations.

Involve the sponsor in the preparation of the business case to ensure that when it is presented it meets the needs of the organization.

Develop a business case

A business case is a proposal developed for management to secure the approval to proceed with a project and the resources needed to complete it successfully (Blackwell, 1992). The development of a business case involves asking questions such as:

- why do we need to conduct an information audit? What are our objectives?

- how will we do it? What components of the process will we use?

- when will we do it?

- what resources do we need to do it successfully?

- what are the issues that can affect its success?

Since it forces you to answer these questions, the process of developing a business case for conducting an information audit will give you a better insight into the issues that will affect the level of success of the project. The content of the business case will depend on what you are actually asking for – authorization, management support or resources (financial, human, technical, physical), or a combination of all of these.

It is important to know who the decision-makers are so that the business case can be aimed at them. It must persuade them that your project is worthwhile and that there are benefits to be gained not just for the information unit but for the organization as a whole.

A business case must be professionally prepared to establish confidence in the proposed project. It must be concise and coherent and must only contain information that is relevant to the proposal.

A professional business case has the following characteristics:

- good layout – the format of the business case must be logical, with each section leading on from, and building upon, the previous sections. A logical numbering sequence should be used

- clear and simple language, with only one idea per sentence

- brevity – including only essential information

- truthfulness – not overstating your case to generate unrealistic expectations

- quantification – backing up words with figures wherever possible.

Some organizations require business cases to follow a consistent format. If not, Figure 2.12 outlines a suggested format for an information audit business case.

1. Project description

1.1 <u>Title</u> – the name of the proposed project.

1.2 <u>Description</u> – brief statement of objectives of the information audit – one or two sentences that state the aim of the project.

2. Request for approval/resources/support – a statement of what you need to conduct the information audit

3. Problems addressed
An outline of the business problems that the information audit will address. Business problems are circumstances or situations that if left unchecked will have a negative effect on the organization. This section clearly and concisely describes the business problems that the information audit will address.

4. Prioritization rationale
Outline the strategic urgency of conducting the information audit and the benefit to the organization. Tie these into the business objectives of both the organization and the information unit. Describe the relationship between the information audit project and other concurrent projects and programmes and show where the information audit project builds upon, and potentially improves, the outcomes of the other projects. In other words, understand your competition when requesting approval and resources to conduct the audit. Inherent in all companies is the political environment that influences the prioritization regime. This needs to be understood and addressed in the business case. The recruitment of an appropriate sponsor can alleviate some of the political issues that exist within the organization.

5. Skill and experience of auditors

5.1 <u>Project sponsor</u> – the person who will oversee the project and support its progression.

5.2 <u>Auditors –</u> details of their background, skills and experience. It is important here to convey confidence in the people who will conduct the audit.

6. Business units affected
A statement identifying the business units that are affected and describing how they will be affected. This will vary according to the scope of your audit and the structure of your organization. It is important that you articulate what you will expect of the business units in terms of their time and resources so that it is included in the overall approval for the project.

Figure 2.12 Format for developing a business case

7. Proposed methodology

Precisely and succinctly describe how the information audit will be conducted.

7.1 <u>Scope</u> – describe the scope of the information audit explaining clearly which parts of the organization will be covered. Highlight any exclusions so that the scope of the audit is evident.

7.2 <u>Communication</u> – describe the communication strategies that will be used to promote the information audit and to ensure adequate feedback. Detail how people will be informed about the audit and its objectives. Also include the channels that will be used to communicate with participants during the audit, and how the results will be communicated on its completion.

7.3 <u>Process methodology</u> – explain how the audit will be conducted (data collection, analysis, evaluation etc.) Include details of any piloting activities. It is important here to include details of the evaluation processes that are incorporated into the methodology.

7.4 <u>Administration/management</u> – how the administration of the audit will be managed, and by whom.

7.5 <u>Timeframe</u> – estimated timeframe needed to complete the audit in both elapsed time and person days.

7.6 <u>Deliverables</u> – what products will be produced during and on completion of the audit. Final reports, progress reports etc.

8. Potential outcomes

Outcomes (for the organization, information unit and stakeholders) should be readily identifiable and clearly dependent on the execution of the audit. Be persuasive but do not overstate your case as this will result in unrealistic expectations. Include both short-term and long-term benefits and state them in terms of the key business objectives of the organization.

8.1 <u>Quantifiable benefits</u> – details of measurable benefits that have a clear base for valuation. A concise description of each benefit, the basis for valuation and its monetary value should be provided.

8.2 <u>Intangible benefits</u> – these benefits can not be quantified, but add value to the organization by supporting the strategies designed to attain the organization's goals.

9. Corporate investment

This section includes all the investments which you are asking the organization to provide to conduct the audit. Include details of all of the resources required, including the types of support required from management. Include costings for personnel (both internal and external), physical resources (computing equip-ment and communications) and other direct costs. Include an estimate of the total cost of the audit.

Figure 2.12 *continued*

> 10. Risk assessment
> A risk is a condition or scenario that will, or could be expected to, affect adversely the planned progression of the project. Identify the risks and explain how they will be managed. Risk management is an action or plan that is designed to counter the risk and so ensure that the project is successfully completed within the planned timeframe and budget.
>
> Examples of risk areas are:
> scope control
> ● customer and user expectations
> ● relationships with other projects
> ● timeframe
> ● budget and cost control
> ● impact of corporate restructuring
> ● project team resourcing.

Figure 2.12 *continued*

As a control measure have an independent person to proof-read the business case before it is submitted. This will ensure that your argument is clear, well structured and complete.

Once the business case has been developed, it must then be submitted to the appropriate person through the appropriate channels for your organization. Arrange a follow-up meeting with the person who will be receiving it, allowing them sufficient time beforehand to read it. This will give you an opportunity to respond to any concerns they may have regarding the project and to provide any additional information that they request.

Step 5 Checklist

The following checklist allows you to consolidate the information that you have gathered and the decisions that you have made as you have worked through Step 5.

STEP 5 CHECKLIST

Enlist Management Support

Have you found a sponsor?

Have you developed a business case?

Has the sponsor been involved in the development of the business case?

Does your business case include:

1. Project description?

2. A statement of what you need to conduct the audit – approval/resources/support?

3. An outline of the business problems that the audit will address?

4. The strategic urgency of conducting the audit and potential benefits to the organization?

5. Details of the skill and experience of the audit manager and audit team? (Details of the sponsor should also be included here.)

6. A statement identifying the business units that will be affected and how they will be affected?

7. Details of the proposed methodology:
 - scope
 - communication strategies
 - administration and management strategies
 - timeframe
 - deliverables?

8. Potential outcomes:
 - quantifiable benefits?
 - intangible benefits?

9. Corporate investment?

10. Risk assessment?

How will the sponsor be used in the communication process? (refer back to Step 4)

before the information audit process begins:
- to generate management support

during the information audit process:
- to ensure ongoing support of participants and management

on completion of the process:
- to present the findings and recommendations to management

implementing the changes:
- to ensure ongoing support for subsequent audits.

Step 5 Outputs

The outputs of Step 5 of the planning process are:

1. Business case

2. Business unit information

The 5-step planning process gives you the opportunity to consider your objectives and what is required to achieve them in terms of resources and management support. The examination of the components of the information audit process enables you to decide which options best suit your organization, considering the resources that are available. The information gathered and the decisions made in Steps 1, 2, 3 and 4 is consolidated in Step 5 to develop a business case (with the assistance of your sponsor) which can be used to persuade management that the benefits of conducting an information audit far outweigh the costs involved.

References

Bartol, K.M., et al. (1995) *Management: a Pacific Rim focus.* Sydney: McGraw-Hill

Blackwell, E. (1992) *How prepare a business plan.* Wrightbooks Business Series, ed. N.E. Renton. North Brighton, Victoria: Wrightbooks

Buchanan, S.J (1999) *The information audit: an integrated strategic approach* (http://www.strath.ac.uk/Departments/In6strategy/). Accessed 28/9/99. Downloaded 28/9/99.

Henczel, S.M. (1998) *Evaluating the effectiveness of an information audit in a corporate environment.* Minor Thesis, Faculty of Business, RMIT University, Melbourne

Jacob, M.E.L. (1990) *Strategic planning: a how-to-do-it manual for librarians.* How-to-do-it manuals for libraries, no. 9, ed. B. Katz. New York: Neal-Schuman

Orna, E. (1999) *Practical information policies* 2nd edn. Aldershot: Gower

Skryme, D. (1992) Knowledge networking: creating wealth through people and technology. *The Intelligent Enterprise*, **1**(11/12), 9–15

St. Clair, G. (1994) *Power and influence: enhancing information services within the organization.* Information Services Management, ed. G. St. Clair. London: Bowker-Saur

The steps to take for conducting an information audit. (1997) *The Information Advisor*, **9**(9), S1–S4

# Chapter Three

Data collection

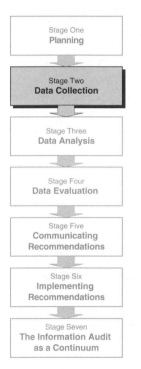

Stage One
Planning

Stage Two
Data Collection

Stage Three
Data Analysis

Stage Four
Data Evaluation

Stage Five
Communicating Recommendations

Stage Six
Implementing Recommendations

Stage Seven
The Information Audit as a Continuum

Figure 3.1 Stage Two – Data Collection

Chapter 2: Planning discussed the various ways in which data can be collected, how the methods differ from each other and the type of data that each method is used to collect. Each collects a different type of data in a different way, requires different resources and timeframes, as well as different methods of preparation, administration and management. The data collection method or methods that you choose for your information audit must be compatible with the structure and culture of your organization. It is important that you take the time to consider these issues in the planning stage so that you can make informed decisions about the best way to collect your data. This chapter will cover each of the data collection methods in more detail to allow you not only to choose the most appropriate method or methods for your organization, but also to make each method as effective as it can be with the resources that you have available.

Data collection is stage two of the seven-stage information audit process (Figure 3.1) and covers the collection of data relating to the information resources used, how they are used, the information produced and the flow of information within an organization and between an organization and its external environment. This stage also covers the development of an information resources database (or 'information inventory') that will be used in the analysis and evaluation stages to store the data that relate to the objectives, CSFs and tasks of each business unit and the information resources used to perform the tasks. This methodolgy was developed by Steven L. Buchanan and is an efficient and effective way to

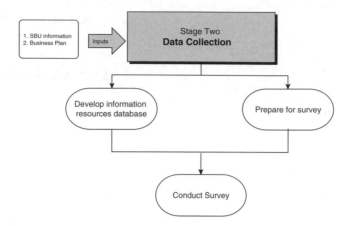

Figure 3.2 Data collection

rate the strategic importance of information resource. The rating scale devised by Buchanan is particularly useful. The data will be used to determine the strategic importance of the information resources to the organization. The data collection component of the information audit process is critical as it forms the basis for the analysis and evaluation stages and consequently for the formulation of recommendations.

Develop an information resources database (or information resource inventory)

The following process has been adapted from Buchanan and Gibb (1998) and Buchanan (1999). It has been included at this stage of the audit process as the database is used to store the data that relate to the business units and the information resources which they use. An information resource database will store the details of the business units, their objectives, CSFs and tasks (using data supplied by business unit managers) as well as all of the information resources that are identified within the organization (using data collected by the information audit survey). It will enable the information resources to be matched with the business unit tasks and subsequently the objectives. It will allow the records to be sorted, searched, updated and analysed and reports to be generated.

1. Using a standard relational database program such as Microsoft Access create a database with the following fields, (Table 3.1).

Create records for strategic business units (SBU), objectives, CSFs, tasks and information resources. Create relationships between the records so that the information resources are linked to tasks, tasks are linked to CSFs, CSFs are linked to objectives and objectives are linked to SBUs. Relationships can be:

Table 3.1 Information resource database fields (adapted from Buchanan, 1999)

ID number	Unique number for each data record
SBU name	Name of strategic business unit
Resource name	Name of the information resource
Source	Origin of the information resource
Task/activity supported	Name (or code number) of task or activity
Importance to task or activity supported	The strategic importance or contribution of the information resource relative to the task supported using a scale from 1 to 5 5 – critical to the task 4 – provides significant benefits or adds value to the task 3 – contributes directly to the task but not essential 2 – provides indirect or minor support to the task 1 – not used or has no perceived benefits for the task
What is the function of the resource?	The purpose of the resource in relation to the task to which it contributes
List any problems with the resource	Problems experienced in relation to the task it supports
How could the resource be improved?	Suggestions for improving the resource

- one-to-one (for example, an information resource supports only one task)

- one-to-many (for example, an information resource supports more than one task)

- many-to-many (for example, many information resources support more than one task).

2. Collect data relating to the details of the business units using a brief questionnaire such as the example (Table 3.2) or using the sample questionnaire for business unit managers at the end of this chapter. Alternatively collect the information by interview.

From the data collected from the business unit managers, and using the database, the objectives of each business unit, their CSFs and tasks can be determined (Table 3.3). The tasks will later be matched with the information resources that are identified in the responses to the information audit questionnaire and interviews.

Table 3.2 Sample questionnaire for strategic business unit managers (adapted from Buchanan, 1999)

1	Business Unit Identification
1.1	Name of business unit
1.2	Name of manager
2	Business Unit Goals and Objectives
2.1	What are the goals of your business unit?
2.2	What are the objectives of your business unit (both organizational and operational)?
3	Critical Success Factors
3.1	What are the critical success factors on which the achievement of your objectives are dependent?
3.2	What are the tasks or activities that deliver the critical success factors?
4	Information Resources [optional]
4.1	What information resources are required for the tasks and activities? [if known]

Table 3.3 Business unit objectives, critical success factors and tasks

	SBU							
Objectives	Objective 1				Objective 2			
CSFs	CSF 1.1		CSF 1.2		CSF 2.1		CSF 2.2	
Tasks	1.101	1.102	1.103	1.104	2.101	2.102	2.103	2.104

The general questionnaire and survey will collect information relating to the information resources that are used to complete the identified tasks. This information will enable you to build up a picture of each information resource relative to the activities which it supports, and to evaluate each information resource according to its strategic importance. The survey and questionnaire will also collect data that relate to information resources used within the organization by groups other than the SBUs.

Prepare for survey

Thorough preparation is essential to ensure that the outcomes of the data collection stage are maximized (Figure 3.3).

There are five issues that need to be addressed in preparation for the survey itself. They have all been looked at to some extent in the planning stage, but now must be considered in the context of the data collection stage of the process.

1. Determine what you need to know

2. Enlist management support

3. Determine the scope of the survey

4. Choose a survey methodology

5. Allocate resources.

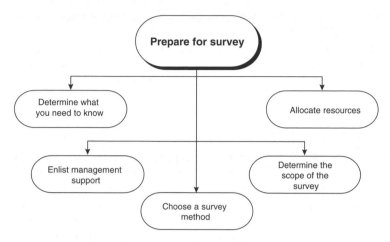

Figure 3.3 Data collection – survey preparation

1. Determine what you need to know

Before you can establish the most appropriate data collection methods to use, you must determine what data you need to collect. In other words, have a clear understanding of what you need to know to achieve the objectives of the information audit. You need to ask questions like these.

- what are the critical information resources and services that people need to do their jobs?

- are they currently available to those who need them?

- how are they being used to achieve business unit objectives?

- where are they coming from and what is being passed on after they have been used, and to whom? (What is the flow of information throughout the organization and between the organization and its external environment?)

The data collection methods used must address these issues by asking for the following types of information:

1. Information resources – the names of information resources used to accomplish the tasks and their importance in terms of how they contribute to the successful completion of the tasks. Ensure that all

formats are covered including print and electronic, and also both internal and external resources

2. The source of the information and to whom it is passed on after use.

To provide data that effectively address these issues, the information audit process uses *survey* data collection methods – questionnaires, focus group interviews and personal interviews. Decisions must be made regarding which survey data collection method or methods to use and how best to use the chosen method or methods to maximize the quality of the data collected.

2. Enlist management support

The importance of seeking management support and commitment was stressed in the planning stage. If management has granted approval for the information audit to be conducted on the basis of the request in the business case, and they have committed an appropriate level of resources to ensure its success, then this commitment must be conveyed to employees throughout the organization. This will ensure that there is an appropriate level of support and cooperation to allow quality data to be collected efficiently. Everyone involved in the data collection process must be informed about the complete audit process, have the opportunity to ask questions, express anxieties and receive explanations. This reduces defensiveness and increases support for resulting changes (Orna, 1996). This will ensure their support for the project in general and specifically for the data collection stage which requires their input. The level of management support and support from survey participants can be related directly to the success or failure of the data collection stage. If the questionnaires are to be completed in the employees' work time and the interviews conducted during working hours, then they must have the support of management and this support must in turn be communicated down the line through to lower-level managers and supervisors. This is also the case if organizational materials are being used to create the questionnaires, and systems such as internal mail and Email are being used to distribute and collect the questionnaires. If middle and top management are seen to be supportive, then the survey itself will carry more weight and the recommendations that result from the collected, analysed and evaluated data are more likely to be accepted.

3. Determine the scope of the survey

The scope of the survey must be considered at a very early stage in the planning process in terms of the purpose of the information audit, and it will differ with each organization. When deciding who will be surveyed, consideration must be given to who are the actual and potential

information users. If the organization includes large groups of employees who are not information producers or users, then it makes little sense to spend time and money on surveying them. For example, a medical library located in a large inner-city hospital conducted a survey and decided to exclude all support staff in the catering, laundry and administration areas as their potential for using or producing strategic information was considered to be negligible. This reduced their survey population base from over 2000 to fewer than 60 people and resulted in a less costly survey process and a more focused outcome (Henczel, 1998). Expense and time are the other major issues to be considered when deciding how many people to survey. The production and distribution of the questionnaires, the collection of completed questionnaires and the analysis of the data collected all take time and incur both direct and indirect costs.

A comprehensive survey will include all of the actual and potential information users in the organization. It is possible ,however, to restrict the survey to business units that have specific needs or sections which use specific types of information or use information in specific ways. It is also possible to select a sample group of participants. This group might include employees of a certain level or employees with a certain function within the organization. It is only advisable to use a sample if that sample can be said to be representative of the organization or group as whole, since it can make the analysis process more complicated.

The results of any data collection process that relies on employee participation *must be seen to be used*. The fact that data have been collected increases employee expectations, and doing nothing with the results may lead to frustration, anger and disillusionment.

4. Choose a survey methodology

The fourth step in preparing for the data collection is to decide how the survey will be conducted and over what timeframe, which resources will be used and how the process will be administered and managed. The following questions are examples of the types of questions that need to be answered.

1. Has an appropriate level of management support been committed?
2. How will the purpose of the survey be communicated?
3. Which survey methods will be used?
4. Who will prepare the survey instrument?
5. Who will conduct personal interviews?
6. Who will moderate the focus group meetings?
7. What type of questions will be asked?

8. Who will be surveyed or interviewed?

9. How will the questionnaire be distributed?

10. When will the questionnaire be distributed?

11. When will the interviews be conducted?

12. When will completed questionnaire be collected?

13. How will the process be administered?

14. How will the costs be budgeted?

Many of these questions will have been answered while preparing the business case during the planning stage. Addressing those that remain unanswered will allow you to refine your plans for the data collection process and to allocate specific resources.

5. Allocate the resources

Human, financial, physical and technical resources are required to conduct a survey. The issues that need to be considered when allocating these resources have been discussed in the planning stage; however, I will repeat some of the most important ones here. The insource/outsource options need also to be considered, as a survey can be conducted using in-house staff and resources, external resources or a combination of both.

Human resources The reasons for choosing in-house people or external consultants to conduct the survey will depend on a number of factors such as:

1. Whether people with survey and interviewing expertise exist in-house or whether expertise needs to be brought in

2. Whether people with survey and interviewing expertise are available in-house, whether they can be redeployed

3. Whether it will be cheaper to use in-house staff rather than consultants.

There are benefits in using in-house personnel when they are available: there will not be any risk in the handling of sensitive or proprietary data; they will have a better overall understanding of the organization in terms of its structure, culture and politics; and they will have existing communication networks within the organization.

There are benefits also in using external consultants to conduct the survey: they are practised surveyors and can be faster and therefore cheaper; they may lend a level of credibility to the survey process;

respondents may feel less 'at risk' when talking to 'outsiders'; and they are also more objective.

The choices will vary according to the type of organization, how the survey is to be conducted, the timeframe and particularly the budget. Using a combination of in-house and external resources enables an organization to gain the benefits of both options without significantly increasing costs (Henczel, 1998).

Financial Resources Regardless of how the survey is conducted, it will be a costly exercise. Not only direct costs but also many indirect costs, such as staff time and the use of physical and technical resources, are incurred. Costing the data collection process will vary according to the practices that are followed in your organization. Consideration must be given to staff salaries and on-costs, materials, communication costs, training and consultancy costs.

The use of the technology infrastructure within the organization can reduce costs and speed up the survey process. The use of email or intranet/Internet distribution and collection methods are much less labour-intensive than mail or personal delivery, and the costs of materials are much lower.

An estimate of the costs involved in conducting the information audit, including the costs associated with data collection, should be included in the business case that was produced in the planning stage. Accurate records should be kept of all direct and indirect costs incurred and these should be included in the final report to management. Conducting an information audit is an investment in the future of the organization and the information unit within the organization. By recording all costs, and measuring them against potential savings and increases in productivity, the return on investment can be calculated.

Physical resources Regardless of whether you conduct your entire survey using in-house resources or whether you outsource selected components you will require physical resources such as office space and furniture as well as materials such as stationery. If you are bringing consultants into the organization they will need somewhere to work. If you are using existing employees it may not be possible for them to work from their usual location and an alternative location will be needed. This may not be a problem for most, but if space is at a premium in your organization it can become a major dilemma, and one that often is not realized until further into the project. Make sure that sufficient working space is available for all auditors and for those employees who have supporting roles.

The quantities of stationery supplies that will be required must be ordered well in advance to ensure that they are available when the auditors are ready to begin. If questionnaires are to be printed this must also be arranged in advance.

<u>Technical resources</u> Technical resources such as computers, printers and photocopiers will be required, as will communications equipment such as telephones and fax machines. If interviews are to be recorded, recording devices will be needed such as dictaphones or tape recorders.

As well as ensuring that sufficient computers are available, it is important to remember to make sure everyone concerned has the appropriate passwords and logons to access the sections of the network that they need to access.

Conduct the survey

'Surveys do not solve problems – they identify potential sources of problems and can act as catalysts for organizational change.'

(Schiemann, 1991)

Regardless of the type of survey method used in the information audit data collection process, an effective survey will make the employees feel that they are part of the decision-making process and that their input is important to the organization. This will increase their support for the information audit project and potentially lead to a better outcome.

A survey is a systematic approach to collecting information. The data collection component of the information audit process is a survey – one that incorporates smaller surveys to collect the required data. The smaller surveys can be questionnaires, focus group interviews or personal interviews. Any one of them can be used alone, or in any combination of two or three methods (see Figure 3.4).

Whether or not each component is used, and how each component is used will depend on the resources available, the objectives of those conducting the information audit, and the structure of the organization.

A <u>questionnaire</u> is a means of collecting both quantitative and qualitative data. It can vary in length and format, and has the advantage of being able to be distributed and returned electronically, saving on distribution

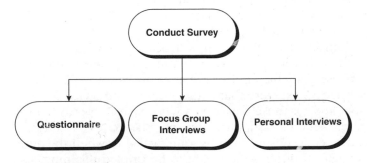

Figure 3.4 Data collection using survey methods

costs and staff time. Questionnaires can be distributed widely regardless of the physical location of the participants, and can be distributed to a large number of participants relatively cheaply and easily. When using the survey questionnaire as a component of the information audit data collection process, there are many decisions to be made to ensure its effective use. These include:

- who will design the questionnaire?

- to whom will it be distributed?

- will all participants receive the same questionnaire?

Focus group interviews are used to explore issues and gather qualitative data. They may also be used to clarify and add depth to the data collected by a survey questionnaire. A focus group interview is a group interview with six to 10 participants. The objective is to generate discussion in a non-threatening environment that allows group members to express their thoughts and feelings about issues of concern about which they know a great deal. When using focus group interviews as a component of the information audit data collection process, issues to consider include choosing appropriate participant groups and moderators, and deciding how structured the interviews will be. The main advantages of using focus groups are the relative ease with which they are organized and run, the ability to explore a topic in depth and their cost-effectiveness in comparison with personal interviews.

Personal interviews are one-to-one interviews which are used to collect qualitative data to clarify, add depth to and consolidate the data collected by a survey questionnaire. When using personal interviews as a component of the information audit data collection process, issues to consider include whom to interview and whether the interviews will be structured or unstructured. The main advantage of personal interviews is the quality of data that can be collected. Their main drawback is the amount of time they take and their reliance on a skilled interviewer to optimize their success.

While questionnaires are structured, both focus group and personal interviews can be conducted in either a structured or an unstructured way. A structured questionnaire or interview means that all participants or interviewees receive the same questions, usually in the same order, to which they must respond. When interviews are unstructured, each participant, or group of participants, is asked questions that arise from the discussions. This means that each interview or focus group may end up addressing very different issues and consequently result in the collection of very different data sets. This limits the scope for comparison between the groups and participants, and makes the overall analysis of data more difficult. It does, however, facilitate the introduction of unanticipated

issues and allows focus to be directed towards those issues that are important to the individuals and groups.

In the following sections each of the data collection methods and the tasks and activities that they involve will be looked at more closely.

Questionnaires

A questionnaire is a survey instrument used to collect data. As a component of the data collection stage of the information audit process, it can be used to collect both qualitative and quantitative data about what information is used for and by whom, how it is used and how it flows through the organization. It can also be used to collect attitudinal and behavioural data, such as how well an information resource or service meets a person's need and how the resource is used (Figure 3.5).

The use of a questionnaire to collect data has certain advantages over other methods of data collection. It can be used to collect data from a large number of people in a relatively short period of time and it can be used to collect data from geographically dispersed groups. Depending on how the questionnaire is designed it can offer recipients a level of anonymity to be frank and honest about their opinions relating to information services and resources and their own information use behaviour.

Instrument design – creating the questionnaire Questionnaire design begins by determining the data which are to be produced by the survey and devising a list of questions to obtain them (Jackson, 1993). It is considered to be an art rather than a science and working out how you will use the responses will help determine the mix or levels of open and closed questions. Consider the costs involved in analysing and evaluating the data as these can be significant and will affect not only the length of your questionnaire, but also the types of questions that you include.

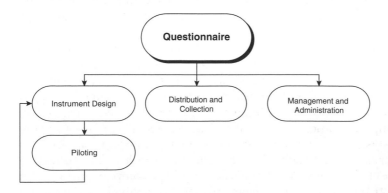

Figure 3.5 Data collection – questionnaire

An important issue to consider is whether the questionnaire recipients are to remain anonymous or whether they are to be asked to identify themselves. Remaining anonymous enables employees to 'speak their mind' if things are not as they think they should be, and facilitates frank and honest responses to open questions and rating scales. However, if the mapping of information flows is an objective of the information audit, then you need to know who is using/producing the information, its source and to whom it is being passed on. Another consideration is the identification of key information users; anonymous questionnaire responses will not reveal who are these people.

The <u>format</u> of the questionnaire is important and must:

- be simple to read and easy to follow

- be well structured with questions grouped according to their purpose

- begin with an introductory paragraph or covering letter explaining its purpose

- include details of how and when the completed questionnaire will be collected.

When designing the questionnaire you must have a clear picture of what data you need to collect and only ask those questions that will give you that data. All data collected MUST be relevant to what you want to know. Ensure that all questions are specific and unambiguous. Do not include jargon or technical words that might confuse the reader. Do not ask questions which you know will cause difficulty for the respondents.

Questions can be:

- open (cannot be answered using a yes/no response)

- closed (requiring a yes/no response, or a check box)

- multiple choice (the selection of one of a number of possible responses)

- rating scales (allowing respondents to rate a resource or service by a number on a scale).

Different categories of questions can be included, with the main types being factual, attitudinal and demographic. As the name suggests, factual questions ask for facts such as the name of resources or services used, the number of times a service is used, etc. Attitudinal questions ask how the recipient feels about a certain issue and are usually open questions or those which ask for a response using a rating scale. Demographic questions relate to the recipient's background, location and position and are included on the information audit questionnaire to enable the mapping of information flows.

Attitudinal questions can be interpreted subjectively and consequently the interpretation can differ from respondent to respondent. Respondents may also interpret the rating scale differently. If there are a large number of questions using a rating scale respondents may answer carelessly. Also bear in mind that the response to attitudinal questions can differ markedly from actual behaviour (Jackson, 1993).

The length of the questionnaire will depend on how much information you need to collect to fulfil your objectives and the resources available to code and analyse the responses. If the questionnaire is too long, there is a risk that respondents will not give adequate time and thought to each question. If the questionnaire is too short, respondents will feel that it is a waste of time. Aim for a maximum of 20 questions, and break them down into at least four sections. Try to limit your questionnaire to four pages or less if it is in printed form.

A suggested format for the questionnaire is outlined in Table 3.4. Ensure that each section is clearly identified and that its purpose is defined. A sample questionnaire is included at the end of this chapter.

Piloting the questionnaire Piloting involves the formal testing of a questionnaire with a small sample of respondents in the same way that the final survey will be conducted. Once your questionnaire is developed, have a trial run using a small representative group of respondents. This ensures that all the questions are presented in such a way as to avoid ambiguity and jargon and that the questionnaire itself is easy to follow.

Table 3.4 Suggested questionnaire format

Section	Description
Title	The title of the survey
Introduction	A paragraph outlining the purpose of the questionnaire and the timeframe for completing it
Instructions	A paragraph outlining how to complete the questionnaire and how to return it when completed. This section should include the names of people who can be contacted if assistance is required in filling out the questionnaire
Section 1 Section 2 Section 3 etc.	Give each section a heading, and include a short explanatory statement of its objectives. List the questions underneath in a logical order
Statement of thanks	Thank the respondents for their time
Instructions for returning	Restate the instructions for returning the completed questionnaire – to whom, the preferred method, and the deadline

It also enables the questions to be validated and a sample set of responses to be analysed and evaluated. The piloting process will identify any potential problems with the questionnaire itself or the chosen distribution/collection methods. If necessary the questionnaire can be modified and re-tested until respondents can complete it accurately and quickly (Jackson, 1993).

Distributing and collecting the questionnaire The distribution methods for the questionnaire will depend on the size and structure of the organization as well as the resources and the timeframe available to collect the data. Usually the questionnaire is distributed by whichever means is the most cost-effective and efficient.

Manual methods of distribution such as internal mail can be efficient or inefficient, depending on the processes used within the organization. The cost of printing the questionnaires will be expensive whether it is done in-house or externally, and the turnaround time for the responses to be received may be unacceptable.

Delivering questionnaires in person is an option for those in very small organizations, or when only targeting a small group of people. This gives the opportunity to add a personal touch as well as an opportunity to respond to initial questions relating to the purpose of the survey. If you also intend to collect the completed responses personally it becomes an opportunity visually to check the responses to make sure that they have been completed correctly.

Electronic methods of distribution such as email and corporate intranets facilitate the instantaneous mass distribution of documents such as questionnaires over geographically dispersed departments of the organization at very little cost. There are no printing costs involved and responses can be automatically downloaded into a database or saved for later analysis. The success of this method will depend on whether there is expertise available to prepare the document for electronic display, and to enable responses to be returned automatically to the auditors. It is very easy to overdo things and send out questionnaires to everyone who has an email address. Be aware of the difficulties you might face if they all complete and return them!

Response rates The response rate is the percentage of people who complete and return a questionnaire. It is a standard practice to indicate the response rate in the final report or presentation as high response rates are seen to be an indication of a quality survey. A target response rate should be at least 50 per cent, but a rate of 70 per cent or higher is considered to be excellent.

The following proactive measures can be taken to maximize the response rate.

1. Promote the survey – notify participants in advance so that they know the survey is being conducted. Tell them the objective of the survey and when they will be receiving the questionnaire. This will hold more weight if it comes from upper management or with a statement of endorsement from upper management.

2. Include a covering letter that explains the purpose of the survey, gives details of how to complete it and the date for return.

3. Communicate continually with survey recipients. Follow up everyone who has not returned a completed questionnaire. This can be done by mail, email, telephone or in person.

4. Facilitate the return by using simple instructions for returning the completed survey. Include a return envelope for mail surveys. Set up electronic forms with a SUBMIT button for Internet or intranet surveys.

5. Personalize the survey – add the company or information unit name and/or logo, and use personal names of contact persons rather than position titles.

6. Keep it short (four pages or less).

7. Minimize open questions.

8. Make the survey meaningful – higher response rates are likely if participants are aware of the potential benefits to themselves.

Management and administration

The management and administration of the survey covers the coordination aspects of the distribution and collection of questionnaires, the follow-up of non-returns and ensuring that all enquiries and concerns are dealt with efficiently and effectively. It also covers the coordination of personal and focus group interviews, the distribution of interview schedules and all clerical tasks associated with the survey.

Follow-ups A survey is more likely to achieve higher response rates if timely follow-ups are done, particularly after the initial distribution of questionnaires. This reminds people that they have received the questionnaire and reinforces the deadline by which it must be completed and returned. Follow-ups should also be sent to non-respondents within a day or so of the deadline (with an apology statement in case the completed questionnaire and the follow-up have 'crossed in the mail'). Follow-ups can be done by email, telephone, mail or in person. Take care, however, in employing 'heavy-handed' tactics to force survey questionnaire recipients to return them as this can result in 'knee-jerk' reactions leading to invalid, inaccurate or incomplete data.

<u>Coordination</u> Dates for the distribution and collection of the question-naires will have been pre-determined to fit in with the other components of the information audit project. It is important that the dates are adhered to as strictly as possible to avoid disrupting the timeframe of subsequent tasks such as analysis and evaluation.

<u>Enquiry 'hotline'</u> If respondents have questions about how to complete the questionnaire or general concerns about the interviews there must be someone available to help. The establishment of an enquiry 'hotline' ensures that questions can be answered before they become real prob-lems that might affect the success of the survey. The 'hotline' can be telephone, email or fax. Responses to questions and concerns must be fast and thorough.

Having used the questionnaire to collect quantitative data and basic qualitative data, focus group interviews and personal interviews can be used to collect further attitudinal and perceptual data. They supplement and expand on data gathered through the questionnaire and help in iden-tifying the organization's natural information gatekeepers and processors. If possible, use some of the data collected by the questionnaire to form the basis of your interview questions. Why have people responded in a certain way? Why do they not use certain services or resources and why are others vital to their work? Which sections prefer print-based resources and why? If services which they use only sometimes were discontinued, would it have a significant impact on their work? These are just a few of the questions that can be asked to build on the information collected by the questionnaire.

Interviewing in both individual (personal interviewing) and group situ-ations (focus groups) has the following advantages over other data collection methods:

- personal contact gives a personal emphasis to the data collection process

- you receive an immediate response to the questions

- they allow discussion of the meaning of the questions to eliminate ambiguity

- they allow the collection of a large volume of rich data in a relatively short period of time. (Gorman and Clayton, 1997)

Interviews also have disadvantages:

- they are costly in terms of both the time they take to conduct and the extraction and analysis of the relevant data

- sorting out the important points from a large quantity of data can be difficult

- they are too personal, which can lead to important facts being omitted. People are more likely to be open and frank in situations that afford a level of anonymity

- interviewer bias can be introduced in the way the questions are asked

- the quality of the data is reliant on the skill of the interviewer, and on the interaction between the interviewer and interviewee, particularly in unstructured interviews.

As with other methods of data collection, interviews must be planned. Decisions must be made as to who will be interviewed, what questions need to be asked and when and where the interviews should take place.

There are mixed opinions about whether personal and focus group interviews should use structured or unstructured methods of questioning, since there are advantages and disadvantages with both methods (Table 3.5). In a structured interview, the interviewer asks everyone the same questions in the same order. In an unstructured interview, also known as an in-depth interview, the interviewer formulates the questions spontaneously within a pre-determined framework.

Focus group interviews

A focus group interview is a free-flowing interview with a small group of people and is named as such because the discussions start out broadly and gradually narrow down to the focus of the research (Crawford, 1996). The group consists of an interviewer, known as a moderator, and six to eight participants. The moderator introduces the topic and encourages the group members to discuss it. Focus groups allow members to express

Table 3.5 Structured and unstructured interviews

Structured	*Unstructured*
Provides a consistent set of data that facilitates data analysis and ensures comparability	Provides a wider range of data and allows for new issues to be raised, making data analysis more difficult
Requires fewer interviewing skills	Success relies on a skilled interviewer
The interviewer has limited flexibility	The interviewer has more flexibility to explore and expand on issues raised in the responses
Each interviewee is asked the same set of questions	The interviewer may vary the interviews as he/she becomes more *au fait* with the types of responses which the questions elicit. This can make the data collected more difficult to analyse

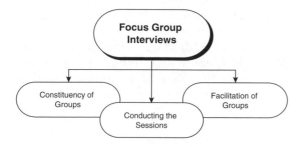

Figure 3.6 Data collection – focus group interviews

themselves in their own words as they discuss issues of common interest with the other group members under the guidance of the moderator.

Focus groups are used as a component of the information audit process after the questionnaire responses have been received to gather the more in-depth qualitative data in order to clarify and add meaning to the questionnaire responses (Figure 3.6). Focus group interviews can also be conducted during the planning stage to gather preliminary information or to assist in the design of the questionnaire. They are easy to organize and run, the data collected are quickly analysed and they are relatively cost-effective.

Constituency of groups – selecting participants The ideal size of a focus group is six to eight people. Groups that are larger tend to hinder participation by group members, individuals with divergent views are able to hide and discussions tend to be more superficial. Group members should be selected based on their common characteristics relative to the issue being discussed. Homogenous groups seem to work best as they allow discussions to develop along lines that are of interest to all group members. Groups can comprise members of a single department, or members at a particular level from a variety of departments.

Facilitation of groups – selecting a moderator The moderator is the facilitator of the group and has the important role of ensuring that the information collected is useful and meets the objectives of the meeting. An effective moderator must have the following characteristics:

- a clear understanding of the objectives of the meeting
- objectivity and honesty
- an understanding of group dynamics and group facilitation
- the ability to draw people out in a group environment
- high-level communication skills, including the ability to listen well.

Conducting a focus group session The moderator should produce a dis-cussion guide that consists of a statement which informs the group about the nature of the focus group and outlines the topics and questions that will be addressed. This should be distributed with an agenda to all par-ticipants well in advance of the meeting. There is no standard format for conducting a focus group session, but the following agenda is an example.

1. Welcome the participants and introduce everyone.

2. Review the agenda and explain the agenda items.

3. Clearly state the purpose of the meeting and are what its objectives.

4. Explain how the meeting will be conducted and the rules of discus-sion as defined by the moderator.

5. List the questions that will be asked so that group members have an opportunity to consider their responses.

6. Wrap up with a summary of the meeting – whether or not its been successful, and details of when the results will be available.

The data resulting from a focus group session can be captured in two ways – either by taking notes of responses and discussions or by tape-recording the session. If a note-taker is used, he or she should be unobtrusive and should take no part in the proceedings of the session. Similarly if a tape-recorder is used, it must be used unobtrusively, and its presence must be explained to the group participants before the meeting begins. The quality of the data that are captured by using a tape-recorder far outweighs those that are captured by a note-taker because they are a complete record of discussions and responses to questions whereas the notes are selective and may exclude important statements and concerns. The tape-recording captures not only the content of what is said, but also how it is said. Vocal expressions such as the tones of voices, stress or annoyance, anger etc. are all evident on a recording, the significance of which can be considered during the data evaluation stage. Test your recording device prior to the interviews, ensure that you have sufficient tape and make sure that the device is positioned such that the responses of all participants can be recorded clearly.

How to optimize the use of focus groups

1. Select the right moderator – choose facilitators who are not part of the organizational information unit as they are more likely to be objective.

2. Recruit the right people as participants, choosing homogeneous and stratified groups.

3. Create a non-threatening environment.

4. Record the sessions or include a co-facilitator to take notes – do not rely on memory.

5. Distribute the questions to the participants well in advance of the meeting to give them time to consider their answers.

6. Restrict the number of issues for discussion to no more than 5.

7. Word each question carefully and allow time for members to consider their responses. Facilitate discussion around the responses. After each question is answered, carefully reflect back a summary of what you heard. Get closure on questions.

8. Ensure even participation by all group members.

9. Keep the meetings informal – people talk more when they are relaxed and comfortable.

10. Keep the communication channels open after the meeting – participants may express valuable thoughts that they chose not to raise during the meeting, or that came to mind afterwards.

Advantages of focus groups As summarized by Young (1993), focus groups have the following advantages over other forms of research:

1. Participants use their own words to express their perceptions

2. The facilitator can ask questions to clarify comments

3. The entire focus group process usually takes less time than a written survey

4. Focus groups offer unexpected insights and more complete information

5. People tend to be less inhibited than in individual interviews

6. One respondent's remarks often tend to stimulate others and there is a snowball effect as respondents comment on the views of others

7. Focus group question design is flexible and can clear up confusing responses

8. Focus groups are an excellent way to collect preliminary information

9. Focus groups detect ideas that can be fed into questionnaire design.

Personal interviews

Personal interviews are one-on-one interviews which are conducted to collect rich data to supplement the data collected using the questionnaire (Figure 3.7). As a component of the information audit data collection stage

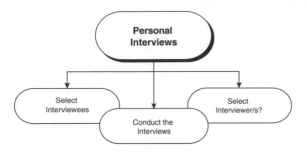

Figure 3.7 Data collection – personal interviews

they are used to collect data from key information users and potential key information users. They are time- and labour-intensive, but vital to the success of the information audit process as they provide not only rich data for analysis, but also the opportunity to meet the key players face-to-face to discuss their information needs and how their use of information contributes to organizational goals and objectives.

Who you interview and the number of personal interviews that you conduct will depend on the purpose of the audit, the size and structure of the organization and the resources that are available to you. It is important that all known key information users are interviewed. This will be at least one person from each functional division or section.

Choosing the type of interview Personal interviews can be structured, semi-structured or unstructured (Crawford, 1993). Table 3.6 lists the characteristics of the three types.

The semi-structured interview is the most appropriate interview method

Table 3.6 Types of interviews

Type of Interview	Characteristics
Structured	Formal interview process
	Structured list of questions
	No deviation from the prepared questions
	Allows interviewer to clarify the meaning of questions
	Requires minimum interviewing skills
Semi-structured	Less formal interview process
	Prepared list of issues
	Open-ended questions derived from the issues
	Allows interviewer to follow up unanticipated responses
	Requires an experienced interviewer
Unstructured	Informal interview process
	General subject is predetermined
	Requires high level of interviewing skills

to use in the information audit data collection stage. It is a less formal interview method that facilitates the development of a rapport between the interviewer and interviewee. The interviewee is likely to feel more at ease and therefore will be more likely to speak frankly and honestly. This method allows for the listing of all of the relevant issues that need to be raised without restricting their coverage to strict questions, and the list can be used for interviews across the organization without significant modification.

Selecting the interviewees All key information users should be interviewed, as should all information guardians and gatekeepers. Although the identities of these people may be unknown at the beginning of the audit, there should be strong indications of who they are once the completed questionnaires have been received. Interview as many people as time and resources allow, as the qualitative data are invaluable and add significant depth to the data collected using the questionnaire.

Selecting the interviewer The interviewer's role is complex and therefore he or she must be skilled and experienced in conducting interviews. Personal interviews require a personal sensitivity and adaptability as well as the ability to stay within the bounds of the designed structure. The interviewer must be able to think quickly when interviewees raise unanticipated objections or concerns.

Creating an interview schedule Contact the people you want to interview and arrange a date, time and venue. This can be done by Email, telephone or in person. Once the schedule of interviews has been established, send all participants a copy of the list of issues that will be covered in the interviews. This gives them the opportunity to consider their responses and to gather any additional data that they might need in order to provide comprehensive responses.

Conducting the interview The following list provides a suggested structure for the personal interviews.

1. Welcome the interviewee.
2. Explain the objectives of the information audit, why it is being conducted and what it hopes to achieve.
3. Explain the objectives of the interview.
4. Explain how the interview will be conducted.
5. Ask the questions.
6. Wrap up by providing details of what will be done with the results and when the results of the information audit will be available.

As with the focus group interviews, the data resulting from the interview can be captured in two ways, by taking notes of responses and discussions or by tape-recording the session. These should be conducted with similar levels of care.

Maximizing the use of personal interviews The following guidelines for conducting the personal interviews must be followed if you want to maximize the quality of the data collected. Some have been taken from Gall, Borg and Gall (1996).

1 Use interviewers who are skilled and experienced in the art of interviewing.

2 Explain the potential benefits of the information audit to the participants.

3 Ensure that questions are clear in their meaning, lacking technical jargon and ambiguity.

4 Ensure that each question contains only one idea.

5 Use simple probes when appropriate, for example 'Can you tell me more about that?'

6 If a participant seems reluctant to respond to a particular question, abandon it and return to it later using different phrasing.

7 Record the interviews rather than relying on memory.

Three checklists have been included at the end of this chapter to enable you to determine whether you have considered all of the issues that are relevant to the planning process.

1. Questionnaire

2. Focus group interviews

3. Personal interviews.

A sample questionnaire has also been provided as a suggested format for a questionnaire designed to be completed by SBU managers. Sample responses to these questions are used as examples in Chapter 4.

Existing data

The data collection discussed in this chapter has focused on the collection of new data and has not considered data that may have already been captured by the organization. Data that has been collected by previous audits and data that is available on information use through data monitoring systems etc. can, and should, be incorporated into the information audit process. For example, data may be available that indicates the level of use of specific resources by individuals or departments. However, be wary of the quality and the relevance of the data – if it was collected for a different purpose it may not be consistent with the data required for the audit.

The importance of the information audit as a continuum is introduced in Chapter 1 and discussed further in Chapter 8. If previous information audits have been conducted, it is important to establish methods for comparing the data to measure changes.

Stage Two: Data Collection Outputs

The outputs of Stage Two: Data Collection are:

1. Database
2. Survey responses.

Checklist 1: Questionnaire

This checklist is designed to be used when planning the survey questionnaire component of the information audit data collection stage.

Has support been gained from management? ✓

Decision to be made	Options	
To whom will the questionnaire be distributed?	The entire organization	
	Targeted sections or business units	✓
	Targeted individuals	
	Library users only	
	Library non-users only	
Who will be excluded?	Individuals	
	Business units	
	Sections	
Who will prepare the questionnaire?	In-house staff	✓
	External consultants	
	Both	
What <u>type</u> of questions will be asked?	Open	✓
	Closed (including check boxes)	
	Multiple choice	
	A mix of open, closed & choice	✓
	Rating scales (0–5)	
What questions will be asked?		
How will the questionnaire be formatted?		

How will the questionnaire be distributed and collected?	Mail (internal or external)	☐
	Email	☑
	Intranet/Internet	☐
	In person	☐

| When will the questionnaire be distributed? | Date for distribution | |

| When must the completed questionnaire be returned? | Date for return | |

How will the process be administered?

– who will be the contact person to handle queries ?

– who will manage the distribution and collection?

– how will non-receipts be followed up – before due date?

– how will non-receipts be followed up – after due date?

How will the costs be budgeted for?	From library budget	☐
	From management budget	☐
	Other	☐

How will the purpose of the questionnaire be communicated?	Personal communication	☐
	Newsletters/Flyers/Notice-boards	☐
	Email/Intranet/Internet	☐
	Presentations	☐
	Group meetings	☐

Checklist 2: Focus Group Interviews

This checklist is designed to be used when planning the focus group interview component of the information audit data collection stage.

Has support been gained from management? ☐

Decision to be made	Options	
How will participants be recruited for the focus group interviews?	Selected persons	☐
	Invited persons	☐
	Volunteers	☐
If participants are to be selected, how will they be selected?	By function	☐
	By business unit/section	☐
	Information users only	☐
How will you ensure that key information users are included?		
Who will conduct the focus group interviews (i.e. act as moderator)?	In-house staff	☐
	External consultants	☐
	Both	☐
Who will prepare the questions?	In-house staff	☐
	External consultants	☐
	Both	☐
What questions will be asked?		
Who will prepare the agenda?	In-house staff	☐
	External consultants	☐
	Both	☐

When will the focus group interviews be held?	Date/time	

Where will the focus group interviews be held?	Venue	

How will the process be administered?

– who will handle queries ?

– who will manage the venue bookings?

– who will arrange participant lists?

– who will contact participants regarding date/time/venue?

How will the costs be budgeted for?	From library budget	
	From management budget	
	Other	

How will the purpose of the focus group interviews be communicated?	Personal communication	
	Newsletters/Flyers/Notice-boards	
	Email/Intranet/Internet	
	Presentations	
	Group meetings	

Checklist 3 – Personal Interviews

This checklist is designed to be used when planning the personal interview component of the information audit data collection stage.

Has support been gained from management? ☐

Decision to be made	Options	
How many personal interviews will be conducted?		☐
How will participants be recruited for the personal interviews?	Selected persons	☐
	Volunteers	☐
If participants are to be selected, how will they be selected?	By function	☐
	By business unit/section	☐
	Information users only	☐
How will you ensure that key information users are included?		
Who will conduct the interviews?	In-house staff	☐
	External consultants	☐
	Both	☐
Who will prepare the questions?	In-house staff	☐
	External consultants	☐
	Both	☐
What questions will be asked?		

Will all interviewees be asked the same questions? ☐

Will interviewees be given the list of questions before the interview? ☐

Has an interview schedule been prepared? ☐

When will the interviews be held? Date/time ☐

Where will the interviews be held? Venue ☐

How will the personal interview
process be administered?

– who will handle queries? ☐

– who will manage the venue
bookings? ☐

– who will contact interviewees
regarding date/time/venue? ☐

How will the costs be budgeted for?	From library budget	☐
	From management budget	☐
	Other	☐
How will the purpose of the interviews be communicated?	Personal communication	☐
	Newsletters/Flyers/Notice-boards	☐
	Email/Intranet/Internet	☐
	Presentations	☐
	Group meetings	☐

Sample Questionnaire: Business Unit Managers

BUSINESS UNIT OBJECTIVES AND TASKS

Responses to this questionnaire will provide data relating to the functions and objectives of your business unit, and your role and responsibilities in fulfilling the objectives.

1.1 What is the name of your business unit?

1.2 What are its objectives and the critical success factors on which the achievement of the objectives depend?

OBJECTIVE	DESCRIPTION	CRITICAL SUCCESS FACTORS
Objective 1		
Objective 2		
Objective 3		
Objective 4		
Objective 5		
Objective 6		

1.3 What tasks are undertaken to meet the critical success factors of your business unit?

CRITICAL SUCCESS FACTOR	TASK NUMBER	TASK DESCRIPTON

Sample Memorandum from the CEO

[*COMPANY NAME*] INFORMATION AUDIT

From: [name], Chief Executive Officer

To: All Department Managers

An Information Audit is a process that enables an organization to identify those information resources that it needs to conduct its business successfully and to ensure that everyone has the right information to do their jobs. As part of our recently introduced Information Strategy Programme the [*company name*] Information Unit is conducting an Information Audit commencing on [*date*].

This Information Audit will consist of a number of data collecting activities including a questionnaire and individual and group interviews. It has been designed to include all departments, regardless of their location. The first stage of the Information Audit is the attached questionnaire which is being distributed to all Department Managers to collect data relating to how information is acquired, used and generated by your departments. Interviews will then be conducted with key information users to collect further data relating to information use.

The Information Audit Manager is [*name, position*]. An Audit Team has been assembled using Information Unit staff and selected employees from participating departments. Specialists from [*consultancy firm*] have been recruited to conduct the individual and group interviews.

I believe that the Information Audit will form the basis for the development of appropriate strategies to build the optimum information infrastructure for [*company name*] which will support our organization well into the future.
On this basis I encourage each of you to work with the Audit Team to maximize the success of the Information Audit.

[*signed*]

[*name*]
Chief Executive Officer

[*date*]

Sample Questionnaire: General Information Users

[COMPANY NAME] INFORMATION AUDIT QUESTIONNAIRE

Thank you for participating in the *[company name]* Information Audit. If you have any questions regarding the completion of this questionnaire please contact *[name, position, location]* by telephone *[extension number]* or Email *[email address]*.

Please return the completed questionnaire to *[address or location]* or return it by Email to [*Email address*] by *[date]*.

PERSONAL DETAILS
(these details are required for communication purposes only and will not be disclosed)

NAME:
POSITION:
BUSINESS UNIT:

CONTACT DETAILS
TELEPHONE:
EMAIL:

INSTRUCTIONS FOR COMPLETING THE QUESTIONNAIRE

This questionnaire is in electronic format to facilitate its distribution and collection and to enable the responses to be prepared automatically for analysis.

Question 1. Please type your response in the space provided, which will expand as you type.

Questions 1.2 to 1.4 Please type your responses in the appropriate columns of each table. Use your TAB key to create additional lines in the tables.

Questions 1.5 and 1.6 Rate each item by placing a cross in the relevant box.

CURRENT INFORMATION ACQUISITION, USE AND GENERATION

Your responses to these questions will provide data relating to the types of information that you use to perform your tasks. It will also provide data that will enable the mapping of information flows within the organization and between the organization and its external environment.

1.1 Please describe the tasks that you perform, and describe the information that you need to complete your tasks successfully.

TASK	INFORMATION REQUIRED
Task 1	
Task 2	
Task 3	
Task 4	
Task 5	
Task 6	
Task 7	
Task 8	

1.2 Where do you currently get this information? Please list all resources, whether print, electronic or personal. Please rate the importance of the resource to the task it supports on a scale from 1–5:

 1 – not presently used or no perceived benefits to the task

 2 – provides indirect or minor support to the task

 3 – contributes directly to the task but is not essential

 4 – provides significant benefits or adds value to the task

 5 – critical to the task

RESOURCE	TASK NUMBER	SOURCE	FORMAT	IMPORTANCE (1–5)

1.3 What reports or other types of information does your business unit or section make available to other sections of the organization, or to entities outside the organization?

RESOURCE	PROVIDED TO (BUSINESS UNIT/SECTION, EXTERNAL ENTITY)	FORMAT	FREQUENCY

1.4 How does the information you get compare with what you need to complete your tasks? (i.e. ideally what would you like to have that is not currently available to you?). Use the scale from 1–5 to indicate the importance of the required resource.

 1 – not task-specific but of general benefit to business unit
 2 – provides indirect support to the task
 3 – contributes directly to the task but is not essential
 4 – provides significant benefits or added value to the task
 5 – is critical to the task

TASK	REQUIRED RESOURCE	IMPORTANCE (1–5)

1.5 Please rate the importance of the following characteristics when choosing/using information resources.

	1 Unimportant	2	3 Important
Accessibility/availability/convenience	☐	☐	☐
Accuracy	☐	☐	☐
Adequacy/relevance	☐	☐	☐
Comprehensiveness	☐	☐	☐
Cost	☐	☐	☐
Currency	☐	☐	☐
Delivery method	☐	☐	☐
Technical accuracy	☐	☐	☐
Timeliness	☐	☐	☐

Other *(please specify)* .

1.6 Please rate the importance of the following resources that are made available by the Information Unit.

 1 – don't use
 2 – provides indirect or minor support to business unit tasks
 3 – contributes directly to business unit tasks but is not essential
 4 – provides significant benefits or added value to business unit tasks
 5 – critical to business unit tasks

	Don't use				Critical
	1	2	3	4	5
Electronic					
AAP	☐	☐	☐	☐	☐
ABI Inform	☐	☐	☐	☐	☐
Bloomberg	☐	☐	☐	☐	☐
Contents page service	☐	☐	☐	☐	☐
Current awareness (daily) Subject-specific	☐	☐	☐	☐	☐
Current awareness (weekly) Industry-specific	☐	☐	☐	☐	☐
Current contents	☐	☐	☐	☐	☐
Disclosure	☐	☐	☐	☐	☐
Electric Library	☐	☐	☐	☐	☐
Elsevier	☐	☐	☐	☐	☐
GeoWeb	☐	☐	☐	☐	☐
INFORMIT Databases	☐	☐	☐	☐	☐
Knight–Ridder (DIALOG) Databases	☐	☐	☐	☐	☐
MAID	☐	☐	☐	☐	☐
Medline	☐	☐	☐	☐	☐
OVID Databases	☐	☐	☐	☐	☐
Reuters Business Briefings	☐	☐	☐	☐	☐
Silverplatter	☐	☐	☐	☐	☐
UnCover	☐	☐	☐	☐	☐
Print					
Chemical Abstracts	☐	☐	☐	☐	☐
Current contents	☐	☐	☐	☐	☐
Consolidated Annual Reports	☐	☐	☐	☐	☐
Contents page service	☐	☐	☐	☐	☐
Handbooks/Directories	☐	☐	☐	☐	☐
Internal Technical Reports	☐	☐	☐	☐	☐

Journal 1	☐	☐	☐	☐	☐
Journal 2	☐	☐	☐	☐	☐
Journal 3	☐	☐	☐	☐	☐
Journal 4	☐	☐	☐	☐	☐
Journal 5	☐	☐	☐	☐	☐
Journal 6	☐	☐	☐	☐	☐
Journal 7	☐	☐	☐	☐	☐
Journal 8	☐	☐	☐	☐	☐
Journal 9	☐	☐	☐	☐	☐
Journal 10	☐	☐	☐	☐	☐
Legislation/Government Reports	☐	☐	☐	☐	☐
Technical Standards	☐	☐	☐	☐	☐

Please complete this questionnaire by *[date]* and return it to *[person, location]*. If you have any questions about how to complete it, please contact *[person]* by telephone *[phone number]* or email *[email address]*.

Thank you

[name]

[position title]

[date]

References

Buchanan, S. and Gibb, F. (1998) The information audit: an integrated strategic approach. *International Journal of Information Management*, **18**(1), 29–47

Buchanan, S.J. (1999) *The information audit: an integrated strategic approach.* Available at www.strath.ac.uk/Departments/InfoStrategy/ (Accessed 28/09/99)

Crawford, J. (1996) *Evaluation of library and information services.* Aslib Knowhow Series, ed. S.P. Webb. London: Aslib

Gall, M.D., Borg, W.R. and Gall, J.P. (1996) *Educational research: an introduction.* White Plains, NY: Longman

Gorman, G.E. and Clayton, P. (1997) *Qualitative research for the information professional.* London: Library Association

Henczel, S.M. (1998) *Evaluating the effectiveness of an information audit in a corporate environment.* Minor Thesis, Faculty of Business, RMIT University, Melbourne

Jackson, S. (1993) *An introduction to sample surveys: a user's guide.* Melbourne: Australian Bureau of Statistics

Orna, E. (1996) Information auditing. *Singapore Libraries,* **25**(2), 69–82

Shiemann, W.A. (1991) Using employee surveys to increase organizational effectiveness. In *Applying Psychology In Business,* pp. 632–639. Lexington, MA: Lexington Books

Young, V. (1993) Focus on focus groups. *College and Research Libraries News,* **54**(7), 391–394

Data analysis

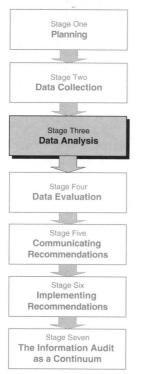

Stage One
Planning

Stage Two
Data Collection

Stage Three
Data Analysis

Stage Four
Data Evaluation

Stage Five
**Communicating
Recommendations**

Stage Six
**Implementing
Recommendations**

Stage Seven
**The Information Audit
as a Continuum**

Figure 4.1 Stage Three
– Data Analysis

Data analysis is the third stage of the seven-stage information audit process (Figure 4.1). Once the data have been collected they must be organized in such a way that allows them to be analysed, evaluated and interpreted. This chapter does not aim to be a comprehensive guide to data analysis. Rather it aims to describe, in very general terms, some simple methods that can be used to make sense of the collected data. It is aimed at the information professional who is not experienced in the art of data analysis and who is not able to outsource this component of the information audit process.

Data preparation and analysis are time consuming and require specialized skills. It is therefore one of the information audit's components that is most often contracted to experts outside the organization. If your audit is very small, and you have the resources available to prepare and analyse the survey responses, then this chapter will help you. If you are able to outsource this component, then I suggest that you find an expert who is familiar with the information industry and who is willing to accept your input into the preparation and analysis of your data. It is important that the codes that are devised during the analysis process are the most relevant for your organization, and therefore your input is critical to the success of this stage. Many information specialist consultants offer this service and will be more than willing to work closely with you to optimize the relevancy of your outcomes.

There are, however, disadvantages in outsourcing this activity if inappropriate consultants are used. One is that you rarely have any input into the methods that are used by a consultant to analyse your data. This may not matter if your audit is small and simple, but for larger and more complex audits it can be critical. Research has found that each consultant has a standard method which they use for analysing data, and they use this method regardless of the type of information audit on which they are working (Henczel, 1998). This is fine if your needs are 'standard' and it may indeed suit most situations. Most use software as part of their method and most use only one type of software. This is important as it determines the type of output that you will have for your presentation of findings to the organization. Decide whether you want textual or visual output and make sure that the consultant you recruit can provide output in this form, or that they can provide it in a form which you can manipulate in-house to produce the type of reports and presentations that you need.

Whether you analyse your collected data using automated or manual methods will depend upon the resources and time you have available. As well as manual methods of analysis, this chapter will look at the various levels of analysis tools that are available, ranging from the commonly used Excel and Access, through to specialist quantitative and qualitative analysis tools such as SPSS, ATLAS.ti and QSR NUD*IST, and business modelling tools. This chapter does not attempt an in-depth look at individual products, but rather will discuss the 'types' of programs available and how they can be used to analyse the data collected by the survey methods used in the information audit process.

The information resources database which was developed prior to collecting the data will store some of the data and will be used to identify those resources that are considered to have strategic significance.

The remainder of the collected data will be input into other analysis tools or used to map the information flows. The data used for further analysis involves editing and coding the data according to the rules established in the data preparation plan. The data can then be entered on to coding sheets or into an appropriate program for analysis. Figure 4.2 illustrates the steps from preparation to data entry and through to analysis.

The information resources database

If the survey questionnaire and interviews have been used to collect data about the information resources that support the tasks performed by the business units to achieve their objectives, then this data must be input into the information resources database (for example the responses to questions 1.1, 1.2 and 1.4 of the sample questionnaire at the end of Chapter 3).

The database already contains data that has been collected during your own initial investigations into the objectives of the business units

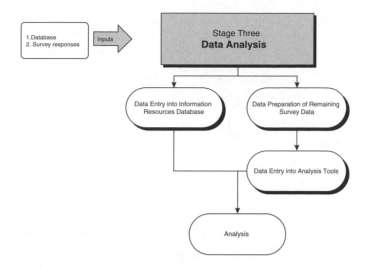

Figure 4.2 Data analysis

and the questionnaire completed by the business unit managers. Once the questionnaire responses are input, the database can be used to generate reports such as:

- tasks supported by each information resource

- information resources that support the tasks of each business unit

- importance of each information resource to the tasks they support (for example, select '5' to extract all 'critical' resources)

- information resources that support each organizational objective

- tasks for which the 'ideal' resource is not provided

- duplications of resources (to identify where rationalization may be possible, for example the networking of electronic resources used by many business units).

The reports can then be evaluated and prioritized and used to formulate recommendations in the next stage of the information audit process. The remaining data collected by the survey must be prepared and input into appropriate analysis tools.

Data preparation

Data preparation is the process of putting the collected data into a form that can be used in the analysis process regardless of how the data are

to be analysed. It consists of the development of a data preparation plan that establishes the rules for how the data are edited and coded (Figure 4.3).

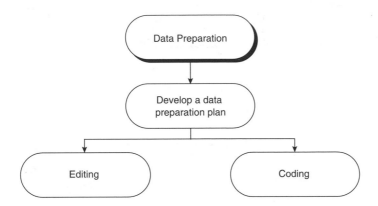

Figure 4.3 Data Analysis – data preparation

Develop a data preparation plan

A data preparation plan is a document that sets out how the data will be prepared for analysis. It states the procedures to be used for dealing with each set of data and how anomalies such as missing data, inconsistencies and contradictions are to be handled. Although unanticipated responses will always require additional thought on the part of the editor it will allow most responses to be handled consistently. The data editor is the person who edits the data prior to coding. The data preparation plan must contain instructions for editing the data, and solutions to all of the decisions that the editor is likely to face.

The most significant problems that are faced by data editors are missing data, intentional response patterns and inconsistency. The consequences of these problems and the ways in which they can be addressed are discussed below.

Missing data Missing data refer to questions that were not answered, only partially answered or answered illegibly. These problems may be caused by accidental omission, by the respondent choosing not to answer or the respondents being unable to answer particular questions. Whether they are accidental omissions or whether respondents chose not to respond to the questions, decisions must be made about how to deal with them.

A common method for dealing with missing data is to create a code that represents an unanswered question. This can then be used to illustrate which questions were unanswered and the distribution of non-

respondents. The distribution of unanswered questions and non-respondents is important as it shows which questions were unanswered and by which people (provided the questionnaire was not based on anonymous responses). It is more desirable to have scattered unanswered questions and non-respondents than large clumps of either or both. If there are clumps of questions that were not answered, then some thought must be given to eliminating those questions from the survey. If there are large groups of non-respondents then thought must be given to eliminating the groups.

Intentional response patterns A strategy must be developed for identifying and dealing with intentional response patterns that occur when using rating scales. The most common problem is when responding to a 5-point rating scale the respondent chooses all low (all 1s), medium (all 3s) or high (all 5s). It can be difficult to recognize when an intentional response pattern has been used, and when it is an actual response to the question. A decision must be made about how to handle the extreme positive or negative responses, but to minimize the chances of the middle number being chosen intentionally in all cases, use an even number of options: for example, a 4-point scale (use numbers 0 to 3) or a 6-point scale (use numbers 0 to 5).

Figure 4.4 shows an example of an intentional response pattern where the respondent chooses the same rating for all items. This may be a valid response but it also may be laziness or disinterest on the part of the respondent. The data preparation plan must indicate when responses such

1.6 Please rate the importance of the following resources that are made available by the Information Unit.

	Don't use				Critical
	1	2	3	4	5
Electronic					
AAP	☐	☐	☐	X	☐
ABI Inform	☐	☐	☐	X	☐
Bloomberg	☐	☐	☐	X	☐
Contents page service	☐	☐	☐	X	☐
Current awareness (daily) Subject-specific	☐	☐	☐	X	☐
Current awareness (weekly) Industry-specific	☐	☐	☐	X	☐
Current contents	☐	☐	☐	X	☐
Disclosure	☐	☐	☐	X	☐
				↑	

Figure 4.4 Incorrect use of rating scales (example 1)

as these are to be recorded and when they are not.

Another problem relating to the use of rating scales is incorrect use. When a respondent is given the option of rating something at a number from 1 to 5, and their response is 3.5 instead of 3 or 4. A decision must be made as to whether the lower or higher number will be used, or whether the complete response will be eliminated from the analysis.

Duplicate responses to rating scales are a further problem and occur when respondents choose more than one optional response to a question. For example they select both 2 and 4. A decision must be made as to whether either one of the options will be used, or an average of the two. Figure 4.5 shows how this would appear as a response to question 1.6 of the sample questionnaire. The data preparation plan must explain how this response is to be handled, for example whether both responses for AAP are disregarded or whether both responses for AAP are included (with a possible explanation being that one part of the AAP service is 'used occasionally' and another is 'vital'). The use of electronic questionnaires (for example, HTML forms) can resolve this problem by only allowing one box to be checked.

Decisions must be made regarding inconsistencies where the response to one question is inconsistent with those given to other related questions. For example, a respondent might indicate in question 1.6 that he/she currently gets vital information from newswire services, yet they rate the importance of the AAP and Bloomberg services in question 1.6 at 2 which is 'of relatively low importance'.

A pilot test will provide an opportunity for editors to examine the types of problems that are likely to be encountered, fix those that can be fixed

1.6 Please rate the importance of the following resources that are made available by the Information Unit.

	Don't use				Critical	
	1	2	3	4	5	
Electronic						
AAP	☐	X	☐	☐	X	←
ABI Inform	X	☐	☐	☐	☐	
Bloomberg	☐	☐	☐	☐	X	
Contents page service	☐	☐	☐	X	☐	
Current awareness (daily) Subject-specific	☐	☐	☐	X	☐	
Current awareness (weekly) Industry-specific	☐	☐	☐	X	☐	
Current contents	X	☐	☐	☐	☐	
Disclosure	☐	☐	X	☐	☐	

Figure 4.5 Incorrect use of rating scales (example 2)

and develop methods for dealing with those that cannot. These decisions will form the basis of the data preparation plan. Figure 4.6 shows a short extract from a sample data preparation plan in which the plan is divided into general and question-specific sections, making sure all options within all the questions are covered.

Once the data preparation plan has been developed, the data can be put into a form that can be readily entered on to coding sheets or into an analysis program. The way in which the data will be prepared will depend largely on how the data were collected and how they will be analysed. However, there are two standard activities in the data preparation process: editing and coding of the data (Figure 4.3).

Editing

Editing is the process of making data ready for coding. Its purpose is to ensure completeness, consistency and reliability of data (Zikmund, 1984). Editing involves detecting and correcting errors and dealing with problems in the survey responses. Editing should be carried out in accordance with the clearly defined rules established in the data preparation plan. It is important that the person(s) responsible for editing are experienced and objective. They will deal with missing data, intentional response patterns and inconsistency as determined in the data preparation plan. There will

General		
Unable to read handwritten response	Contact respondent if time and resources allow, otherwise use best interpretation	
Incomplete responses to specific questions	More than 50% complete – process responses Less than 50% complete – do not process	
Incomplete questionnaire	More than 50% complete – process responses Less than 50% complete – do not process	
Personal details incomplete	Can person be identified? Yes – process responses and add missing details No – do not process	
Contact details incomplete	Process available responses. Complete details where possible	
Question-specific		
Q2.4	Department/Section name	Standardize according to list 3
Q2.3	Details of use	Response other than 'a' – 'h' if possible, categorize as a–h. If not possible to categorize then add as 'other'

Figure 4.6 Extract from sample data preparation plan

always, however, be unanticipated issues which the editor must address.

Editing also involves checking that only relevant questions have been answered. For example, where directions were given to move to a specific question the responses have been provided to all the interim questions. The editor must remove these responses as they are not applicable.

The editor must also decide whether an incomplete questionnaire contains sufficient data to be useable. If the respondent has only answered the questions in Section 1 and not those in Section 2 a decision must be made as to whether the responses should be used at all.

Once all of these issues have been dealt with and the data have been edited, they are ready for coding.

Coding

Coding is the process of identifying and classifying each response with a numerical score or other symbol (Zikmund, 1984). It involves allocating numbers, or codes, to each possible answer to each question. It is a critical component of the data preparation process as it enables the questionnaire and interview responses to be slotted into defined groupings to allow them to be analysed.

Closed questions are the simplest to code, as the variables in the

1.5 Please rate the importance of the following characteristics when choosing/using information resources.

	1 Unimportant	2	3 Important
Accessibility/availability/convenience	☐ [271]	☐ [280]	☐ [289]
Accuracy	☐ [272]	☐ [281]	☐ [290]
Adequacy/relevance	☐ [273]	☐ [282]	☐ [291]
Comprehensiveness	☐ [274]	☐ [283]	☐ [292]
Cost	☐ [275]	☐ [284]	☐ [293]
Currency	☐ [276]	☐ [285]	☐ [294]
Delivery method	☐ [277]	☐ [286]	☐ [295]
Technical accuracy	☐ [278]	☐ [287]	☐ [296]
Timelines	☐ [279]	☐ [288]	☐ [297]
Other (please specify) [298]			

Figure 4.7 Pre-coding questionnaires

responses are known. Coding for closed questions including yes/no and multiple choice can be done during the questionnaire design stage. Numerical codes are assigned to each of the alternative responses offered in each question. For best results, maintain consistency when coding, for example always use 0 for NO and 1 for YES. Codes can be included next to the responses to closed questions on the questionnaire as in Figure 4.7 to facilitate the transfer of responses to a coding sheet or spreadsheet.

The examples in Figure 4.8 show a breakdown of the codes that would be used for responses to a question that related to the type of information resources used by employees.

Hierarchies can also be established for organizational decision-making levels (Figure 4.9). These can be used to cross-tabulate responses to analyse the data within a specific organizational group, department or section. Additional hierarchies can be created for 'Information Value' and 'Information Use'.

Codes for textual responses to the open-ended questions can be assigned according to coding frames formulated from pilot tests, or on receipt of the completed questionnaires or transcribed interviews. When developing codes, begin with broad groupings and add more specific

Level 1
001–099 Electronic Journals
100–199 Online databases
200–299 Print journals
300–399 Print books
400–499 Internet/WWW resources
500–599 Internal reports (hardcopy)
600–699 Internal reports (electronic)
700–799 Internal databases
800–899 CD ROM Products
900–999 Other

Level 2
Online databases
100–110 OVID Databases
111–120 Knight-Ridder Databases
121–130 Newswire Services
131–140 Informit Databases
141–150 Subject-specific Databases

Level 3
Newswire Services
121 Reuters
122 Bloomberg
123 AAP

Figure 4.8 Coding hierarchy-information resources

Level 1
001–099 Group 1
100–199 Group 2
200–299 Group 3
300–399 Group 4
400–499 Group 5
500–599 Group 6

Level 2
Group 2
100–110 Department 1
111–120 Department 2
121–130 Department 3
131–140 Department 4
141–150 Department 5

Level 3
Newswire Services
121 Reuters
122 Bloomberg
123 AAP

Figure 4.9 Coding hierarchy-organizational decision-making levels

codes under the headings as they become evident in the responses.

A standard list of codes can be created for each question and responses are then matched with the list and allocated the appropriate code or codes. It is important that codes are independent of one another and that there is no overlap. During analysis the number of times a particular code is assigned to a response is recorded. Whenever a response contains a new comment or thought a new code is created and added to the list. The list is therefore in development until all responses have been coded with the end result being a list of all comments and thoughts given in response to a particular question. The codes can be broken down into sub-codes if necessary. Once created, the list can be re-used in subsequent information audits.

You can begin developing your code list using the responses to questions used in the pilot study. Figure 4.10 shows the process of assigning codes to textual responses and using them to create a code list (question 1.4 of the sample questionnaire).

Data entry

How the data are entered will depend on the type of analysis tool being used and the type of data. If your collection of responses is a manageable size it is possible for the data editor to input the data as it is edited.

Task	Required Resources	Codes	Code List
Task 05	I need more efficient access to internal reports, market intelligence information and company information.	Internal reports Market intelligence Company information	Company information Customer records Desktop delivery Economic indicators
Task 09	I have all the information I need, but would like more of it delivery electronically	Desktop delivery	Internal reports Internal reports-sales Market intelligence Market research Product analysis Stock-market – real-time
Task 10	Real-time stock market information and economic analysis indicators delivered to my desktop	Stock-market – real-time Economic indicators Desktop delivery	
Task 12	Desktop access to customer records, market research, product analysis and internal sales figures	Desktop delivery Customer records Market research Product analysis Internal reports-sales	

Figure 4.10 Manual creation of a code list from survey responses

If you have a larger collection of data, or if you have decided to break down the process into separate tasks, then the data entry can be done separately. If it is done as a separate task it is usual to use a standard input form that records the edited responses. It is difficult to be specific here as each tool has different features and different requirements. However, if you are able to implement some degree of validation or 'automated checking' of the data being input it will assist in the quality control of the datasets that you have to analyse. If you are using specialist qualitative analysis tools such as QSR, NUD*IST or ATLAS.ti the person entering the data must be familiar with their requirements and understand how to add the primary documents (the responses) and create the code lists.

Manual data analysis requires the transfer of responses to standardized coding sheets. The data can then be entered into a database or spreadsheet for manipulation and storage. Alternatively the data can be transferred from the coding sheets onto a master response sheet for manual

analysis. Analysing the collected data manually will be effective only when the information audit has been conducted in a small organization, or when it has been limited to a section or department of a larger organization. Common database and spreadsheet software can be used to store and manipulate the data, but the analysis itself is done manually.

Data analysis

There are three separate tasks associated with data analysis (Figure 4.11):

1. The analysis of survey data

2. The mapping of information flows

3. The matching of information resources with organizational objectives (using the information resources database).

Analysis of survey data

There are three levels of analysis tools that can be used to analyse the survey data:

1. Common database and spreadsheets such as Excel and Access

2. Specialist analysis tools such as SPSS, QSR NUD*IST and ATLAS.ti

3. Specialist tools created by consultants and professional business analysts.

Of course, the data can also be analysed manually if the volume is manageable, but this is not recommended.

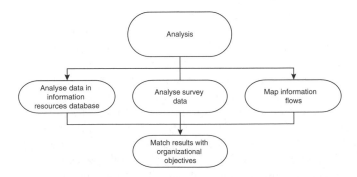

Figure 4.11 Data analysis – three types of analysis

Analysis of questionnaire data

Most organizations have database and spreadsheet programs that can be used to store and manipulate the collected data. Database products such as FoxPro or Access are suitable for small to medium volumes of data. Spreadsheet products such as Excel can be used to tabulate data. Both database and spreadsheet products allow the generation of reports.

The following examples are based on the sample questionnaire included in Chapter 3 and use common database and spreadsheet tools. The sample questionnaire is a mix of open and closed questions, and these worked examples show the different methods that can be used to analyse the survey responses.

Open questions *[Questions 1.1–1.4, and also transcribed interviews]*

Question 1.4 asks the respondent about the information needed that is not currently available. Figure 4.12 contains a sample response to this question. When all responses to this question have been coded and a code list has been created they are ready for analysis. Record the total number of times that a code is repeated in the responses.

Tabulate the repetitions against the business unit that the respondent is from. In this example an Excel spreadsheet has been used. Figure 4.13 contains the list of information resources, and the number of times each business unit responded that they needed it.

Using the features of the software, these figures can be converted to charts or graphs. Figure 4.14 shows how the results for SBU01 to SBU06 can be converted to charts to show them in a different format to facilitate the analysis process.

Category List	Number of repetitions
Company information	12
Customer records	15
Desktop delivery	33
Economic indicators	5
Internal reports	12
Internal reports-sales	6
Market intelligence	15
Market research	15
Product analysis	15
Stock-market – real-time	2

Figure 4.12 Analysing open questions #1

	SBU01	SBU02	SBU03	SBU04	SBU05	SBU06
Company information	2	2	2	2	2	2
Customer records	7	8				
Desktop delivery	8	8	4	2	4	7
Economic indicators	1		1	1	1	1
Internal reports	2	2	2	2	2	2
Internal reports-sales	1	1	1	1	1	1
Market intelligence	7	8				
Market research	7	8				
Product analysis	7	8				
Stock-market – real-time			2			

Figure 4.13 Analysing open questions #2

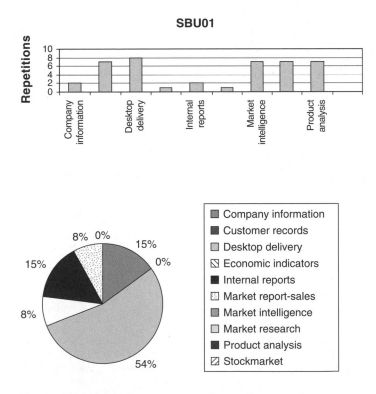

Figure 4.14 Analysing open questions #3

Rating scales *[Questions 1.5 and 1.6]*

Rating the importance of certain characteristics when choosing/using information resources	Unimportant		Important
	1	2	3
Accessibility/Availability/Convenience		10	12
Accuracy		2	20
Adequacy/Relevance	10	7	5
Comprehensiveness	5	5	12
Cost	5	5	12
Currency	6	8	8
Delivery method	12	5	5
Technical Accuracy		2	20
Timeliness		7	15
Other			

Figure 4.15 Excel spreadsheet containing responses

Question 1.5 uses a rating scale from 1 (unimportant) to 3 (important) to rate a list of characteristics when choosing or using information resources. Responses to this question were entered onto an Excel spreadsheet that contained the full list of characteristics in the first column, and the rating scale in row 1. The responses for each characteristic were entered into the appropriate rating column. Responses that were provided as 'other' are treated as open question responses.

Question 1.6 uses a rating scale from 1 (don't use) to 5 (critical to business unit tasks) to rate the importance of the resources made available by the Information Unit. It is divided into two sections: *Electronic* and *Print*.

Responses to this question were entered onto an Excel spreadsheet that contained the full list of resources in the first column, and the rating scale in row 1. The responses for each resource were entered into the appropriate rating column. Figure 4.16 is an example of the responses received for the first part of question 1.6: Electronic resources.

Using the features of Excel, the responses can then be converted to graphs or charts. In the following examples, selected resources have been grouped according to their type. This enables a comparison of the importance of like resources. Figure 4.17 illustrates how the rating of three newswire services can be contrasted visually to facilitate the interpretation of the analysis of the responses.

Interpreting and evaluating what the chart in Figure 4.17 shows is the next step and will be covered in more detail in Chapter 5. It involves making observations about what the data shows (interpretation) and

ELECTRONIC RESOURCES	Don't Use	Use occasionally	Use Often	Important	Vital
	0	1	2	3	4
AAP	4				18
ABI Inform	8	8	5	1	
Bloomberg	4	4	2		12
Contents Page Service	10	6	2		4
Current awareness – daily	4	1	2		15
Current awareness – weekly	4				18
Curent Content	15	2	5		
Disclosure				18	4
Electric Library	18	4			
Elsevier	6	6	10		
GeoWeb	3	6	9	4	
INFORMIT Databases	20		2		
Knight-Ridder (DIALOG)	2	2	3	5	10
MAID	2	2			18
Medline	12	10			
OVID databases	1	5	6	10	
Reuters	4	6	2		10
Silverplatter	14	3		5	
UnCover	5	5	5	5	2
Total	136	70	53	48	111

Figure 4.16 Excel spreadsheet for inputting responses to rating scale question

Figure 4.17 Spreadsheet data converted to chart

deciding how the observations impact on the organization and its information environment (evaluation).

Some initial observations of the chart in Figure 4.17 might be:

● an equal number of respondents do not use any of the listed resources

- a relatively high number of respondents rate all resources as vital, with AAP rated more highly than Bloomberg or Reuters

- both Bloomberg and Reuters are used occasionally by a small number of respondents.

Once you have made these observations, additional dimensions such as cost and department-specific information needs to be introduced in order to place the responses in the correct context. Some further steps in this example might be to

- allocate costs to these resources – direct costs such as subscriptions, access fees, licences etc. and indirect costs such as hardware/support and management

- link the data with other data – which departments rated them as vital?

- What else do you need to know? If Bloomberg and Reuters were cancelled would the respondents who rated them as vital use AAP instead? (Questions such as this can be asked in the personal and focus group interviews.)

The resources are listed in the sample questionnaire in alphabetical order rather than in groupings by type. This was to ensure that respondents did not consciously choose one resource over another, but rather rated them as accurately as possible according to their importance.

Figure 4.18 is another example of how the ratings of individual resources can be shown visually. In this example the ratings of the three current awareness services produced and distributed by the Information Unit are converted to a chart. The chart illustrates clearly the variation in the ratings and which resources are most important and least important to the respondents.

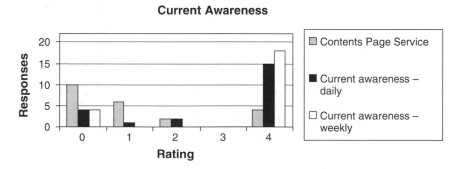

Figure 4.18 Rating Individual Resources

The responses to this question show that the weekly current awareness service is vital to a large number of participants. The contents page service is used by a smaller but still significant number of participants. These results need to be matched with department-specific data to enable them to be analysed in more detail.

For example, if we match the respondents who do not use the contents page service with their department we might discover that they all belong to the Accounting and Finance Departments. Conducting a similar cross-check on the 18 respondents who indicated that the weekly current awareness service was vital to them might show that they are all from Marketing, Advertising and Customer Service Departments. Now that we know this, we can ask further questions to find out why certain services are not used and why others are vital to specific groups within the organization. Services may not be used because they do not contain information that is relevant to specific groups, in which case their distribution could be rationalized. If they are not used because they are not provided in a useable format or in a timely manner, but they do contain information that is needed, then the service needs to be modified. What is it about the contents page service that makes it vital to the Marketing, Advertising and Customer Services Departments? Once you know this you can determine whether there is a way to deliver the same information faster or cheaper or in a way that facilitates its use. We can do basic analysis of the questionnaire results, but many of the results will lead to further questions that must be answered before we can make informed decisions about the future of specific services.

Analysis of interview data The data collected during personal and focus group interviews are dealt with in the same way as the open responses on the questionnaire. Some will be qualitative and fit into the codes already established for the closed questions on the questionnaire. Others will be qualitative and will be coded in the same way as the open responses on the questionnaire (Figure 4.19).

Using specialist analysis tools The choice of analysis tools will depend on what is available within your organization and what resources you have to purchase software and provide training for those who will be using it. Specialist data analysis tools include SPSS, ATLAS.ti and QSR NUD*IST. Be aware however, that the specialist products do not do the analysis for you, but assist by managing the data in such a way that facilitates the analysis process. The raw data can be explored in much more detail and the relationships, links, attributes, explanations, comments and issues can be identified and developed in a more effective and efficient way.

Both ATLAS.ti and QSR NUD*IST are marketed as specialist qualitative data analysis tools. They facilitate comprehensive and thorough analysis

Question	Response	
If Bloombert and Reuters were cancelled, would you use AAP instead?	Yes	Use standard code for YES
Would AAP provide you with the information to complete your task?	Yes	Use standard code for YES
How would you prefer to receive the current awareness services?	Electronically	Use established code for ELECTRONIC
What does the weekly current awareness service contain that is vital to you?	Stockmarket listings, industry contract information	Code as: 1. Stockmarket listings 2. Contracts

Figure 4.19 Sample coding of interview data

of complex data, and the generation of professional reports. They are costly to purchase and although they are user-friendly, training is required to become adept at using all of their features. If your organization uses these products it is certainly worth considering using them to analyse the information audit data.

ATLAS.ti is qualitative analysis software that can be used to analyse the responses to open survey questions on the questionnaire and also focus group and personal interview transcripts. It is specifically designed to assist in the qualitative analysis of large bodies of textual, graphical and audio data. It offers a variety of tools for accomplishing the tasks associated with a systematic approach to analysing data that cannot be analysed by formal statistical approaches in meaningful ways.

Textual responses are stored as text documents that, once assigned to a project (hermeneutic unit), become the Primary Documents on which the analysis is based. A list of codes is developed as codes are assigned to single words, phrases or any selected string of words from the responses. If an established list of codes is available for import (for example from a previous information audit) an 'auto-coding' feature can be used to code automatically the text responses. Codes can be grouped into broader categories called 'families'. This broader outlook is useful when theory-building in more general terms, as it facilitates the identification of themes, patterns and trends in the responses.

ATLAS.ti provides a variety of outputs such as written reports or HTML documents. Figure 4.20 shows how the sample responses to questionnaire question 1.6 can be coded and reported using ATLAS.ti.

QSR NUD*IST is qualitative analysis software that can be used to analyse the responses to open survey questions on the questionnaire and also focus group and personal interview transcripts. It stores survey question

Q2.6 What would you like to have that is not currently available to you?

| CODES | Responses | | | | |
	1	2	3	4	Totals
Company information	0	0	0	0	0
Customer records	0	0	0	0	0
Desktop delivery	0	1	1	1	3
Economic indicators	0	0	1	0	1
Internal reports	1	0	1	0	1
Internal reports-sales	0	0	0	1	1
Market intelligence	1	0	0	0	1
Market research	0	0	0	1	1
Product analysis	0	0	0	1	1
Stock-market – real-time	0	0	1	0	1
Totals	2	1	3	4	10

Figure 4.20 ATLAS.ti table of coded responses

responses as text files in its Document System. The documents are searchable and both predetermined and new codes can be assigned by either browsing or searching. The Index System comprises the Nodes that contain the codes and memos constructed by the user. By exploring and coding documents, you link them to categories you make in the Index System.

Data can be exported into spreadsheets or data modelling programs. A variety of reports can be generated that includes the text of documents, coding patterns and/or statistical summaries.

ATLAS.ti and QSR NUD*IST are just two examples of currently available specialist qualitative data analysis software products. Either could be used to analyse the data collected during the information audit.

Statistical packages such as SPSS can be used to analyse quantitative data efficiently and effectively. They offer storage and manipulation options and have a variety of output options. The use of one of these specialist products is vital if your information audit is large and you are collecting a large volume of quantitative data that could not be managed effectively by manual methods. Most organizations use one or more of these packages in their accounting, marketing or customer services areas. Many may have an in-house program that performs similar functions. The existence of one of these programs within the organization infers that there would also be employees around who are familiar with how to use it and could assist with the analysis of the information audit data.

Mapping information flows

The information audit survey provides the data needed to map how information flows within an organization and between an organization and its external environment. The development of information flow diagrams enables the identification of the information that is acquired and generated by the organization, who acquires or generates it, who uses it and how they use it. This enables bottlenecks and duplications to be identified, and allows analysis of the flows to optimize the use of resources. It also identifies the person or business unit that has the authoritative information on specific topics, and identifies the formal and informal communication channels existing within the organization.

Information flow diagrams can be developed using commercially available computer software, such as Micrografx Flowcharter, Microsoft Draw or other drawing and charting products, and qualitative analysis software such as ATLAS.ti and QSR NUD*IST. Useful tools for developing information flow diagrams are business modelling software tools. Products such as System Architect 2001 and ProVision Workbench–Business Pro Edition allow the incorporation of business requirements and processes, workflows, goals and objectives and delivery mechanisms.

The development of information flow diagrams at two levels enables the analysis of information flows from an organizational perspective (level one) and from the more specific business unit level (level two).

Level one information flow diagrams show the general internal and external flows for the organization. They can be based on the organizational chart and show flows in and out of the organization, as well as general flows in and out of each business unit. These diagrams show relationships between the organization and external entities, and between the business units within the organization. They also identify the internal communication channels (both formal and informal).

Level two information flow diagrams reflect the information flows in and out of each business unit. They show the detail of the inflows and outflows of each business unit which enables the identification of bottlenecks, gaps, duplications and inefficiencies. The following examples show how level two information flow diagrams can illustrate information flows using the responses to sample questionnaire responses.

Questions 1.2 and 1.3 of the sample questionnaire in Chapter 3 relate to information flows and sample responses to these questions have been used in the following tables and figures to demonstrate how they can be used to map information flows.

Figure 4.21 shows a sample response from the advertising department of a large organization. The resources they use to acquire information are listed in the first column, and where they come from in the second column. Column three lists whether the resource is used in hard copy or electronic format and columns four and five list what the resources are used for and their importance to the department.

1.2 Where do you currently get this information? Please list all sources, whether print, electronic or personal. Please rate the importance of the resource to the task it supports on a scale from 1–5.

RESOURCE	TASK	SOURCE	SOURCE	IMPORTANTCE (1–5)
Daily sales figures	01	Customer services	Electronic	5
Customer records	01	Customer services	Electronic	5
Current awareness – daily	05	Info Unit	Electronic	4
Current awareness – industry	05	Info Unit	Electronic	4
Contents page	02	Info Unit	Paper	3
MAID	05	Info Unit	Electronic	4
Reuters Business Briefings	05	Info Unit	Electronic	4
Adnews	04	Marketing	Electronic	3
Companies online	03	Marketing	Electronic	4
Telemarketing Online	03	Telemarketing Direct	Electronic	5

Figure 4.21 Mapping information flows-inflows

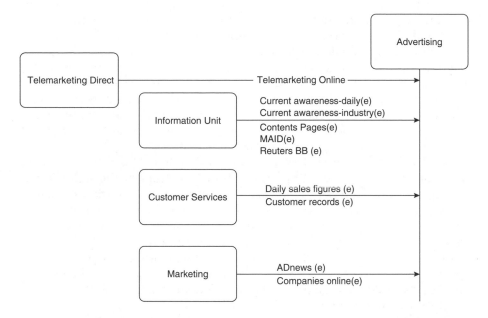

Figure 4.22 Mapping information flows-inflows #1

The visual representation of this response to sample question 1.2 in Figure 4.22 provides a 'picture' of how information is being acquired by a specific business unit.

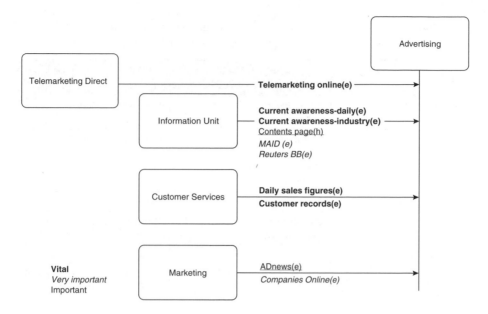

Figure 4.23 Mapping information flows-inflows #2

Once the inflows have been mapped, then the data in columns two, four and five relating to the task, format and importance can be added (see Figure 4.23) if required. Use text variations to represent the level of importance, for example bold, italics, or colours.

Question 1.3 of the sample questionnaire requests data on those resources that are produced or acquired by a business unit and passed on to other business units, departments or sections within an organization or to external bodies. It asks for the name of the resource, the units that receive it, its format and the how often it is produced. Figure 4.24 shows a sample response to question 1.3 and Figure 4.25 shows how this response would be represented visually to illustrate the flows of information.

The visual representation of the flows facilitates the identification of:

- bottlenecks and inefficiencies (lots going in but very little coming out)

- information gatekeepers (lots coming through a single internal distribution point)

- dead ends (lots going in but nothing coming out)

- over-provisions (does one business unit really need three newswire services?).

1.3 What reports or other types of information does your department make available to other sections of the organization or external bodies?

RESOURCE	PROVIDED TO (BUSINESS UNIT/SECTION)	FORMAT	FREQUENCY
Advertising report – daily	Accounting Marketing	Electronic	Daily
Advertising report – weekly	Executive Information unit Finance Marketing	Electronic	Weekly
Marketing plan	Executive	Hardcopy	Annual
Advertiser Database	Business planning Customer services Marketing Adnews Inc.	Electronic	Online
Activity report	Marketing	Hardcopy	Quarterly

Figure 4.24 Mapping information flows-outflows #1

N2 diagrams (N by N matrix) can also be used to represent the information flows at an organizational level (level one diagrams) or business unit level (level two diagrams).

In the N2 diagram in Figure 4.26 business unit tasks make up the main diagonal with the remaining squares in this N by N matrix representing information as inputs and outputs of these tasks. It provides a representation of the information flows from one task by showing the source of the information, the task that transforms the information and the information resource that is passed onto the next task. Downwards arrows, e.g. T2 to T3, represent information flows between tasks while upwards arrows, e.g. T4 to T1, represent feedback information flows.

Information flows to or from external activities can be shown outside the matrix. Figure 4.27 shows a simple example of information flows that represents the tasks, the sources of information (inputs) and the information resource that is passed on (outputs). It is evident from these representations that the information products can become sources of information (inputs), and so on. This is called organizational filtering.

The final information resources are matched against the organizational or business unit objectives. The critical success factors on which the objectives depend can be used to determine the value of the information resources in meeting those objectives.

These are very simple examples using only a small number of resources and business units. When dealing with hundreds of information resources

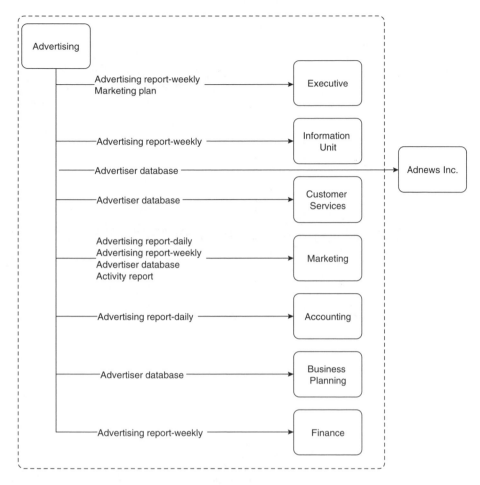

Figure 4.25 Mapping information flows-outflows #2

and a large number of business units the process becomes much more complex and requires the use of business modelling software tools to illustrate adequately the flows. If you prefer to do this analysis manually, or if you do not have access to software, break down the organizational chart into manageable 'chunks' and treat each business unit or section as a separate entity with 'inflows' and 'outflows'. It is only by looking at the flows throughout the entire organization as a whole, however, that the complete picture can be seen, and it is only by looking at the complete picture (level one information flow diagrams) that bottlenecks, duplications and inefficient flows can be identified.

Evaluating and interpreting the flows will be discussed in Chapter 5.

Figure 4.26 N2 diagram *(adapted from Figure 4.3-4. N 2 Chart Definition, INCOSE Handbook (1998), page 4.3.12)*

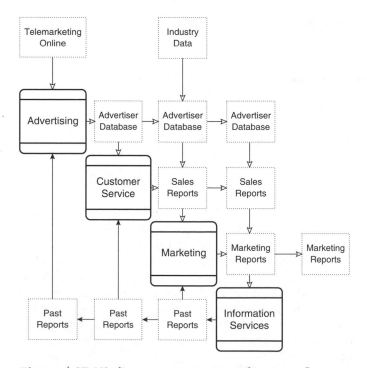

Figure 4.27 N2 diagram representing information flows

Table 4.1 Recording the strategic importance of information resources to the tasks they support

Objectives CSFs Tasks	SBU Objective CSF 1	2	Objective CSF 3	4	CSF 5	6	CSF 7	8
Information Resources								
001								
002								
003								
004								
005								

Matching information resources with organizational objectives

This process involves identifying the strategically significant resources using the information resources database. The process of matching information resources with organizational objectives is done at the business unit level. Once the business unit objectives and their critical success factors have been determined, the specific tasks undertaken by each business unit can be defined. Once the tasks have been defined, the information resources that support those tasks and contribute to their successful completion can be identified and rated. Each information resource can be associated with one or more tasks and each task can be reliant on one or many information resources.

Each information resource must be addressed in relation to the task or tasks that it supports and its strategic importance assessed using the 1 to 5 scale. The questions on the sample questionnaire that relate to this section of analysis are 1.1, 1.2 and 1.4.

Using the responses to questions 1.2 and 1.4 of the sample questionnaire the information resources can be plotted against the task they support. The responses to rating column (importance) of sample question 1.2 are used to assess the strategic importance of each resource in relation to the task or tasks that it supports. The mean value for strategic importance is derived by adding the values and dividing the total by the number of resources for each task.

The mean value for strategic importance is inserted wherever there is a relationship between the information resource and the task (Table 4.1) The completed matrix will illustrate the strategic importance of the information resources relative to the tasks undertaken in the organization.

Keep in mind that this analysis is subjective as it is based on the values assigned by survey respondents and represents the 'current' value of an information resource. Further analysis is needed to determine the future

potential value of each resource, and whether or not each resource is being used to its full potential by the business unit or organization.

Use the data contained in the information resources database to match the information resources with current information needs elsewhere in the organization and also with new information needs as they develop.

Stage Three: Data Analysis outputs

1. Information resources database
2. Analysed survey responses

 • information flow diagrams

 • analysis reports.

References

Henczel, S.M. (1998) *Evaluating the effectiveness of an information audit in a corporate environment.* Minor Thesis, Faculty of Business, RMIT University, Melbourne

Zikmund, W.G. (1997) *Business research methods*, 5th edn. Forth Worth: Harcourt Brace Jovanovich

Data evaluation

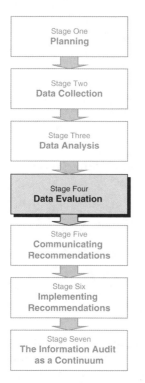

Stage One
Planning

Stage Two
Data Collection

Stage Three
Data Analysis

Stage Four
Data Evaluation

Stage Five
Communicating Recommendations

Stage Six
Implementing Recommendations

Stage Seven
The Information Audit as a Continuum

Figure 5.1 Stage Four – Data Evaluation

Data evaluation is stage four of the seven-stage information audit process. Once the survey results have been analysed, they must then be evaluated and interpreted in order to determine what they really mean in the context of the organization in which the information audit has been conducted. The processes of evaluation and interpretation are independent with each having a separate set of results. Although the results sets are separate, they complement one another and are used together to create the complete picture of the existing and the ideal information environments.

Evaluation is the process of expressing the analysed data in terms of the known or familiar and determining the 'value' of what the data shows. *Interpretation* is the process of explaining what the analysed data shows, drawing conclusions concerning the meaning and implications and determining its significance in the organizational context. This chapter covers the evaluation and interpretation of the data to enable the identification of problems within the organization that are impacting on information provision and use and opportunities for improving the information environment. It explains how to compare the existing information situation with the ideal information situation and also how to interpret the mapped information flows that were identified and illustrated in Chapter 4. It describes the methods for developing strategies and introduces the three levels of formality that exist when formulating recommendations and considering their implementation.

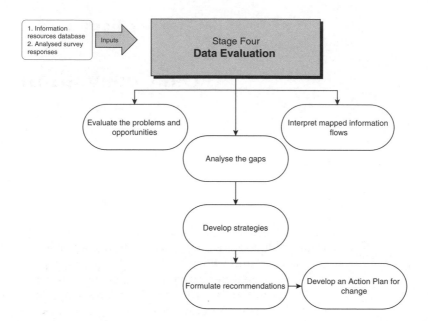

Figure 5.2 Data evaluation and the formulation of recommendations

Figure 5.2 illustrates the three steps that must be worked through before strategies can be developed:

1. Evaluate the problems and opportunities

2. Analyse the gaps

3. Interpret the mapped information flows.

Evaluate the problems and opportunities

The first step in the data evaluation process is to articulate the problems and opportunities that were identified by the analysis process and then evaluate them within the context of the organization. The analysis process may have identified problems such as:

● information hoarding – a person or department acquires a significant amount of information and does not pass the information on to others either in its original form or in the form of a filtered resource. This could be a 'people' problem rather than a 'process' problem as many people recognise the power of being the holder of 'exclusive' information. It could also be due to a level of competitiveness between

departments, each wanting to have more information than the other, or it could relate to budgetary issues where a department is paying for a resource and does not feel others should share it.

Example: A high level of competition existed between two departments of a research organization. The information audit identified that each was drawing on expensive resources to conduct its research and there was no information flow between the two departments. When the information needs of the departments were analysed during the audit process it was discovered that if one department passed on information to the other, it would result in the acquisition of fewer costly resources from external sources, potentially improve the quality of the outputs of at least one of the departments, and assist in minimizing the duplication of research activities.

- <u>biased distribution of resources</u> – once needs have been identified, it is a problem if departments with similar needs do not have access to a similar level of resources. Often it is a case where those who make the most noise win access to the most resources, while others 'make do' with fewer.

Example: The information audit process identified that two independent divisions of an organization required similar statistical data. Each division was using the data for a different purpose. One division was receiving the data directly from the source and in a useable format, whereas the other was extracting the required data from an aggregated source and converting it to a form that could be incorporated into their processes. Although the cost of the aggregated data was lower, it was resulting in a timely and costly conversion process and a higher incidence of error.

- <u>the use of sub-standard, redundant or inappropriate resources</u> (e.g. outdated, out of context, lacking authority, etc.) – departments using superseded editions of print resources, outdated statistical data, inefficient electronic resources or resources that are not the most suitable for their needs can be identified. This is particularly important where the tasks that the resources support have been identified as strategically significant.

Example: The information audit process identified that a corporate services division within an organization was using an inhouse database to support one of its tasks. The database was rated as 5 (critical to the task). The source of the database was a department that had been merged with another department in a recent restructure. The audit process identified that the task of maintaining the database was no longer a task of the newly amalgamated department and that the data was significantly out of date. The audit process was able to identify the existence of an appropriate alternative source.

- <u>gaps in the provision of resources</u> – where needs have been identified yet no resources are being provided to meet them.

 Example: The information audit process identified that a marketing department required information about the organization's competitors. There was no system in place to provide this information on a regular basis and the department was acquiring it on an ad hoc basis from a variety of external sources with varying levels of authoritativeness. The audit resulted in the establishment of a flow of authoritative competitive intelligence information to the department.

- <u>duplication of information handling</u> – where resources are entering the organization through inefficient channels or where flows from one department to another are not as direct as they could be.

 Example: Examination of the information flow diagrams identified resources that were being distributed to departments by the information unit. It was accepted that the flows would be more efficient if the resources were delivered directly to the departments as that would eliminate a step from the process and ensure that the information was received faster. This change also reduced the workload of information unit staff.

- <u>information overload issues</u> – too many resources are being provided for a specific level of need. This could be multiple resources that supply similar material, for example print and electronic versions of the same resource, or it could be just too many resources being acquired unnecessarily.

 Example: The information audit process identified a department that was acquiring and accessing a large number of resources to support their tasks. When an analysis of their needs was carried out it was agreed that they could be met with two specific resources. Access to the superfluous resources was cancelled resulting in cost savings for the organization and more efficient work practices for the department.

- <u>lack of transparency and accountability</u> in information handling which leads to the unproductive use of information resources – resources being acquired by departments independently rather than through a central unit results in duplication, higher costs, the use of inappropriate resources and costly inefficiencies in flows due to 'hidden' resources.

 Example: The information audit process identified that three very costly resources were being acquired by a planning unit to support the task of preparing a monthly industry analysis report. The matching of the information needs with resources was unable to identify the strategic significance of the report (i.e. it did not support any of the objectives of the planning unit). Further investigation (the collection of

additional data by personal interview) highlighted that the report was critical to the planning unit in previous years when the privatization of the organization was being considered. Since privatization, the report had continued to be produced and was filed in the corporate information unit. Information unit records indicated that the report had not been referred to in over three years. The cancellation of the resources used to produce the report resulted in significant cost savings for the organization.

- lack of information traceability – when information is transformed/ filtered and provided to the next level of the organization, how confident can the next user be in the validity/relevance/authority of the source information?

 Example: The information audit process identified that an organization required each of its decentralised units to provide statistical data for the production of annual reports. When examining the source data, inconsistencies were discovered in the way the data was collected and the way it was recorded. For example, some units were collecting statistics based on a January to December calendar year, while others were collecting statistics based on a July to June fiscal year. Regardless of how the statistics were collected, they were aggregated at the next level to produce reports that were used to support the production of a high level document that was used to support strategic planning decisions.

- lack of understanding of user information needs – incorrect resources being supplied or an inappropriate level of resources being supplied.

 Example: The information audit process identified the needs of a research group which was using a variety of resources to obtain the information they needed to perform their work. Once their needs were understood it was found that there were more appropriate resources available and that their needs could be met with two primary resources. This resulted in significant time and cost savings for the unit.

These are a few examples and there are many more problem situations that an information audit can identify.

Once identified, the problems must be looked at from a holistic perspective to determine whether or not they need to be addressed. Consider the following questions for each problem:

1. Does the problem have strategic significance? The level of strategic significance is the degree to which this problem impacts on the achievement of organizational goals. Problem situations that have a high level of strategic significance must be addressed immediately. Those with a low level of strategic significance must also be addressed at some point as they impact on resources and information provision

efficiencies, but moves to address them are not as critical. For example, the identification of a problem such as inappropriate data being used to produce a monthly report for a strategically significant task, needs addressing before a problem such as a duplication of resources, even though the duplication may be costly.

2. <u>Are financial and other resources being used inefficiently or ineffectively?</u> Problem situations that identify the inefficient or ineffective use of money, people and equipment (including computers) must be addressed, provided that the benefits of the solutions outweigh the costs. If the cost of the solution is similar to the cost of the inefficiency, then other criteria must be used to determine whether or not an attempt should be made to address the problem.

3. <u>Will the organization as a whole benefit from this problem being addressed?</u> As each part of an organization relates to another part, it is important to understand the interrelationships and to recognize whether or not the solutions to this problem will have a negative impact elsewhere in the organization. If reducing the level of resource duplication in one section results in additional expenditure in another to counteract the changes, then the solution for the organization as a whole may be more costly than the initial problem.

4. <u>Is it possible to solve the problem within the constraints of the organization?</u> The constraints that an organization imposes are limited not only to the resources that are available, but also the cultural and political situation within an organization. Human and financial limitations are the most common resource-related constraints faced by people wanting to solve problems within an organization. Firstly, money and people are not always available to implement a change and to maintain a new process, especially if significant training or re-education is involved. Secondly, it is important to recognize whether the cultural and political situation within an organization is conducive to addressing the problem situation. Although the situation has been identified as a problem, if there are cultural or political reasons why a change will not be supported (or if it will be actively resisted), the positives and negatives must be weighed up before suggesting changes. Keep in mind that the mere suggestion of a change can get people offside, even if the change never happens.

In many cases the problems that have been identified are opportunities to improve the provision, access, filtering and coordination of information resources and services. These opportunities must be considered in terms of the overall role of the information unit and the resources that are available. Some may be able to be addressed in the short-term, while others will become part of longer-term plans.

By considering these issues, you will be able to ensure that the changes that you do recommend are ones that have a high degree of success and that benefit the organization as a whole.

Analyse the gaps

The second step is to compare the 'existing information situation' with the 'ideal information situation'. Orna (1999) refers to this as the 'what is' versus the 'what should be' scenario. The survey responses, together with the information resources database, have provided you with the data to represent the existing information situation. Use the information resources database to compare what is currently being provided with what is needed. The comparison will identify any gaps, duplications and over-provisions.

Question 1.4 of the sample questionnaire asks information users what they need for their job that is not available to them. The responses to this question will supplement that data established in the planning phase by providing it from the perspective of the information user. Responses to a question such as this will vary enormously as some respondents will name specific products while others will describe a 'type' of information, for example 'real-time stock market data' or 'company financial data'. Anything mentioned here is a 'gap' in information provision and must be considered in the comparison.

Once the comparison has been made, each situation must be evaluated to determine its significance within the organizational context. Of the four points above, we have already determined that the problem has strategic significance when it impacts on the successful achievement of organizational objectives. Consider the issues raised in points 2 to 4 to determine whether it is possible to solve the problem and whether or not strategies should be developed and changes recommended.

The results of the comparison will also show where information provision is matching information needs – it is important not to disregard this aspect of the comparison, and to include this information in the findings of the information audit.

Interpret the mapped information flows

The third step is the evaluation of information flows. In Chapter 4 it was explained how the analysis of the information flows results in the identification of inefficiencies such as bottlenecks, gaps and duplications. As with the analysis, the interpretation of information flows is best done using a visual representation of the inputs and outputs of each business unit (level two information flow diagrams). Examine the inflows and

outflows of each business unit, then put the results together to form the bigger picture.

The information flows can then be used to identify efficient flows. Keep in mind that the strategies enabling some flows to work well could possibly be used elsewhere where inefficiencies have been identified.

As well as efficiencies and inefficiencies, the flow diagrams can also be used to identify the 'information gatekeepers' within the organization. These are the people or departments that bring information into the organization or who are responsible for disseminating information throughout the organization. The information unit is a significant 'information gatekeeper', but there will always be others. Look for links between departments and external organizations and departments that disseminate large quantities of information to both internal and external users.

Duplications and over-provisions

Figure 5.3 shows (in a very simplified example) how the visual representation of information flows can readily identify duplications. This example shows a marketing department that is receiving AAP, BRS and MAID services from external sources. These are services that are also supplied to the organization by the information unit. This situation is very common, especially in organizations where departments have been encouraged to operate independently or competitively and where there has been minimal coordination of their activities on an organization-wide scale. It could also be a result of the information unit not engaging in the right sort of marketing and communication of the services that they provide throughout the organization. Duplications such as this can cost an organization thousands, and sometimes hundreds of thousands of dollars per year and often go unnoticed.

A similar example is where one business unit is using an information resource that is different from the resource that is provided by the information unit or used by any other business unit. This raises a whole range of issues that affect the transition or filtering of information. It results in the mismatching of information and inconsistencies that lead to poor quality decision making and ultimately affects the performance of the business. The transparency of information flows enables everyone to see the source of the information on which their decision-making is based.

Gaps

The information flow diagrams can also help you to identify gaps in information provision. That is, areas where information is needed but not supplied. To do this you must 'overlay' the data that tells you what information each business unit needs to know to fulfil its role (using the data established during the planning stage and the supplementary data collected from responses to question 1.1 of the sample questionnaire) and

Figure 5.3 Interpreting information flow – duplications

what information a business unit currently receives (question 1.2 of the sample questionnaire).

Once the analysis process has identified, the duplications and over-provisions and the gaps, their significance must be evaluated by answering questions such as:

- is this problem affecting the achievement of organizational objectives?

- is there a reason why this product or service has been duplicated? Does it matter? What are the cost implications? Is the duplication improving information access?

- what alternatives are possible?

- what are the implications of suggesting a change to this situation? Who will be affected? What other services will be affected? What barriers are likely to be faced?

Following are some of the decisions that must be made and issues that must be considered during the process of formulating the recommendations (some are taken from Curzon (1989))-

1. Is the change necessary? Does the identified problem need to be solved and will the proposed change solve it? Not all problems identified by the information audit need to be addressed as some may solve themselves in time and others may be resolved as a consequence of different changes. If a duplication of resources is identified, but the duplication is not costing the organisation additional money, then it seems unnecessary to spend time on changing it. However, if the duplication is causing inefficiencies in information flows, which are having consequences elsewhere in the organization, or is contributing to inconsistencies in the use of resources, then it should be addressed.

2. Why is the change necessary? What exactly will it improve? What will happen if the change is not recommended? Have a clear understanding of the consequences of not implementing the recommended change. For example, the use of inconsistent data for reports on which high-level decisions are being made has consequences for the organization's success and credibility.

3. What may impact on the success of the change? Does it conflict with other existing or recent changes? Is it in line with developments and trends both within the organization and in the external environment, for example technological developments or budgetary changes? Is the change likely to cause resistance or insecurity amongst employees? If so, how can these be minimized or overcome? For example, a change from print-based to electronic resources may require an extension or upgrade of the computer systems that deliver the information. This may conflict with existing plans for technological development, or may not fit within current budgetary limitations. A change such as this may also involve major changes to work processes and procedures and therefore steps must be taken to minimize resistance and generate support for the change.

4. What is the nature of the change? What exactly does the change involve? What will be done, and what will the results be? Does it complement the goals of the organization? Will the benefits outweigh the costs? Are there risks involved? For example, a move to negotiate a site license for an electronic product rather than maintaining a multitude of single licenses or purchasing, managing and storing the print version of the product, will be more cost effective as the financial outlay is less and more employees will be able to access the resource. This will complement the goals of an organization that aims to become

technologically efficient and which wants to be seen as a user of the latest technology. Both tangible and intangible costs and benefits must be considered. How the organization is viewed externally by its customers and competitors and internally by its employees can be boosted by such a change. There will be costs in terms of the changes to processes and procedures. There will be benefits in terms of costs, access and efficiency.

5. <u>Who will experience the impact of the change</u>? Whose workflows and processes will be affected by the change? Will the impacts be minor or major, positive or negative? How will they be addressed? Understand that every part of the organization is related to another and that to change one part impacts on another – ensure that all inter-relationships are understood. Have parameters for the change been set? If not, a roll-on effect may occur with subsequent changes being incorporated.

6. <u>Are the resources available to support the change</u>? Changes cost time and money – understand how much the change will cost in terms of human and financial resources.

7. <u>Is the change for the overall benefit of the organization</u>? Have personal goals influenced the decision to recommend the change?

It is only by answering questions such as these that you can decide whether strategies should be developed to address the problem that has been identified. Not all problems that the information audit identifies will result in action being taken to address them. Some will be deemed insignificant and will be ignored. Some will be regarded as significant, but will not be addressed because the actions necessary to address them will have far-reaching and unmanageable impacts elsewhere in the organization. It is important to consider not only the changes themselves, but the impacts of the changes throughout the organization.

Many potential changes will require comprehensive cost-benefit or cost-effectiveness analyses to be carried out before a decision can be made whether or not to rectify them. The costs involved in implementing the changes may be significant and if they require training and re-education as well as changes to workflows, they may not result in cost savings in the short term. If there is no evidence of potential long-term cost savings either, there must be evidence of a potential improvement in efficiency or effectiveness to justify the changes.

It is important not to introduce change for change's sake. All recommendations will impact somewhere in the organization and may affect workflows, processes and budgets. These impacts must be understood and acknowledged, and never underestimated.

Develop strategies

Once you have established which problems are significant and are able to be addressed within the constraints of the organization and its environments, you can develop strategies for solving them. The strategies may involve discontinuing or modifying existing services or developing new services to meet the newly identified needs. They may involve the purchase or creation of new information products, or changes to the way information is delivered to the users.

The development of strategies involves having a clear vision of what the solution will bring, and articulating the steps needed to get there.

1. Detail the problem, list what needs to be addressed and the departments and individuals affected

2. Determine alternative ways of addressing the problem

3. Match the alternative solutions against the predetermined selection criteria

4. Allocate costings to each alternative solution

5. Determine goals that are quantifiable, or at least able to be evaluated and measured.

For each problem there will be more than one solution. The alternative solutions must be considered in relation to the resources required to implement and manage the change as well as the organization and its people. It will be easier to justify the most appropriate solution if formal procedures have been followed in making the decision, for example:

1. List all alternative solutions – they must be comparable in completeness, that is, one can be substituted directly for the other, and they must all meet the minimum specifications for the solution.

2. List the selection criteria – the set of factors that are the key characteristics of the solution (cost, risk, performance, etc.). Use quantifiable selection criteria where possible and ensure that all performance criteria are independent of each other. The following example (Table 5.1) lists the selection criteria for an electronic reference product.

3. For each selection criterion, produce a metric showing how well the various solutions satisfy that criterion. Use a scale from 1 to 10 with 1 signifying total dissatisfaction and 10 signifying ideal. The subjective component of this task is how the scores are allocated.

4. Weighting values assigned to each of the selection criteria, reflecting their relative importance in the selection process. Use a scale from 1 to 10 with 1 signifying negligible importance and 10 signifying the

Table 5.1 Selection criteria

Cost	Price (initial, and ongoing)
Source	Authority of producer, country of origin
Quality of information/ comprehensiveness	Coverage, audience level, comprehensiveness
Ability to network	Maximum number of simultaneous users
Reliability of product	System downtime, faults
Maintainability of product	Ease of maintenance
Ease of use	Efficient searching capability
Format	CD-ROM, disk, online, print
Pricing structure	Subscription-based or transaction-based
Licensing	Site, organization, single or multi-user
Currency of information	Update schedule
Availability	Time zone, downtime etc.
Sustainability	Will changing technology influence it?
Scalability	Can the product be expanded or scaled up/down?

most critical criteria for selection. It is important that all who are interested in the decision reach consensus on the weighting values before the alternative solutions have been scored to ensure objectivity.

Table 5.2 is an example of how weighted values can be used to select an appropriate solution from a shortlist of alternative solutions. The solution chosen is the one that scores the highest weighted value.

Table 5.2 Measure of suitability of alternative solutions

Alternative Solutions *Weighting Values*	*Cost/Pricing Structure*	*Quality*	*Reliability*	*Useability*	*Format*	*Availability*	*Currency*	*Compatibility*	*Authoritativeness*	*Licensing*	*Measure of Suitability (Maximum: 770)*
	5	10	10	6	9	5	10	5	10	7	
Solution 1	8	8	9	6	9	7	8	8	8	6	604
Solution 2	7	5	7	9	8	9	5	9	7	9	554
Solution 3	5	9	9	9	10	5	9	7	8	5	614

Using this process, an objective measure of the suitability of each alternative as a solution to the problem is determined. If this process is performed correctly then the alternative with the best overall score is the best solution.

It is important to document the decision process, especially where the choice of a particular solution may be controversial or lack general support. The preparation of a written report that contains the following information will support all decisions that you make:

- a summary description of each alternative solution

- a summary of the evaluation factors used

- a graphical display of the overall scores

- a summary of the evaluation factors used and an explanation of how and why the weighted values were selected

- a summary description of how and why the specific scores were assigned to each alternative for each criteria

- a graphical display of the weighted scores for each criterion for each alternative (INCOSE, 1998).

It will become apparent that the nature of the problems and the possible solutions require different levels of formality. That is, you may find that immediate action needs to be taken as it is quite apparent what the solution is and as such does not require formal approvals. You may still want to document this so that the benefits of the information audit process can be fully understood.

It is suggested that you adopt three levels of formality in terms of the data evaluation and strategy formulation process. The level of formality is dependent on the implications of the recommendations at each of the following levels:

1. Organizational Level – when recommendations need to be formally documented, and reviewed by all stakeholders, impacting at a organizational level requiring agreement between various departmental managers, or where this cannot be obtained by the executive officer/board.

2. Departmental Level – when recommendations are recorded in the information unit's management system, and are reviewed by stakeholders affected, impacting at a departmental level, requiring agreement between the departmental manager/s and the information unit.

3. <u>Local Level</u> – when recommendations can be implemented by the information unit without approval at a departmental or organization level.

One chooses the level of data evaluation and strategy formulation depending on the consequences to the organization, the complexity of the issue, and on the resources available.

Formulate recommendations

Once the alternative strategies have been scored and the process has been documented to support the decisions made, recommendations can be formulated based on the strategies that scored the highest against the selection criteria.

In formulating the recommendations, apply costings, processes and goals to the selected strategies.

Costings

Costings must include implementation, maintenance (ongoing) and replacement costs. Implementation costs include:

- the initial purchase of the product (including hardware and software)
- the cost of any training and re-education that is necessary during or after implementation
- man-hours needed to change from one system to another.

Maintenance costs include:

- ongoing charges such as subscription or access costs, hardware and software upgrades.

Replacement costs include:

- consideration of how long the product will last and the cost of replacing it.

Processes

Processes must be developed to incorporate the recommended changes into existing workflows. These must be described in sufficient detail to enable employees to understand exactly how their workflows and practices will be affected.

Goals

Each recommended change must have quantifiable goals to enable the change to be evaluated and measured. The goals also indicate to employees and management what the potential results of the change are expected to be.

Develop an 'Action Plan' for change

The Action Plan is the plan that has been developed from the findings of the information audit to address the problems and inefficiencies identified. It will become part of the written report or oral presentations used to present the audit findings and recommendations to management and other stakeholders. Each recommendation must be detailed individually, but overlaps and links with other recommendations, as well as impacts on other aspects of the organization's operations must be identified.
 For each recommendation;

1. Identify the problem to be overcome – Describe the problem and articulate the consequences of not addressing the problem.

2. Identify the solution – Describe how the problems or inefficiencies will be addressed (details of the recommendation) and what the results will be (in terms of specific and measurable goals).

3. Detail – Provide details of exactly what the recommendation involves. List what the changes will be and what their impacts will be on individuals and departments.

4. Implementation – Describe the recommendation in terms of who will do what, how and what the results will be.

5. Cost – Provide details of how much the change will cost to implement and maintain. Consider monetary cost as well as the cost of human, technical and physical resources.

6. Timescale – Detail the schedule for implementation and evaluation.

An *Action Plan Checklist* is included at the end of this chapter to ensure that all of the above issues have been considered. A checklist for the formulation of recommendations process is also included.

Stage Four – Data Evaluation outputs

1. List of recommendations
2. Action Plan.

Formulation of Recommendations Checklist

Evaluating the change itself

Is the change necessary?

Does it conflict with other changes that are currently being implemented, or that have recently been implemented?

Does it conflict with other changes that are being considered for future implementation?

Does this change fit with plans for future developments within the organization?

Does this change fit with the trends that are evident in the organization's external environment?

What is the nature of the change? What needs to be done, and how?

What are the costs and benefits associated with this change?

What are the risks associated with this change?

Who will be affected by the change?

Evaluating the change in relation to the organization

Are the consequences of the change understood, including how it will affect other parts of the organization and what subsequent changes will be necessary (both short and long-term) as a consequence?

Does the change support the goals of the organization?

Will this change be compatible with how the organization works?

Are sufficient resources available to implement this change?

Has the decision to recommend this change been made for the good of the organization? (rather than for personal benefit)

The Action Plan Checklist

The development of an Action Plan of this nature will become the basis for your written report or oral presentation. Each recommendation must be considered individually, but the overall consequences and impacts of the 'set' of recommendations must also be considered and articulated in the Action Plan.

Identify the problems to be overcome	– details of identified problems – consequences of not addressing the problems
Suggested solution	– how problems or inefficiencies will be reduced – specific and measurable goals
Detail	– details of what the change involves
Implementation	– what will be done, by whom and how
Money matters	– how much it will cost to implement and maintain
Timescale	– schedule for implementation and evaluation

References

Curzon, S.C. (1989) *Managing change: a how-to-do-it manual for planning, implementing, and evaluating change in libraries.* How-to-do-it manuals for libraries: number 2, ed. B. Katz. New York: Neal-Schuman

International Council of Systems Engineering (INCOSE) (1998) *The INCOSE handbook: a 'how to' guide for all engineers.* Release 1.0. Seattle, WA: INCOSE

Orna, E. (1999) *Practical information policies.* 2nd ed. Aldershot: Gower

Communicating the recommendations

Figure 6.1 Stage Five
– Communicating
Recommendations

Communicating the findings and recommendations is stage five of the seven-stage information audit process (Figure 6.1).

> 'The value of any audit depends on how effectively the results of the audit are communicated. High quality audit results support change and achieve results, while poorly written ones can detract from the most professional audit work.'
>
> *(Didis, 1997)*

Although the above quote is referring to audits in the accounting sense, it applies equally to information audits. The level of the success of an information audit can depend not only on the quality of the recommendations, but also on how those recommendations are communicated to the information stakeholders. The method that you use to communicate the information audit recommendations must be carefully considered and must suit the culture and political situation of the organization.

Since many of the recommendations will represent an element of change to the resources and services available in the organization they may affect the daily work processes of some, if not many, employees. It is critical that the changes are communicated in a positive way, and in a way that guarantees management support for their implementation. Also, if you have established and maintained successful communication channels throughout the audit process, the employees will recognize the validity of the process which has been worked through to reach the final recommendations.

There are many ways in which you can communicate the information audit results and recommendations. The most common method is a written report, with the second most common being an oral presentation (or a series of presentations depending on the size and structure of the organization). Other methods include seminars and workshops, newsletters and bulletins, either in hardcopy or posted on corporate intranets and web sites.

Many of the suggestions made in this chapter were taken from the article by Stephen Didis, the former audit director of the Boeing Company. Although his article focuses on internal auditing in a financial sense, the points that he raises can be equally applied to the information audit.

Figure 6.2 illustrates the various methods which you can choose to communicate the findings and recommendations resulting from your information audit. Any one can be used, or more than one if you choose different methods for different groups within the organization.

The written report

It is important that you prepare a written report, even if it is not the main method you choose for presenting the results. The written report is the official findings of the information audit and includes details of the objectives, scope, findings and recommendations. It must cite your original business case and detail how well the information audit project matched the initial objectives stated in the business case. If your budget allows, it is worth considering outsourcing this task as professional writers with desktop-publishing skills can produce an impressive report based on your

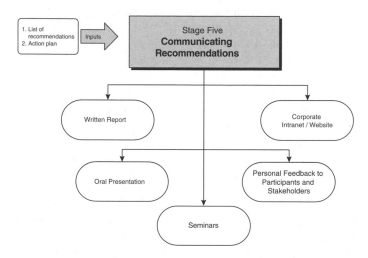

Figure 6.2 Communicating recommendations

data that usually surpasses anything that can be produced in-house. A professionally produced report highlights the professionalism of the auditors and consequently adds weight to the recommendations.

Two important considerations are the structure and content of the report and the style in which the report is written.

Structure and content

The structure of the report must be logical with each section of the report clearly identified. Use hierarchical heading formats and numbering systems to assist the reader. Table 6.1 outlines a suggested structure for a comprehensive information audit report.

It is not necessary to include details of the methodology used to conduct the audit as this is irrelevant to the report readers. However, the auditors should retain documentation containing the details of data collection methods and the problems encountered during the various stages as this can be used to refine the procedures for future information audits, as well as provide an accountability mechanism.

A decision must be made as to whether the main results section of the report is structured to match the sequence of events, or whether the items are listed in order of their importance. Bear in mind that the matter of importance can be very subjective and the readers of the report may not agree with the order of your listing.

Many of the problems listed in the report will be those that were identified by survey participants during the data collection stage. When describing these problems in the report make it clear that survey participants identified them. This gives the participants a degree of ownership of the problems and increases the level of support from them when implementing the recommendations formulated to solve the problems.

All of the problems identified during the audit process should be matched with proposed solutions in the report. Survey participants will have suggested solutions to many of these problems and you must ensure that they receive the appropriate acknowledgment in the report.

Writing style

To be effective, written reports must be:

- well written in a language that its readers can understand – clarity and precision are important. Avoid jargon, technical terms and words with vague meaning. There are many texts available that describe how to prepare quality reports and suggest guidelines for structure, content and style

- positive and focused on the benefits of the project – the focus of the written report is not merely to describe the existing situation, but to provide solutions to the problems that have been identified. Keep in

Table 6.1 Written report structure

Section	Description
Introductory Pages	
Title page	The title of the report, the name of the person or group for whom the report was prepared, the name of the person or group that prepared the report and the date of the report
Table of contents	A list of sections and sub-sections contained in the report
An executive summary	A summary of the main points of the report – why the audit was conducted, the audit scope and purpose and the importance of the issues covered
Body of the report	
Introduction	Background information about the audit – why it was necessary and what were the objectives
Who conducted the audit	Who the audit was conducted by and their skills and experience
Why it was done	The reason why the information audit was conducted and the importance of the issues covered
What it hoped to achieve	The objectives
Who it was done for	The identified stakeholders
Scope	A definition of the scope of the audit and details of any exclusions and the reasons for their exclusion
Findings	The results of the audit – detail any significant negative or positive conditions that were uncovered during the audit
Recommendations	Final recommendations based on the findings and how they improve the existing situation
Preliminary implementation programme	A suggested programme for the implementation of recommendations
Ongoing evaluation	Plans for continued improvement
Appendices	
Data collection forms	Questionnaire, interview sheets etc.
Other support material	Letters of authorization

mind that a positive report can still be threatening to employees if it recommends changes with which they do not agree or do not fully understand. If they perceive the report in a negative way their reaction to it will be defensive and they will be less likely to support fully the recommendations.

The oral presentation

'Presenting the audit findings and recommendations for action on them is a critical point in the process because it determines whether the audit will be acted on, or added to the tally of dead and unceremoniously buried initiatives.'

(Orna, 1999)

An oral presentation is a verbal summary of the major findings, conclusions and recommendations of the information audit. The audit findings and recommendations should be presented in a face-to-face situation to all of the key stakeholders – upper management, identified information users and all survey participants – to allow them the opportunity to ask questions and discuss the issues raised during the presentation.

Preparation is the key to a successful oral presentation, and Orna suggests a 'dress rehearsal' before a Steering Committee or sponsor. This 'will pick up things that are likely to be misunderstood, to give rise to questions or to hostile responses or to be seen as threats to power structures – and to suggest alternative approaches, different ways of putting the same point, how to deal with opposition, and what arguments to address to potential allies and to likely opponents. It is particularly important to discuss possible structural changes implicit in the findings and recommendations and their political implications, and to develop strategies for presenting them' (Orna, 1999).

An oral presentation should contain much less detail than the written report and must focus on the needs and concerns of the stakeholders rather than the technical details of the information audit process. The advantage of an oral presentation lies in the fact that it allows discussion and interaction between key players and groups of information users. Opportunities should be provided for discussion of the audit findings, the formulation of recommendations and suggested procedures for implementation to 'enable people who have contributed information to the audit to consider what use has been made of it, to see how their input matches other contributions, correct inaccurate representations, discuss the conclusions drawn and recommendations made, and propose alternative or additional courses of action' (Orna, 1999).

Table 6.2 lists the components that should be included in a presentation and the order in which they should be presented.

The inclusion of pictures and diagrams in a presentation can place emphasis on important points and clarify the meaning of complicated issues. Graphics such as tables, charts and graphs can be used to provide a visual representation of survey results, or the comparison of the existing information situation and the potential information situation. All visual representations must be explained by the presenter and must be tightly coordinated with what is said to result in a seamless presentation.

Table 6.2 Presentation outline

Introduction	Introduce yourself and your role in the information audit process
Objectives of the audit	Outline the objectives of the information audit – why it was conducted – what it hoped to achieve
How things are	Explain the audit findings Describe problems identified by the audit – bottlenecks, gaps, duplications, areas of over-provision Explain the implications of these problems for the organization Describe situations that are operating well
How things should be	Describe the ideal information situation for the organization
Bridging the gap – what needs to be done	Describe the changes that need to take place for the organization to maximize its use of information
How they can be done	Explain how the recommended changes can be implemented

The following guidelines will make your oral presentation more effective:

● maintain a conversational tone, rather than lecturing or reading from prepared notes

● thorough preparation will result in a smoother and more confident presentation

● focus the presentation on the major issues of concern to each audience

● use visual aids to clarify or emphasize points, but take the time to explain them in the context what is being said

● refer those who want more detail about the information audit to the written report or to members of the audit team.

Support and commitment is further enhanced by the attendance of the information audit sponsor and members of senior management (if possible the CEO). This makes their support visible to the employees and other stakeholders which has the roll-on effect of increasing overall support and commitment. Arrange for the sponsor or CEO to introduce the session at the beginning and review it at the end. This ensures that their support for the information audit findings and recommendations is visible to everyone.

The Seminar

A seminar is a presentation to a small group which provides opportunities for questions and discussion of the issues raised. Seminars are useful for communicating findings and recommendations in a group situation without the formality of an oral presentation.

Mixed groups of managers and lower-level employees are preferable as they allow each group to listen to the concerns of the other as issues are raised and discussed. This facilitates the implementation process by ensuring that the suggestions made by managers are incorporated into the plans, and that employees understand the reasons for the recommended changes from both their own perspective and that of the managers. It also improves the level of cooperation between the managers, employees and audit team by providing them with common objectives. The involvement of as many people as possible at this stage transfers an element of the ownership of the project across a wide base and gives as many people as possible a vested interest in the outcome.

Although primarily used to communicate audit findings and recommendations, seminars and workshops can also be used prior to the audit to promote and instruct employees about the audit process and objectives.

Corporate intranet/web site (and other electronic methods)

Make use of the corporate intranet or web site to communicate audit findings and recommendations. Create online versions of the formal written report, or create new and dynamic electronic documents that contain all of the text of the formal report. Use hyperlinks to incorporate other relevant documents and additional background information. Publicize the availability of the information using email, or manual methods such as noticeboards, flyers or the corporate or information unit newsletter.

Use email distribution lists as a means of communicating information audit findings and recommendations. The advantages of email include its speed and efficiency, its cost-effectiveness and the ease by which responses can be solicited.

Personal feedback to participants

Time and resources will limit the levels of personal feedback in which you can engage. It is, however, worth allocating the time if you have groups or individuals who are concerned about the recommendations and how they might affect their workflows, processes and outputs.

Personal feedback to survey participants is important in situations where there are individuals or small groups who are experiencing discontent or insecurity as a result of the findings of the information audit. The short time taken to discuss the benefits of the recommendations with them may mean the difference between defensive reluctance to accept the changes (or outright opposition) and support for the changes and their implementation.

Stage Five: Communicating Recommendations outputs

1. Written audit report (findings and recommendations)

2. Oral presentation

3. Seminars

4. Electronic dissemination

5. Personal feedback.

References

Didis, S.K. (1997) Communicating audit results. *The Internal Auditor*, **54**(5), 36

Orna, E. (1999) *Practical information policies,* 2nd edn. Aldershot: Gower

Chapter Seven

Implementing the recommendations

Stage One
Planning

Stage Two
Data Collection

Stage Three
Data Analysis

Stage Four
Data Evaluation

Stage Five
**Communicating
Recommendations**

Stage Six
**Implementing
Recommendations**

Stage Seven
**The Information Audit
as a Continuum**

Figure 7.1 Stage Six
– Implementing the
Recommendations

'Implementation is the process that moves the orga-
nization from the current state to the desired state.'
(Curzon, 1989)

Implementing the recommendations is stage six
of the seven-stage information audit process
(Figure 7.1). Once the findings of the information
audit have been developed into strategies and the
recommendations formulated from the strategies
have been communicated successfully to manage-
ment and throughout the organization, plans must
be made for implementing the recommenda-
tions. Although a preliminary implementation pro-
gramme (or action plan) was included in your
written reports, oral presentations and/or seminars,
a fully comprehensive implementation programme
must now be developed. This chapter explains
the issues that must be considered and how to
incorporate the recommendations into strategic,
marketing and business plans (Figure 7.2).

In the process of data evaluation and formulating
strategies, decisions on the implementation of the
recommended strategies are dependent on three
levels of formality – the organization, the depart-
ment and the information unit. Those recom-
mended strategies that have an immediate effect on
the effectiveness and efficiency of the information
unit, and do not require external approval or support, should be imple-
mented as soon as there is an opportunity to do so. At the departmental
level, if there are clear opportunities and immediate benefits that can be
gained by all parties from implementation of the recommendation, then

direct negotiation with the department should be instigated as soon as possible, subject to resource allocation and prioritization. However, when the recommendations (i) clearly require resources outside the capabilities of the information unit and affected business units, (ii) have long-term implications for the organization and/or (iii) have a significant impact across the organization, then a well thought through implementation programme is necessary. This chapter addresses the implementation programme at the organizational level, and there are some reminders that whatever the magnitude of the change, thought has to be given to each and every recommendation.

Figure 7.2 illustrates the activities that must be completed to implement the recommendations, review their success and ensure that the changes become part of the formal strategic, marketing and business plans. The way in which the implementation programme is developed will depend on what the recommendations are and to what extent they will affect individuals and groups. This chapter explains how to manage the changes that the recommendations entail. It does not propose to be a comprehensive change management guide, but rather will make you aware of potential problems and enable you to incorporate appropriate methods into the implementation plan to help to reduce the opposition to the

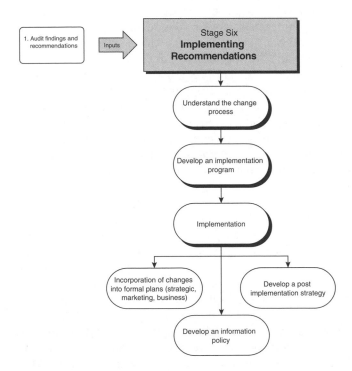

Figure 7.2 Implementing the recommendations

changes. For their implementation to be successful, whether they are minor or major changes, they must be carefully planned and executed. Even seemingly minor changes can be unsuccessful if their impact is underestimated or if they conflict with aspects of the political and cultural environments within the organization.

Understanding the change process

Whether the recommendations involve major or minor changes to procedures, workflows, resources or services, their implementation will have an impact on individuals or groups within the organization. In order for the implementation to be successful there must be support for the changes from those who are affected. Without this support there will be resistance, feelings of insecurity and unrest that will be counter-productive to the implementation process. To maximize the chances of a successful implementation process, the levels of support must be as high as possible and the opposition to the changes must be minimized.

There are many texts that clearly explain how to introduce and manage successfully change operations within organizations. If the changes you wish to introduce are significant and are likely to affect the workflows and procedures of a large number of people it may be worth becoming familiar with basic change management theory. This will help you to understand better the behaviours of those affected and how to streamline the process.

If your organization is going through many changes simultaneously, or if there have been constant changes over a long period of time, then be prepared for some individuals and groups reacting out of proportion to the degree of change that is required.

If your changes are relatively minor with low levels of complexity, then the points below should help.

- *Clearly state the goals.* It is important that everyone who will be affected by the change understands why it is happening and what the benefits will be for him or her and for the organization. Describing the benefits in terms of the entire organization puts the change into a broader perspective and helps to allay fears that specific departments are being 'targeted'.

- *Clearly state the process.* Everyone must understand how the change will be implemented, what is the timeframe and what are the costs. If the change involves workflows and procedures, explain the schedule for the implementation programme. If training is necessary, for example in the case of new resources, ensure that everyone is clear about when and where it will take place.

Figure 7.3 The change-reaction cycle

● *Understand the different ways in which people can react to change and the stages that they go through in the change–reaction cycle* (Figure 7.3). The following emotional responses represent a typical sequence of events. The initial state is *shock* where there is very little reaction and also very little action. This period can often be mistaken for acceptance by the unwary change implementer. Gradually the shock becomes *denial*. The denial stage can be particularly difficult, as people tend to ignore the changes and carry on almost as if the changes had not happened. A period of *depression* follows as they realize that they must 'sink or swim'. Once this hurdle is overcome and people realize that the new ways are not quite so bad they begin to show more *optimism*. It is during this period that they tentatively seek out more information about the changes as their interest increases. Once the benefits of the changes become evident the stage of *acceptance* is reached when people are reconciled to the changes and are able to develop a degree of commitment. It is often not until the acceptance stage that people will be sufficiently interested to participate in a training programme.

This cycle is the most common; however in flatter organizations and those that have a 'team-based' structure (or 'autonomous groups', as discussed in Chapter 2) the change–reaction cycle can be reversed, with people readily accepting the changes, and then over time becoming less optimistic and discouraged with the changes. Understanding the structure of your organization will ensure that you have a good understanding of how people are likely to react.

● *Understand who will be affected ,and how they will be affected with regard to their workflows and procedures and the resources which they use.* This will determine how you communicate the changes to them and what level of interaction is required during the change implementation process.

- *Understand the culture within the organization and how it facilitates or impedes the change process.* The degree to which an organization is a 'learning organization' or has an 'information culture' will determine how the benefits of information-related changes will be accepted by employees. This in turn will determine the level of support for the changes or, alternatively, the resistance to their implementation.

- *Be clear about the expectations of management and the levels of support that they are willing to provide for implementation.* If a high level of support is offered and openly communicated throughout the organization, then it is likely that the expectations of management are high. They will expect the changes to result in significant benefits for the organization. Recruit the CEO (or someone else who is well respected by employees) to introduce and articulate the change process.

- *Involve the employees in the change process.* Listen to their concerns and ideas and ensure that they have ownership of the solutions to the problems.

- *Introduce the change formally.* This makes the details of the change clear to everyone at the same time and offsets the resentment that staff may have about not being informed about vital information. Do not gloss over problem areas and do not over-emphasize the benefits as this will cause unrealistic expectations and discontent later.

- *Communicate openly before, during and after the change process.* Listen as well as speak, and understand when and where your communication skills and the available communication channels can be best used. Open and efficient communication channels will ensure that employees who have negative feelings towards the changes will receive prompt responses to their questions and concerns.

- *Consider the timing of the implementation.* Identify whether people are being asked to deal with more than one change simultaneously. A change may be unsuccessful if attempts are made to implement it at an inappropriate time.

- *Anticipate events that might affect the quality of the change* – budget, staff shortages, major restructuring etc.

- *Become a 'change agent'* – make the changes happen.

Developing an implementation programme

Once you understand the change process and the many ways in which people can react you are in a better position to develop the implementation programme. This is a schedule for introducing the recommendations

and for describing the process that will be used to incorporate the changes into existing processes and workflows. It must contain clear objectives and a clear understanding of the impacts of the proposed changes. It must also be communicated to those involved in an effective and appropriate manner (Figure 7.4).

The details needed for the implementation programme have already been articulated in the 'Action Plan' developed when formulating the recommendations in Chapter 5 and included in the written audit report. These details must now be brought together into a single document that explains the recommendations, how they will be implemented (by whom and what the results will be) and the timeframe. They must incorporate feedback and address comments and concerns that have been raised by employees and management since the distribution of the audit report and the presentations.

Each recommendation must be treated individually with clear objectives, acknowledged impacts and clearly set parameters. The communication strategy developed for the implementation can be a general strategy that takes all of the recommendations into account.

Clarify the objectives

For each recommendation the following aspects should be addressed:

1. Identify the problem to be overcome – describe the problem and artic-ulate the consequences of not addressing the problem. Also include details of the audit findings on which each recommendation is based and the potential benefits

2. Identify the solution – describe how the problems or inefficiencies will be addressed (details of the recommendation) and what the results will be (in terms of specific and measurable goals).

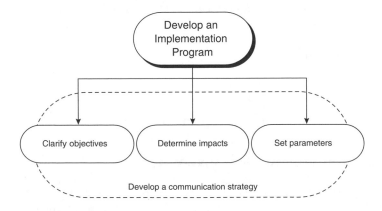

Figure 7.4 Implementation program

3. Provide details – give details of exactly what the recommendation involves. List the changes and what their impacts will be on individuals and departments.

4. Describe the implementation – describe the recommendation in terms of who will do what, how and what will be the results.

5. Explain the cost – provide details of how much the change will cost to implement and maintain. Consider direct monetary cost as well as the indirect cost of human, technical and physical resources.

6. Present the timescale – detail the schedule for implementation and evaluation.

The following additional details should be included:

7. Give piloting details – explain how the changes will be piloted or trialled to determine their impacts, and other relevant issues.

8. Determine priorities – prioritize all the recommendations into 'critical', 'important' and 'suggested'. This will enable those that are rated as critical to receive immediate attention and allow people to recognize the importance of implementing them.

Determine the impacts

It is important that the people who will be affected by the implementation of the recommendation are encouraged to support it. Whether the impacts on them are minor or major, without their support the implementation will be less efficient and consequently more costly. Therefore, work with them when developing the implementation plan as they are the ones who will have the clearer picture of how things such as workflows and processes will need to be modified, and what other issues will have to be taken into account.

When preparing the implementation plan it is important to know exactly what are the impacts and how they can be handled. Table 7.1 shows some examples of how people can be affected by minor changes and how they might be handled.

Set the parameters

Since all parts of an organization interrelate with the other parts, a change in one area will affect other areas of the organization. This will result in a 'rolling' change unless clear parameters are set. Identify the boundaries of the change in terms of area, people, products and equipment and make sure that the change remains within these boundaries.

Table 7.1 The impacts of changes and how to address them

Change	Impact	Solution
Increase in the provision of resources in electronic format	Necessary to improve – searching skills – computer skills	Incorporate training (computer skills and online searching techniques) into the implementation plan
	Changes to scheduling of workflows	Assist with the rescheduling of workflows
	More computers needed	Provide more computers or create access schedules for existing computers
	More costly	May mean less spent on other resources
Substitution of a current resource with a new one	Unfamiliarity with new product	Training in using the new product
	Resistance to new product	Involvement of users in evaluation of the product so that they recognize its benefits

Develop a communication strategy

The communication strategy developed in the planning stage must be continued through to the implementation stage. As with all of the stages since planning, communication must be free and open, and concerns must be addressed efficiently and effectively.

In the implementation stage the following issues are particularly important:

- ensure that the people who are affected by the changes have a clear understanding of exactly what is going to happen, how it will happen and when

- discuss the changes with those people who are affected, and engage their help in developing the implementation plan wherever possible

- ensure that there is a forum where they can raise concerns and discuss issues associated with the change.

Implementation

Developing a post-implementation strategy

A post-implementation strategy ensures that there are methods to collect measurements on how successfully the recommendations are addressing the identified problems and inefficiencies. The post-implementation strategy will involve measuring the results of implementing the recommendations and the introduction of methods to facilitate the acceptance of the changes through awareness sessions, training sessions, a help desk, online instructions, online technical support (FAQs) etc.

Incorporating the changes into formal strategic, marketing and business plans

If the implementation programme is comprehensive it can form the basis for developing strategy documents and a more formal information policy (or a first information policy if one does not already exist) and can be incorporated into formal strategic, marketing and business plans.

Developing an information policy

An information policy is a document that defines how information will be managed within an organization. It is the basis for strategic information management, and the foundation on which procedures for controlling and coordinating the management of information are based. The important components of an information policy are:

1. *Mission statement* – a statement that conveys the purpose, values and objectives of the organization

2. *Information policy statement* – a clear set of guidelines for the effective management of information in relation to the organization's mission and objectives

3. *Objectives* – lists the objectives of the information policy and incorporates monitoring criteria that are relevant and attainable

4. *Review cycle* – the information policy should include the review cycle for subsequent information audits. It must define the guidelines and schedule for regular information audits and allow for interim audits in times of rapid change or crisis.

The development of an information policy is a milestone in the management of information within an organization as it ensures the ongoing

evaluation of the information environment. To be effective it must be widely publicized throughout the organization, and supported by management and key information stakeholders.

Stage Six: Implementing the Recommendations outputs

1. Information policy

2. Post-implementation strategy

3. Revised Business Plan and information management processes

4. Updated Information Resources database.

References

Curzon, S.C. (1989) *Managing change: a how-to-do-it manual for planning, implementing, and evaluating change in libraries.* How-to-do-it manuals for libraries: no. 2, ed. B. Katz. New York: Neal-Schuman

Chapter Eight

The information audit as a continuum

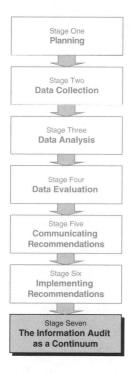

Stage seven is the final stage of the information audit process (Figure 8.1). Rather than being an ending, however, this chapter looks at ways in which the information audit process can become a regular process within an organization. (Figure 8.2) This will ensure that the information services and resources available to the information users within the organization are always the best match for their needs.

Once the recommendations have been implemented, it is important to assess and measure the resulting changes to the information environment within the organization. This must be done over time, as often the impacts are not evident immediately. Also the needs of information users are constantly changing as the organization changes and the range of products and services available to meet those needs is also constantly changing.

Measuring and assessing the changes

Measuring the impacts of the changes and assessing the levels of improvements resulting from each change is an important component of the implementation process as they establish whether or not the change achieved its objectives. Assessments can be used not only to justify the costs associated with the change but also to pave the way for future changes.

Figure 8.1 Stage Seven – The information audit as a continuum

Some means of assessing the changes must be incorporated into the implementation programme. Some measures will be quantifiable, but most will relate to how the information users perceive the improvements or benefits (Table 8.1).

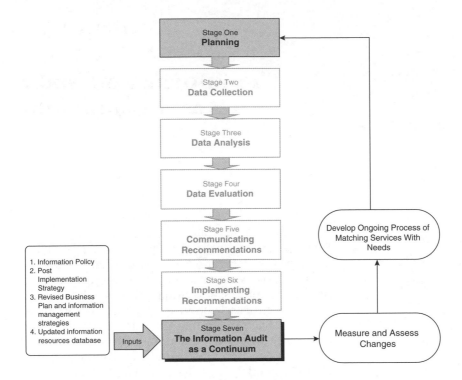

Figure 8.2 The information audit as a continuum

Table 8.1 Quantifiable and perceptual measures

Quantifiable measures	Perceptual measures
Increase in the number of users of a product or service	Access to better quality information
Time saved	Information is easier to access
Money saved	Easier to find and use

There is no standard appropriate time for evaluation, as it will depend entirely on the size and complexity of the change. There is also no standard number of times that a change should be measured or evaluated. A minor change could be evaluated within a few weeks and then never again. A major change however, may not be evaluated for months, and then at regular or 12-monthly intervals to make sure that all is working as it should.

Everyone affected by the change should be aware of the measurement and evaluation programme so that problems of which they are aware can be included.

Careful consideration must be given to recruiting an appropriate person who has knowledge and understanding of the project to evaluate and measure the changes. Whether or not it requires objective evaluation will determine whether the information unit staff or the information users are able to evaluate it. All changes will have an impact beyond the boundaries of the original objectives but the change must only be evaluated in terms of the original objectives.

Develop an ongoing process of matching services with needs

Use the Information Policy as the foundation for an ongoing review of how well the information resources provided meet the needs of the information users. The initial information audit has provided you with an Information Policy, and a database containing information relating to the tasks that support business objectives and the information resources that support them. Subsequent information audits need not be conducted using the same framework. They may vary in their scope; for example, they may be restricted to a single business unit or group of business units, a geographical area or a functional section of the organization. The methodology used could also vary according to the objectives of a specific audit. This is known as 'tailoring' the audit to suit the objectives, and is discussed further in Chapter 9.

The incorporation of 2^{nd} (subsequent) generation audits into the Information Policy will not only ensure that resources meet needs, but will also ensure that the data gathered during the 1^{st} generation audit (the initial audit) are built upon. Second generation information audits must not be conducted in isolation and must measure and account for any changes that have occurred since the previous audit. Each information audit conducted adds to the information resource database. As the organization changes, the changing needs can be matched with either existing or new resources using the data stored in the database.

Planning

Before conducting subsequent information audits, return to *Stage 1: Planning*. This will enable you to work through the five steps, define your objectives and tailor the audit to match what you want to achieve.

Bringing it all together

Chapters 2 to 8 have explained each stage of the seven-stage information audit process and all the associated tasks and activities. This chapter summarizes the process and highlights the important issues that must be addressed, not only when planning an information audit for your organization but also when working through each stage of the process. In addition, this chapter looks at how the process can be tailored to suit your objectives, organization and resources, and the ancillary benefits that can be gained by the information professionals who take part in conducting the audit, the information unit and the organization itself.

The seven-stage information audit model (Figure 9.1) was introduced in Chapter 1. It consists of a sequence of activities that must be undertaken in order to conduct an information audit. As each organization is different, and each information auditor has different levels of resources available to him or her, there is no single method of working through the process and decisions must be made at each stage along the way. Ideally the major decisions will be made in the planning stage. The objective of the audit and its scope and timeframe, the most appropriate methods of data collection, analysis and evaluation and communication strategies should all be considered before you start. This will enable an appropriate audit plan to be developed, with the support of management, within the limits of the resources that you have available.

Each stage of the process is covered in the order in which it should be considered or completed and important issues are highlighted. These important issues can be tasks, activities, decisions or things of which you need to be aware as you work through the process which should not be ignored.

Stage One: Planning

Planning is the first stage of the information audit process. Prior to the commencement of the project consideration must be given to how

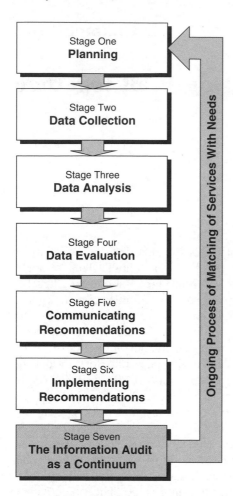

Figure 9.1 The seven stage information audit model

the process will be conducted, how it will be resourced, what will be its scope and timescale and what are the communication issues.

There are five steps in the planning stage that will take you through all of the important issues associated with the information audit process. Each step addresses one or more of the major issues to help you determine the most appropriate way to conduct an information audit in your organization using the available resources.

Step 1: Develop clear objectives

Step 2: Determine scope and resource allocation

Step 3: Choose a methodology

Step 4: Develop a communication strategy

Step 5: Enlist management support

Figure 9.2 illustrates these steps and the activities and tasks associated with each of them.

Step 1: Develop clear objectives

The first step of the planning stage makes you examine your reasons for conducting the information audit and asks you to consider what you might hope to achieve. The reasons for conducting an information audit will be different for each organization, as will the expectations. Some of the more common reasons (both strategic and operational) for conducting an information audit are listed below:

- to evaluate existing services/resources

- to promote existing services/resources

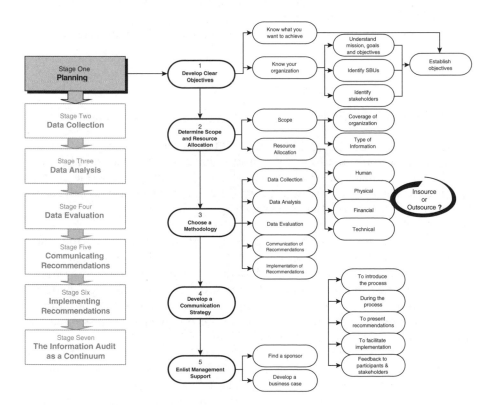

Figure 9.2 Stage One – Planning

- to maintain current staff and funding levels
- to support a request for additional staff and funding
- to identify user needs
- to identify gaps in service/resource provision
- to identify service/resource duplication and areas of over-provision
- to support the restructure of information services
- to map information flows throughout the organization
- to ensure that information services support organizational goals
- to raise the profile of information as a strategic asset
- to link information resources and services to management processes
- to improve the efficiency and effectiveness of information services.

Any one of these reasons may be the primary objective for conducting the information audit, but the outcome of the audit will address many, if not all of them, to some degree depending on the process chosen.

There are three important issues associated with this planning step:

1. Know what you want to achieve
2. Know your organization
3. Identify the stakeholders.

Know what you want to achieve The information audit process has the potential to identify many features and characteristics of information use within an organization. You may choose to concentrate on one or two specific outcomes, or you may decide that your audit should cover the complete range of possible outcomes.

Know your organization It is important that all members of the audit team have a strategic understanding of the organization's business. When establishing your objectives it is important to learn as much as you can about your organization and how it works, develop a clear understanding of its culture and recognize the 'people' issues that need to be considered. You need to know and understand your organization's mission, goals and objectives, its structure and its culture.

Identify the SBUs and understand how each contributes to the business objectives of the organization as this will form the basis for determining which information resources and services have strategic value.

Understand how the structure of your organization facilitates or impedes the sharing, and consequently the flow of information. Recognize that your

organization has both formal and informal structures and that both must be taken into account when examining the information environment.

The culture of the organization can have a direct impact on the information environment within your organization. Whether or not employees value information for their own work, and the degree to which they recognize its contribution to the success of the organization, will have an impact on your objectives and anticipated outcomes.

Identify the stakeholders Understanding who are the stakeholders, both within and outside the organization, will enable you to generate support for the information audit by making them aware of the potential benefits. Whether the stakeholders are information stakeholders, organizational stakeholders or external stakeholders they are all affected by the information environment within the organization.

Step 2: Determine scope and resources allocation

Thought will have been given to the scope of the information audit and the allocation of resources in Step 1 when developing the business case. Step 2 step covers these issues in more detail by explaining the options you have for determining the scope of the information audit and what resources will be required to conduct it. It covers human, physical, financial and technical resources as well as covering the insource/outsource options. Step 3 also introduces the insource/outsource issue and looks at financial and efficiency comparisons of the various options.

Scope There are two ways in which an information audit can be scoped:

1. By type of information
2. By its coverage of the organization.

Type of information. A comprehensive information audit covers all types of information including records management, archives and information technology departments as well as the traditional information resources. What you include in your audit will depend on how these departments are structured within your organization. A reasonable starting point for a first information audit would be to cover only those resources that are, or could be, provided by the information unit. As subsequent audits are conducted, their scope can be increased incrementally to incorporate other types of information and the technological resources required to access the information.

Coverage of the organization. An information audit can be conducted over an entire organization, or can be restricted to specific departments or sections of the organization. I suggest that a complete information audit is conducted initially, then subsequent audits can target specific sections

where measurements and assessments indicate that changes to resources or services may be required. A smaller targeted audit can also be used as a pilot project prior to conducting a major information audit.

Resource allocation An information audit requires the commitment of human, financial, physical and technical resources. This step of the planning process asks you to estimate the level of commitment of each of these resources to complete the information audit successfully.

Human. People are needed to plan, manage, conduct and evaluate the information audit. In addition to an audit manager and an audit team, support may also be required from other people in roles such as administration and communications.

Physical. Workspace and furniture will be needed to house the audit team and administrative support people.

Financial. There will be many direct and indirect costs associated with staff, materials and communication. These costs must be estimated and included in the budget.

Technical. Access to computer hardware, software, printers, photocopiers etc. will be needed.

Once the resource requirements have been determined, decisions must be made as to whether internal or external resources will be used.

Step 3: Choose a methodology

There is no universally accepted methodology for conducting an information audit because each organization is different and requires a different approach. This means that you can choose an approach that best suits the structure and culture of your organization. Regardless of the process you choose there are 5 standard components.

1. Data collection

2. Data analysis

3. Data evaluation

4. Communication of audit findings and recommendations

5. Implementation of recommendations.

Data collection. The information audit process uses the survey method of data collection. Data can be collected using questionnaires, focus group interviews and personal interviews. Whether you choose one or all of these methods will depend on your objectives, the size and scope of your information audit and the resources available. When deciding on a method for data collection, consideration must be given both to the type and volume of data that you collect as these have implications for the data analysis stage of the process.

Data analysis. The analysis of the data will identify problems in information supply such as gaps and duplications. It will also identify bottlenecks and other inefficiencies that affect information flows. Data analysis can be manual, automated using software or a combination of manual and computerized methods. The methods chosen will depend on the types of data collected and the skills of the people available to do the analysis.

Data evaluation. Once the data have been analysed they must then be evaluated and interpreted within the context of the organization. This involves comparing the current information situation with the 'ideal' information situation and noting where changes are required. It evaluates the strategic significance of gaps, duplications and inefficiencies that have been identified and enables decisions to be made as to whether changes are necessary. The outputs of the data evaluation process are the recommendations.

Communication of audit findings and recommendations. Once the recommendations have been formulated they must be presented to management and other stakeholders in such a way that support is generated for their implementation. Common methods include written reports, oral presentations and seminars. Findings and recommendations can also be communicated using electronic means such as email, Internet or intranet documents.

Implementation of recommendations. How the recommendations will be implemented will depend on what they are, how much change is involved and the level of support needed from management and employees. The development of an implementation plan will ensure that the impacts of the recommendations have been considered (who, how, when, where) which will facilitate their implementation.

Step 4: Develop a communication strategy

Identifying the appropriate communication channels during the planning stage of the information audit will facilitate effective communication during and after the audit. The communication channels chosen will depend on your organization's structure and the methods already in place. They can include brochures, newsletter articles, posters, Internet or intranet documents, email messages or personal methods such as meetings, presentations or seminars. It is important to begin communication before the audit has started, continue it thoughout the process and maintain it beyond the audit and to consider communication strategies at each stage.

Before the audit. Communication before the audit will ensure that everyone understands what it is and why it is being conducted. They will understand better their role in the data collection stage and be more prepared to provide quality data.

During the audit. This allows for questions to be asked and concerns to be addressed as they arise.

After the audit. Appropriate feedback to participants and stakeholders will help generate support for the implementation programme. Communication with management whilst formulating recommendations will give them 'ownership' of the recommendations, which will increase support during the implementation process. There must also be formal communication of the findings and recommendations by written report, oral presentations, seminars or electronic means such as email or intranet/ Internet documents.

Step 5: Enlist management support

Once clear objectives have been established it is critical to the success of the information audit project that you secure the support of upper management. There are two activities associated with this step:

1. Recruit a sponsor

2. Develop a business plan.

Recruit a sponsor By recruiting a key player in the organization as a sponsor or advocate you can raise the profile of the audit and ensure a higher level of support for the implementation of recommendations. A sponsor will:

● increase management support for the information audit

● improve the chances of obtaining the resources required

● provide support for the implementation of recommendations

● open new communication channels

● improve access to decision-makers

● understand the organizational culture and how it affects information provision and use

● add a level of validity to the audit project

● promote the merit of the audit to management and stakeholders.

A sponsor must be a person who:

● is regarded highly by management

● understands the value of information to the organization.

Develop a business case The development of a comprehensive business case which includes details of the objectives, resources, methodology, corporate investment and the anticipated outcomes will ensure that management is aware of what the information audit potentially could

achieve. A suggested format for a business case is included in Chapter 2. It must only contain information that is relevant to the information audit proposal. It must also be:

- professionally presented

- logical in layout and numbering

- written in clear and simple language (no library jargon!)

- concise

- honest (overstating your case will result in unrealistic expectations)

- quantitative (include figures wherever possible).

The development of the business case forces you to consider all of the major issues associated with the information audit project and will form the basis for the remaining steps in the planning stage. Involve the sponsor in its development to ensure that it meets the needs of management.

Once the information audit has been carefully planned, the next stage is to collect the data.

Stage Two: Data collection

The second stage of the seven-stage information audit process covers the collection of data relating to the information resources used, how they are used, the information that is produced and the flow of information within an organization and between the organization and its external environment.

This stage also covers the development of an information resources database that will store some of the collected data and enable relationships to be established between information resources and the achievement of business unit objectives.

The information audit process uses the survey method of data collection. A survey is a systematic approach to collecting information and there are three survey methods used in the information audit process to collect data. Each has a different focus and can result in the collection of a different type of data. Any one can be used alone, or in a combination of two or three methods.

Figure 9.3 illustrates the three methods of data collection that can be used and the tasks and activities relating to each of them.

Questionnaire

A questionnaire is a survey instrument used to collect data. It can be used to collect both quantitative and qualitative data about what information is used and by whom, how it is used and how it flows through

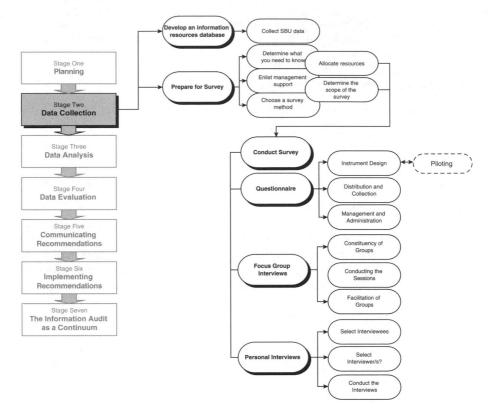

Figure 9.3 Stage Two – Data Collection

the organization. It can be used to collect attitudinal and behavioural data such as how well an information resource or service meets a person's need and how the resource is used.

There are three tasks associated with the questionnaire method of data collection:

1. Instrument design, including piloting for refinement
2. Distribution and collection
3. Management and administration.

Instrument design. This involves determining what data are to be collected, then devising a list of questions to obtain them. Important issues are:

● format (simple, logical structure)
● types of questions (open, closed, multiple choice, yes/no, rating scales)
● length (20 questions/4 pages maximum).

Piloting. Once the questionnaire is designed, test it out in a pilot situation to validate the questions and to ensure that they are resulting in the type of data that is required. If necessary, modify the questionnaire and re-test it until respondents can complete it accurately and quickly.

Distributing and collecting the questionnaire. The distribution methods for the questionnaire will depend on the size and structure of the organization as well as the resources and the timeframe available to collect the data. Distribution methods must be cost-effective and efficient and can be manual (mail, personal delivery) or electronic (email, intranet/Internet) depending on the technology available.

Management and administration. This covers the coordination aspects of distribution and collection of questionnaires, following up non-returns and ensuring that all enquiries and concerns are dealt with efficiently and effectively. It also covers the coordination of personal and focus group interviews, the distribution of interview schedules and all clerical tasks associated with the survey.

Focus group interviews

A focus group interview is a free-flowing interview (conducted by a moderator) with a small group of people (usually 6–8). Focus group interviews are used as a component of the information audit process to gather more in-depth qualitative data to clarify and add meaning to the questionnaire responses.

There are three tasks associated with conducting focus group interviews:

1. Determining the constituency of the groups
2. Selecting a moderator
3. Conducting the interview sessions.

Determining the constituency of the groups. The ideal size is 6–8 people. Group members should have common characteristics related to the issue being discussed. Homogeneous groups allow discussions to develop along lines that are of interest to all group members.

Selecting a moderator. The moderator is the facilitator of the group and must ensure that the information which is collected is useful and meets the objectives of the interview session. He or she must have

- a clear understanding of the objectives of the interview session
- objectivity and honesty
- an understanding of group dynamics and group facilitation
- high-level communication skills (including listening skills)

- the ability to interpret the responses in the context of the topic under discussion.

Conducting the interview sessions. How the sessions are conducted will affect their success, and planning and communication prior to the interview sessions and during the interview sessions is important.

Prior to the interview session:

- prepare and distribute the agenda, an outline of the topic and the list of the questions that will be asked.

During the interview session:

- ensure that the group understands the purpose of the session
- explain what will be done with the data collected at the interviews
- tape the session or use an independent note-taker who is familiar with the topic
- ensure even participation by all group members
- keep the meetings informal – people talk more when they are relaxed and comfortable
- word the questions carefully and allow people time to consider their responses
- get closure on questions.

Personal interviews

Personal interviews are one-to-one interviews, which are conducted to collect data from key information users to supplement the data collected by the questionnaire. Although personal interviews are time- and labour-intensive, they are vital to the information audit process as they provide not only rich data for analysis but also the opportunity to meet the key players face-to-face to discuss their information needs and how their use of information contributes to organizational goals and objectives. It is important that at least one key information user from each functional division or section of the organization is interviewed.

There are three activities associated with personal interviews:

1. Selecting the interviewer(s)
2. Selecting the interviewees
3. Conducting the interviews.

Selecting the interviewer(s). The person selected to conduct the personal interviews must be a skilled and experienced interviewer who is objective and familiar with the topic, and who can think quickly when interviewees raise unanticipated questions.

Selecting the interviewees. All key information users should be interviewed if possible. If time and resources do not allow this, then at least one key information user from each functional department or section of the organization must be interviewed.

Conducting the interviews. It is important to send interviewees a list of the issues to be covered well in advance of the interview. This gives them the opportunity to consider their responses and to gather any additional data that they might need in order to provide comprehensive responses. The following should be done to maximize the effectiveness of the interviews:

- tape the responses or use an independent note-taker who is familiar with the topic

- explain the objectives of the interviews and the potential benefits to the interviewees

- explain what will be done with the data collected at the interviews

- ensure that the questions are worded clearly and concisely.

Stage Three: Data analysis

Data analysis is the third stage of the seven-stage information audit process (Figure 9.4). It involves the editing and coding of the data that have been collected in preparation for analysis, and then the actual analysis where the data are used to identify problems and inefficiencies. Figure 4 illustrates the tasks and activities associated with the data analysis stage of the process.

There are four tasks that must be completed before the data can be analysed:

1. Input relevant data into the information resources database

2. Develop a data preparation plan for the rest of the data

3. Prepare the data

4. Enter the data into the analysis tool.

Input relevant data into the information resources database

Use the collected data to complete the records in the information resources database.

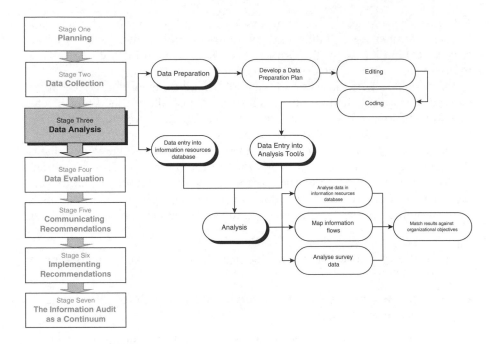

Figure 9.4 Stage Three – Data Analysis

Develop a data preparation plan

A data preparation plan is a document that sets out how the data will be prepared for analysis. It states the procedures that will be used for dealing with each set of data and how anomalies such as missing data, inconsistencies and contradictions will be handled. A comprehensive data preparation plan ensures consistency in the way the data are handled.

Data preparation

Data preparation is the process of putting the collected data into a form that can be used in the analysis process. It involves three major tasks:

1. Transcription of the focus group and personal interviews
2. Editing the responses
3. Coding the responses.

Editing the responses. Editing is the process of making data ready for coding. It involves detecting and correcting errors in accordance with the rules defined in the data preparation plan.
Coding the responses. Coding is the process of allocating numbers or codes to each possible answer to each question. This enables the data to be

slotted into defined groupings that allow them to be entered into the analysis tool. A standard list of codes is created for each question and responses are matched with the list and allocated to the appropriate codes.

Data entry

Data entry is the entering of the coded data into the tool that is to be used for analysis.

Data analysis

Analysis of the survey data Manual data analysis should only be considered if the volume of data collected is small and manageable. Common spreadsheet and database programs can be used to store and manipulate the data. This enables reports and graphical representations of the data to be produced to facilitate the analysis process.

Specialist data analysis tools are available to assist in the analysis of both quantitative and qualitative data. There is however, no fully computerized method of analysing qualitative data. Specialist programs are available but they are relatively costly and require training (or time to self-learn). They require manual intervention to identify relationships and links but can build theories by enabling the identification of themes, patterns and trends.

Analysis of the data in the information resources database The information resources database will enable you to match information resources with business unit objectives, which in turn can be matched with organizational objectives.

Mapping of information flows By visually representing the flows of information within the organization and between the organization and its external environment, bottlenecks, gaps, duplications and other inefficiencies can be identified. It also assists in the identification of information gatekeepers within the organization. Use an organizational chart as the basis for the 'map' and record inflows and outflows from each department. Include those that are produced by the department, and also those that are acquired from, or supplied to, sources outside the organization.

As well as identifying flow inefficiencies, the data can be used to identify problems such as non-provision of critical resources (needs not being met), over-provisions (services provided but not required) and ineffective supply (resources are supplied, but they are not the best ones to meet the need).

Matching findings with organizational objectives

Using the information resources database, the strategic value of information resources can be determined as well as their suitability for the tasks

that they support. The mapped information flows enable you to see the way the resources flow through the organization and between the organization and the external environment.

Stage Four: Data evaluation

Once the data have been analysed, the results must be evaluated and interpreted in order to determine what they really mean in the context of the organization in which the information audit was conducted. Evaluation is the process of expressing the analysed data in terms of the known or familiar and determining the 'value' of what the data show. Interpretation is the process of explaining what the analysed data show, drawing conclusions concerning the meaning and implications and determining the significance in the organizational context.

Both evaluation and interpretation require a comprehensive understanding of how the organization works and its mission, goals and objectives. They also require an understanding of the cultural and political situation within the organization. There are six tasks and activities associated with data evaluation (Figure 9.5).

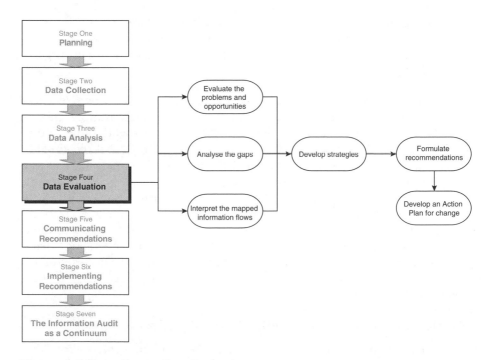

Figure 9.5 Stage Four – Data Evaluation

1. Evaluate the problems.

2. Analyse the gaps.

3. Interpret the information flows.

4. Develop strategies.

5. Formulate recommendations.

6. Develop an Action Plan for change.

Evaluate the problems and opportunities

The problems that have been identified must be evaluated within the context of the organization.

1. Does the problem have strategic significance? The level of strategic significance is the degree to which this problem affects the achievement of organizational goals.

2. Are financial and other resources being used inefficiently or ineffectively? Problem situations which identify the inefficient or ineffective use of money, people and equipment (including computers) must be addressed, provided that the benefits of the solutions outweigh the costs.

3. Will addressing this problem benefit the organization as a whole? Since each part of an organization relates to another part, it is important to understand the interrelationships and to recognize whether or not the solutions to this problem will have a negative impact elsewhere in the organization.

4. Is it possible to solve the problem within the constraints of the organization? The constraints imposed by an organization are delineated not only by the available resources but also by the cultural and political situation within an organization. Human and financial limitations are the most common resource-related constraints faced by people wanting to solve problems within an organization.

By considering these issues, you will be able to ensure that the changes which you recommend are those that will have a high degree of success and will benefit the organization as a whole.

Analyse the gaps

The data collected must be broken down to reflect the 'current information situation' and the 'ideal information situation'. Once you have a clear picture of both situations you can identify the gaps in information supply that need to be filled, and the duplications and over-provisions that need to be reduced.

Interpret the mapped information flows

Once the flows have been mapped and gaps, duplications and ineffi-
ciencies have been identified, they must be interpreted within the context
of the organization. This involves considering their significance and deter-
mining whether or not they need to be addressed.

Develop strategies

Strategies must be developed to address: (i) the problems which have
been identified as significant in the evaluation process; (ii) the gap
analysis; and (iii) the interpretation of information flows. For each problem
there will be more than one solution. The alternative solutions must be
considered in relation to the resources required to implement and manage
the change as well as the organization and its people. It will be easier to
justify the selected solution if formal procedures have been followed in
making the selection. For example:

1. List all the alternatives

2. List the selection criteria – the factors that form the key characteristics
 of the solution (cost, risk, performance etc.)

3. Produce a metric for each selection criterion showing how well the
 various solutions satisfy that criterion

4. Assign weighting values to each of the selection criteria, reflecting their
 relative importance in the selection process.

With these components an objective measure of the suitability of each
alternative as a solution to the problem is obtained. If this process is
performed correctly and objectively then the alternative with the best
overall score is the best alternative.

Once the best alternative has been selected it is important to investi-
gate it further.

● will it have adverse consequences? What are the potential risks?

● does it match the cultural and political environment within the orga-
 nization?

● is it maintainable?

● is it reliable?

● will it be influenced by changing technology?

● is it expandable or scalable?

Formulate recommendations

The process of formulating recommendations applies costings, processes and goals to the selected strategies that scored the highest against the selection criteria.

Costings. Costings must include implementation, maintenance (ongoing) and replacement costs.

Processes. Processes must be developed to incorporate the recommended changes into existing workflows.

Goals. Each recommended change must have quantifiable goals to enable the change to be evaluated and measured.

Once recommendations have been developed, they must then be communicated to management and stakeholders in a way that generates support for their implementation.

Develop an Action Plan for change

List the details (problem, solution, detail, implementation, cost and timescale) of each recommendation individually. Identify links and overlaps with, and impacts on, other areas of the organization's operations.

Stage Five: Communicating the recommendations

The level of success of an information audit can depend on how the findings of the audit and the recommendations which have been formulated are communicated to management and stakeholders. The method or methods chosen must be appropriate for the organization and must take into account the culture and political environments within the organization. Figure 9.6 illustrates the tasks and activities associated with communicating the information audit recommendations.

Common methods used to communicate information audit recommendations are:

1. Written report
2. Oral presentation
3. Seminars
4. Personal feedback to participants
5. Corporate intranet/web site.

Written report

It is important that you prepare a written report, even if it is not the main method chosen for presenting the findings and recommendations. The

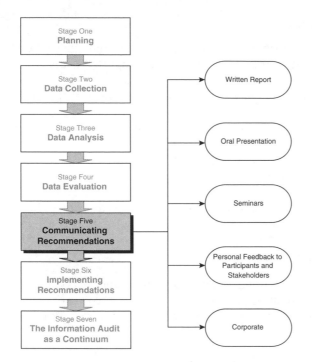

Figure 9.6 Stage Five – Communicating the Recommendations

written report is the official record of the information audit and includes details of the objectives, scope, findings and recommendations.

The structure of the report is important. Divide it into logical sections, and use a hierarchical numbering system. Ensure that it is written clearly and concisely, and that it presents a positive view by focusing on the benefits that the audit has provided. Match identified problems with proposed solutions, and acknowledge those solutions that were provided by survey participants.

Oral presentation

An oral presentation is a verbal summary of the major findings, conclusions and recommendations of the information audit. Oral presentations should be used to present the audit recommendations to stakeholders to allow them the opportunity to ask questions and discuss the issues that they see as significant. The attendance of the sponsor and members of upper management will ensure that their support for the project is visible to employees. This will increase overall support and commitment.

An oral presentation should:

● contain less detail that the written report

- focus on the outcomes

- focus on the needs and concerns of the stakeholders rather than on the technical details of the audit

- include an opportunity for discussion and interaction between attendees

- use visual aids to clarify or emphasize significant issues.

Seminars

Seminars are presentations to small groups which provide opportunities for questions and discussion. They are less formal than oral presentations and should include mixed groups of managers and lower-level employees to facilitate communication and cooperation. The involvement of upper management (preferably the CEO) to introduce the sessions will convey a level of support for the project and for the implementation of recommendations.

Personal feedback to survey participants

Provide personal feedback to individuals and groups whom you feel may not support the recommendations and who may act against their implementation. A short discussion may alleviate their concerns and reduce their opposition to the recommendations.

Corporate intranet/web site (and other electronic methods)

Use the corporate intranet or web site to communicate the findings of the information audit and the recommendations. Create online versions of the written reports and the oral presentations and use hyperlinks to incorporate additional background information and other relevant documents. Use email to publicize the availability of the information and use email distribution lists to communicate the recommendations – this method is fast and cost-effective.

Stage Six: Implementing the recommendations

The implementation of recommendation is stage six of the seven-stage information audit process. It involves the development of an implementation programme and the incorporation of recommendations into strategic, marketing and business plans. Figure 9.7 illustrates the activities and tasks associated with this stage of the process.

Regardless of whether the recommendations involve major or minor changes to procedures, workflows, resources or services, their implementation will have an impact on individuals and groups within the

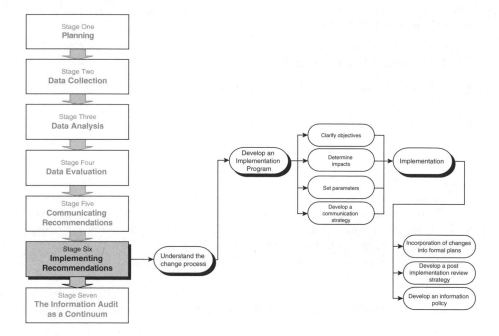

Figure 9.7 Stage Six – Implementing the Recommendations

organization. The effect of the changes and who will be affected must be understood when planning the implementation of the recommendations.

Understand the change process

Regardless of whether the recommendations involve major or minor changes to procedures, workflows, resources or services, their implementation will have an impact on individuals or groups within the organization. If your changes are relatively minor with low levels of complexity, then the points below should help.

- Clearly state the goals.
- Clearly state the process.
- Understand the different ways in which people can react to change and the stages that they often go through in the change-reaction cycle:
 - *shock* where there is very little reaction and also very little action
 - *denial* where people tend to ignore the changes and carry on almost as if the changes had not happened
 - *depression* as they realize that they must 'sink or swim'

- *optimism* as interest increases
- *acceptance* when people are reconciled to the changes and are able to develop a degree of commitment.

- Understand who will be affected and how they will be affected with regard to their workflows and procedures and the resources they use.

- Understand the culture within the organization and how it facilitates or impedes the change process.

- Be clear about the expectations of management and the levels of support they are willing to provide in order for the changes to be implemented.

- Involve the employees in the change process. Listen to their concerns and ideas and ensure that they have ownership of the solutions to the problems.

- Introduce the change formally. This makes the details of the change clear to everyone at the same time and offsets the resentment that staff may have about not being informed about vital information.

- Communicate openly before, during and after the change process.

- Consider the timing of the implementation and whether people are being asked to deal with more than one change simultaneously.

- Anticipate events that might affect the quality of the change – budget, staff shortages, major restructures etc.

- Become a 'change agent' – make the changes happen.

Develop an implementation programme

The implementation programme is a schedule for introducing the recommendations. It breaks each of them down into activities and processes and describes how they will be incorporated into existing workflows. It must incorporate feedback and address comments and concerns that have been raised by employees and management since the distribution of the audit report and the presentations.

Rate the changes as 'critical' – to be incorporated immediately, 'important' – to be incorporated as soon as possible and 'suggested' – to be incorporated as time and resources become available.

There are four tasks and activities associated with the development of the implementation programme:

1. Clarify the objectives
2. Determine the impacts
3. Set parameters
4. Develop a communication strategy.

Clarify the objectives. Understand why each change is being recommended in terms of the individual employees, the departments or sections affected and the organization as a whole and understand the consequences of non-implementation. The following information is required for each recommendation:

1. Identify the problem to be overcome.

2. Identify the solution.

3. Provide details of exactly what the recommendation involves.

4. Describe implementation – who will do what, how and what will be the results.

5. Explain the cost – include implementation, maintenance and replacement costs.

6. Give the timescale – detail the schedule for implementation and evaluation.

The following additional details should also be included:

1. Give piloting details – how the changes will be piloted or trialled to determine their impacts and other relevant issues.

2. Prioritize recommendations into 'critical', 'important' and 'suggested'.

Determine the impacts. Recognize who will be affected by the change and the potential costs and benefits to them.
Set parameters. Establish boundaries for the changes in terms of people, products and equipment.
Develop a communication strategy. Establish methods of communicating details of the change processes to employees and open communication channels to enable their concerns to be raised.

Implementation

Incorporate the changes into formal plans The strategies to implement the recommendations must be incorporated into:

1. The strategic plan

2. The business plan

3. The marketing plan.

Develop a post-implementation review strategy Review the success of the recommendations, and ensure their continued success by:

- measuring the results of implementing the recommendations

- introducing methods to facilitate acceptance of the changes through awareness sessions, training sessions, a help desk, online instructions, online technical support (FAQs) etc.

<u>Develop an information policy</u> An information policy is the document that contains the procedures for controlling and coordinating the management of information.

Stage Seven: The information audit as a continuum

The final stage of the seven-stage information audit process looks at why the information audit must become a regular means of matching information services and resources with information needs. It describes ways of measuring and assessing the changes introduced as a result of an information audit, and introduces ways of developing an ongoing process to ensure that information services match information needs. This stage also looks at the ancillary benefits to be gained by conducting the information audit on a regular basis, and the ways in which the process can be tailored to suit the specific needs of individual organizations. Figure 9.8 illustrates the tasks and activities associated with this stage of the process.

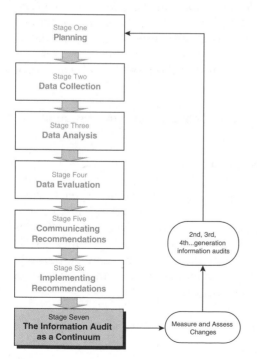

Figure 9.8 Stage Seven – The Information Audit As A Continuum

Measuring and assessing the changes

Measuring the impacts of the changes and evaluating the levels of improvements resulting from each change is important to establish whether or not the change achieved its objectives.

● both quantifiable and perceptual measures must be used.

● there is no standard appropriate time for evaluation.

● there is also no standard number of times that a change should be measured or evaluated.

● everyone affected by the change should be aware of the measurement and evaluation programme.

● the evaluator must have knowledge and understanding of the project.

● the change must only be evaluated in terms of the original objectives.

Tailoring

A comprehensive information audit comprises all seven stages of the seven-stage information audit model described in the previous chapters. The model is not a highly structured and controlled process that operates in a tightly defined manner. Rather it is a structured framework that is flexible and can 'bend' to meet the varying conditions and constraints of an organization. The components presented in the model can be adapted, or tailored, to suit

● the objectives of the auditors in conducting an information audit

● the available resources

● the structure and culture of the organization.

Tailoring the information audit process consists of examining each stage of the process (and each step within each stage) and identifying the outcomes that are appropriate considering the objectives, circumstances and constraints. The tailoring process focuses on the outcomes to be achieved and will determine not only which stages (and steps) will be conducted but also how they will be conducted. How the information audit process will be tailored will depend on:

1. The *complexity and dynamics* of the organization;

2. The *constraints* set by the organization;

3. The *maturity* of the information audit process.

Complexity and Dynamics Key factors in determining the effort required to conduct an effective and efficient information audit are:

- the size and structure of the organization

- the nature (level and type) of the interactions within the organization and between the organization and its external environment

- who are the stakeholders and their behaviour

- environmental factors influencing the organization (legal requirements, customers, competitors, technological developments etc.)

- the type of information flows within the organization.

Constraints The scope and timing of an information audit will depend on the constraints set by the organization. Information audits are often conducted in conjunction with other organizational reviews such as full organizational reviews or the re-engineering of business unit tasks. Common constraints include:

- availability of funds and resources

- availability of technology to assist the audit process (hardware and software)

- prioritization criteria (political agendas).

Maturity The initial information audit conducted across an entire organization is a 1st generation information audit. Subsequent information audits are known as 2nd followed by 3rd generation audits etc. The key factor in moving from one generation of information audit to the next is the ability to use the historical data already captured and the framework developed in previous audits. This can only be done if the data are structured and stored in such a way to facilitate the progression to an effective and efficient subsequent generation audit. This is an important consideration when outsourcing the audit process, as you must ensure that the collected data are returned to the organization in a useable format, and that the framework that was developed can be re-used and built upon by subsequent audits.

Each information audit creates a baseline of the organization's information requirements which can be re-used to ascertain their continual relevancy and effectiveness as the organization evolves and changes.

A 1st generation information audit can be conducted at:

- business unit level (to gain insight into the audit process or to focus an particular problems where significant benefits can be achieved)

- organizational level (to identify clearly how information is acquired, transformed and used to meet the objectives of an organization).

Subsequent information audits can be conducted following the same process as the 1st generation information audit, or they can be restricted to specific business units or sections of the organization. Alternatively they can be restricted to a specific functional level of the organization.

Application of tailoring A 1st generation information audit will require all seven stages of the seven-stage information audit model to be completed. There is, however, the opportunity to vary how and when each stage is conducted and the methods that can be employed. As you work through the process from stage one to seven, there are alternative methods that you can use to match the process with your objectives and the needs and constraints of the organization.

Second (and subsequent) generation information audits benefit from the lessons learned in previous audits. Much of the required data have already been collected and stored. Many problems have already been identified, and inefficiencies documented. The focus of subsequent audits is to measure the effectiveness of changes and to reassess how well the information services meet the changing needs of the organization. Subsequent audits build on existing data to create a new baseline that forms the basis of modifications to policies (including the Information Policy) and processes.

Summary of outputs

Figure 9.9 illustrates the outputs of each stage of the information audit process.

Conducting an information audit has benefits for the organization, for the information unit and for the information professionals and others who work on the audit team. Some of the additional benefits that might be gained are listed below.

Benefits for the organization include:

- a framework for standards and procedures
- identification of skills gaps and consequently of training needs
- identification of individual areas of expertise
- raised awareness throughout the organization of the value of information which if cultivated can build an 'information culture'
- increases in information accuracy due to the shared ownership of, and responsibility for, information
- a basis for building a knowledge-based culture.

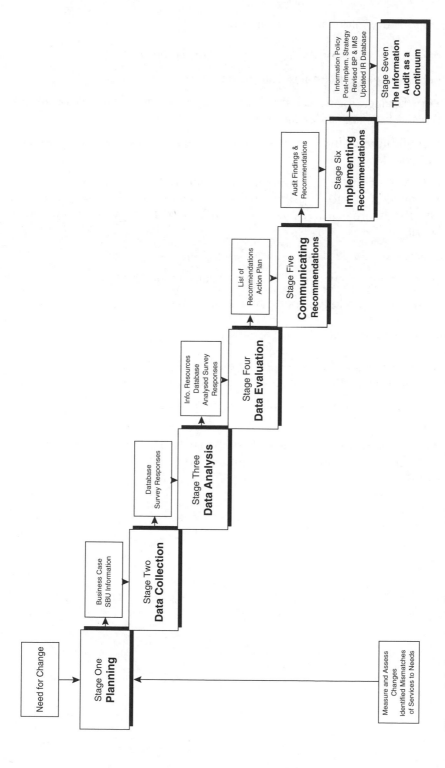

Figure 9.9 Summary of outputs Ancillary benefits

Benefits for the information unit include:

- raised awareness of the role of the information unit
- better developed communication channels
- opportunities to market the services and resources and to promote those which are under-utilized
- identification of the core customer base, information gatekeepers and stakeholders
- evidence of the value of the services and resources provided by the information unit to organizational success which can be used to calculate the return on investment for funds used to provide information services
- more streamlined planning and budgeting
- more easily formulated collection development strategies
- a basis for developing performance measures.

Benefits for the information professional include:

- a comprehensive knowledge of the organization and how it functions, both internally and in relation to its external environment
- a better understanding of his or her individual role within the organization
- the development of practical skills such as interviewing, project management, planning and communication skills.

Case studies

Case study 1: Preston and Northcote Community Hospital (PANCH), Victoria, Australia (Majella Pugh, Library Manager)

The organization

The Preston and Northcote Community Hospital (PANCH) was a community hospital located in Preston, Victoria, Australia. It offered a wide range of both inpatient and outpatient services, including obstetrics, gynaecology, plastic and reconstructive surgery, general medicine, psychiatry, radiology, pathology, pharmacy and emergency services. The hospital had a secondary role involving the training of medical, nursing and allied health students.

PANCH was relocated to a new site in February 1998 and continues trading under the name of The Northern Hospital, as part of the North Western Health Care Network.

The chart in Figure 10.1 shows the structure of the organization and the position of the Library. The shaded boxes indicate those departments that were included in the information audit. The unshaded departments were excluded from the audit as it was felt that they did not use the health information that was seen as the Library's core business.

Reasons for conducting an information audit

The imminent move to a new site was seen as an opportunity to overhaul the existing information services and to develop one that focused on the needs of the organization. An earlier analysis of the organization's information requirements identified the need for a professional librarian to develop an information infrastructure by automating the library catalogue and providing access to online databases such as Medline. A part-time Librarian was employed on a one-year contract to establish an information service and address the information problems being experienced by the organization.

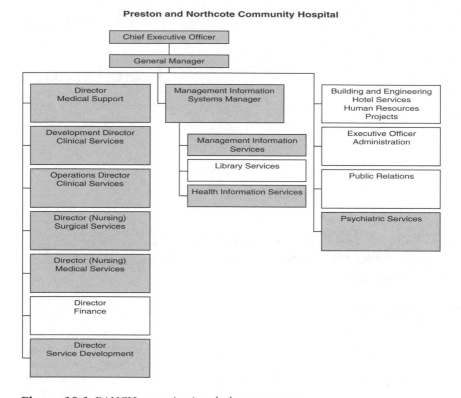

Figure 10.1 PANCH organizational chart structure

The existing collection of resources was antiquated and needed to be updated. The organization did not have an information policy; many of the library services had been partially developed and then abandoned and it was realized that the information needs of the staff were unknown as they were getting their information from sources other than the library. Over 800 people were employed by PANCH, yet fewer than 100 used the information service. The information flows within the organization were unknown. These were seen as critical issues and the decision was made to conduct an information audit. The information audit was chosen as a methodology because it was seen as the broadest and most thorough approach to capture the data necessary to develop a series of recommendations for management.

Objectives

There were three primary objectives:

1. To identify the information needs of the staff of the organization
2. To develop an information service that meets those needs

3. To ensure that the information service contributes to the success of the organization.

The organization did not have an information policy in place and the development of one was not an objective of the audit process.

The process used

<u>Planning</u> The information audit process was carefully planned. In the hope of learning more about how the information audit should be conducted and the likely pitfalls to look out for a message was posted to the MEDLIB-L listerv asking for details of experiences and references.

The following decisions were made prior to the commencement of the information audit process.

- the scope of the audit would be limited to those departments that were considered to be potential information users.

- the timeframe would be limited as the audit had to be completed prior to relocation.

- data would be collected by questionnaire and personal interviews.

- all processes would be carried out using in-house resources.

- those aspects of the information audit where there was no in-house expertise would be omitted – for example the mapping of information flows.

<u>Scope</u> The Audit Manager was the Librarian who took the advice of the Library Sub-committee for the scope of the information audit. Limited resources forced the restriction of the audit to selected departments of the organization and it was decided to include only those which were potential users of an information service.

<u>Timeframe</u> The timeframe was established in the planning stage to ensure that the information audit was completed well before relocation of the hospital. The information audit was completed in seven months.

<u>Sponsorship</u> The sponsor was the Manager of Information Technology who was also the Chair of the Library Sub-committee. She recruited the Librarian who was employed to develop the information service and who subsequently became the Audit Manager. The sponsor provided guidance and mentoring in all aspects of the audit process.

The Library Sub-committee consisted of the Professors of Medicine and Surgery heading the University of Melbourne's teaching units, the IT Manager, representatives from Allied Health and Nursing, senior medical

staff and surgeons. It was formed to oversee the running of the Library and to ensure that the staff's information needs were being met. It had a major role in guiding the Audit Manager through the audit process and the subsequent relocation of the information service.

As it was not necessary to recruit a sponsor or to generate support amongst senior management for the information audit process it was decided not to prepare a business case prior to conducting the audit. However a business case was prepared after the audit to support a request for a grant and an increased Library budget.

Resources The information audit was completed using in-house resources as it was considered to be less expensive that employing an external consultant.

Methodology Although personal interviews were the preferred method of data collection, a questionnaire was also used to capture the responses of key people who could not be pinned down for interviews. A standard questionnaire was used to collect responses from 29 people who were a mix of current Library users and non-users. There were considerable time constraints on the Audit Manager, who was employed only part-time, and on the interviewees who were preparing for relocation, and for this reason a questionnaire was considered to be appropriate as it was a faster method of data collection.

Structured personal interviews were used to supplement the data collected using the questionnaires. Structured interviews were chosen to keep the data consistent and comparable, and thus make them more meaningful.

Focus group interviews were not used as a method of data collection because:

1. There was no in-house experience in organizing or facilitating focus groups, and it was considered that the timeframe available for the audit did not allow for training in this area

2. Due to the part-time availability of the Audit Manager the coordination of groups would be difficult.

Data analysis All data collected were analysed in-house using manual methods. The responses were transcribed and entered into Microsoft Word under question headings. Patterns were identified and summarized. Responses were then quantified as percentage responses.

Formulating recommendations Recommendations were formulated by identifying key positives, negatives and opportunities as requested by the Library Sub-committee. Significant trends and responses were noted. Once

formulated, the recommendations were then costed. Recommendations included a review of journal subscriptions, a review of the centralization policy and suggestions for key resources to be purchased.

The collated responses were then compiled as a written report that took the form of an SWO (Strengths, Weaknesses and Opportunities) document. It detailed key positives, negatives and thoughts for the future directions of the Library. The SWO document was then expanded to 'Upgrade Brief' containing the costed recommendations. The report was distributed to all the staff who were contacted about the information audit whether they participated or not.

Evaluation of the information audit process The Audit Manager felt that the findings of the information audit did support the reasons for conducting it as they offered solutions to the problems that led to the audit being conducted. The findings were helpful in determining how to modify existing services to meet better the needs of the organization and also in determining which new services should be developed.

As a result of the information audit, existing services were modified in the following ways:

- the collection was weeded extensively which led to an improved and more focused service

- after rationalization journal subscriptions were consolidated making them easier to manage and more reliable and efficient

- journal storage was centralized with a written policy and noted exclusions

- the contents page bulletin was only sent to those who needed it.

Ancillary benefits Significant ancillary benefits were identified as being attributable to the information audit process. The primary benefit was in marketing. There was a significant increase in awareness of the Library and the number of clients increased.

There were also benefits for the Audit Manager who increased her knowledge of the organization and how it functioned. This significantly assisted her forward planning responsibilities. She became more familiar with the staff, their information seeking patterns and their information needs.

Follow-up measures Measures were taken through the Library Sub-committee to ensure that the recommendations of the information audit would be implemented. The information audit was to be repeated in six months' time.

Rating the information audit process When asked to rate the information audit as a means of achieving a number of specific objectives on a scale of zero (not at all) to five (completely), the Audit Manager rated them as follows:

Justifying existing services/resources	4
Evaluating existing services/resources	5
Promoting existing services/resources	4
Maintaining current staffing levels	0
Maintaining current funding levels	0
Supporting request for additional funding	5
Supporting request for additional staff	5
Identifying user needs	5
Identifying gaps in service/resource provision	5
Identifying service/resource duplication	3
Supporting restructure of information services	4
Mapping information flows throughout the organization	3
Ensuring that information services support organizational goals	5
Raising the profile of information as a strategic asset	4
Linking information to management processes	3
Improving efficiency of information services	5
Improving effectiveness of information services	5

Overall Outcomes

The information audit resulted in:

● a budget increase of 30 per cent with a further possible increase of 25 per cent likely

● complete support of the Library Sub-committee

● the clear identification of user needs

identification of gaps in information provision which have been used as opportunities to develop the service.

Case study 2: Department of Justice and Attorney-General, Brisbane, Queensland, Australia (Susan Rigney, Library Services Manager)

The organization

The Department of Justice and Attorney General is a Queensland Government department, located in Brisbane, Australia. Its job is to administer the justice system and promote Queensland's cultural lifestyle throughout the State. Its mission is to 'advance the protection of human

rights and the rule of law for people in Queensland and to build and enrich Queensland's art and cultural life'. Based in Brisbane, the Department provides services throughout the state of Queensland.

The Department's services include supporting the courts, mediating disputes, prosecuting alleged offenders, helping victims of violent crime, registering Justices of the Peace, providing legal services to the government, protecting human rights, developing and revising laws, registering births, deaths and marriages and promoting the Arts.

The information audit described in this case study covered the Justice Portfolio and did not include the Arts section of the Department.

Structure

Figure 10.2 shows the structure of the Department and position of the Justice Portfolio.

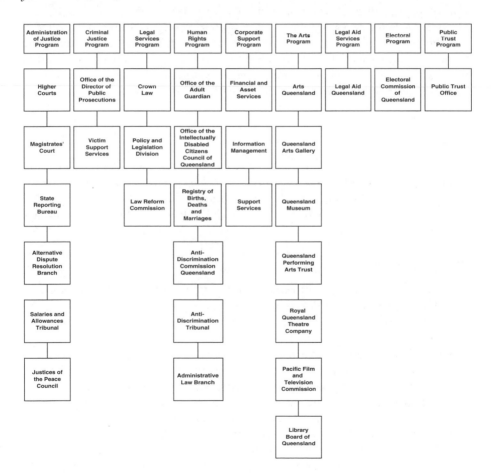

Figure 10.2 Department of Justice organizational structure

Reasons for conducting an information audit

In 1997 the Director-General of the Department of Justice initiated a review of the libraries in the Justice Portfolio. This resulted from the difficulties that the three libraries within this jurisdiction (Justice, Supreme Court and Legal Aid) were experiencing with resourcing due to an increased demand for 'hybrid' operations (parallel hardcopy and electronic). It was hoped that the review would identify opportunities for cooperation between the libraries but its primary objective was to identify the goals, objectives and strategies for directing the activities of the Justice Portfolio libraries and provide a framework for future decision-making and the implementation of long term goals.

The Justice Portfolio Libraries Review recommended that an information audit be conducted as a critical first stage in ascertaining a strategic direction for the libraries to determine whether there was a match between library users' information requirements and the services offered by the libraries. A Steering Committee was established to provide expert opinion on the scope of the review and the range of issues examined. The Committee endorsed the recommended strategy. The information audit was conducted by the consultant who conducted the Justice Portfolio Libraries Review who worked closely with the Director-General and with the Library Services Manager.

Objectives

The Justice Portfolio Libraries Review stated that the information audit would reflect the information requirements and perceptions of the users, be they right or not. It was the consultant's view that the users of the library services were critical in determining the future strategy of the library services.

The process used

Prior to the commencement of the audit process, the Project Sponsor and the Steering Committee determined the scope of the audit and designed the survey questions so that the responses would provide the data required.

They also agreed that the focus of the audit would be on the general information needs of the respondents, both formal and informal and incorporate information from both internal and external sources. The objective was to focus on identifying information needs rather than limiting it to the assessment of the information currently provided by the libraries.

The information audit project had the total support of management. The Steering Committee was representative of all agencies within the department and the members actively engendered support for the project. In addition, the Director-General of the Department endorsed the activity

through an article in the staff newsletter, and the high participation rate was undoubtedly a direct result of this.

Scope The Department employs 2000 people, of which there are 300 actual library users. There are a further 200 who are potential library users.

The information audit was conducted over the entire organization, but excluded groups such as administrative and clerical staff who were not users of legal research information. This decision was made by the Steering Committee with the guidance of the consultant.

Timeframe The information audit was completed in three months over-all with 4 weeks expended time provided by the consultant.

Resources The information audit was conducted by external consultants and did not use Departmental staff. It was considered important that the audit was conducted by consultants to provide an objective assess-ment of the Department's information needs. Table 10.1 shows the resources employed to complete the audit, and the tasks they were assigned to.

Methodology It was unnecessary to prepare a business case as the information audit resulted from the review that was commissioned by the Director-General. The strategies recommended by the review were

Table 10.1 Resources employed to conduct the information audit

Activity	Nature of Work	Number of Resources
Administration	1. Organize focus group session logistics – participants, timing, venue, catering etc 2. Organize effective distribution and return of electronic survey	1
Subject Specialists (Information and organizational development)	1. Prepare audit documentation for survey and focus groups 2. Conduct focus group sessions	2
Collation (Information subject specialist and administrative)	Collate and integrate responses from focus group and survey into format to facilitate comparison and evaluation	2
Reporting (Information specialist and organization development specialist)	Write and present report	2

endorsed and supported by the Steering Committee. This gave the auditors significant support within the organization to conduct the information audit.

Data was collected using a questionnaire, focus group interviews and personal interviews.

A standard questionnaire was used and 221 responses were received. A range of staff from all levels across all agencies within the Department across a range of geographical locations received the survey which was distributed electronically and supplemented in hard copy for those who did not have electronic access. Everyone was asked the same questions.

Focus group and personal interviews were also conducted. Members of the Steering Committee were invited to submit names of those people they believed would be able to contribute to the information audit. All people whose names were submitted were interviewed and in addition more names were sought by the principal consultant to increase the size of the sample. Everyone was asked the same questions.

The questions formulated for both the survey and the focus groups fell into the 3 traditional groupings as shown in Table 10.2.

Data analysis The collected data were analysed statistically and graphically by the consultant using Excel.

Consideration was given to the following key factors:

● the context of the responses

● the frequency and/or extensiveness of the comments

Table 10.2 Question types used in survey and interviews

Type of Question	Information Sought	How Used
Behavioral	Factual information on what the respondents did, the frequency with which certain actions were carried out, demographics etc	To find out awareness, usage rates, market size etc
Attitudinal	What the respondents thought about certain issues/ activities. Their image and rating of various matters. Why they did certain things.	To find out the image of certain sources/services and to help map existing branding/loyalty
Classification	Information that was used to group respondents to see how they differ from one another.	To differentiate user requirements according to location, level within organization, age etc

- the intensity of the comments
- the internal consistency of the comments
- the specificity/fact base of the response
- the non-verbal communications (focus groups only).

Formulating recommendations Recommendations were formulated by the consultant. The consultant's report of the findings and recommendations of information audit was produced and presented to the Steering Committee. As this was just one phase of a much larger project, business plans and other documentation came later. Six months later the Department instituted a Departmental Library committee, part of whose role in the process of recommending the future direction of the Justice Law Library will be to consider the findings of the Justice Portfolio Libraries Review.

- introduction
- description of project
- project findings
- key themes
- recommendations.

Communication issues All communication was primarily with and through the Steering Committee, although some liaison did occur with the internal project management team. There was no communication back to the survey and interview participants.

Changes implemented as a result of the audit Some policies were changed in the areas of collection development, electronic access and fee for service.

Ancillary benefits There was a significant increase in awareness of the:

- value of information generally
- the access to information currently available
- technology limitations
- current inconsistencies in 'policies'.

Follow-up measures
As part of an ongoing review plan follow-up measures may be implemented in the future, however this has not yet been approved.

Rating the information audit process

Justifying existing services/resources	5
Evaluating existing services/resources	5
Promoting existing services/resources	4
Maintaining current staffing levels	4
Maintaining current funding levels	1
Supporting request for additional funding	2
Supporting request for additional staff	2
Identifying user needs	3
Identifying gaps in service/resource provision	3
Identifying service/resource duplication	2
Supporting restructure of information services	4
Mapping information flows throughout the organization	1
Ensuring that information services support organizational goals	1
Improving efficiency of information services	1
Improving effectiveness of information services	1

Overall outcomes

The information audit vindicated the library's ability to read its client base well. There have been various rumblings since to revisit the findings over the overall review report. Information comes a poor second in the Department at present with the need for a sound computing infrastructure still the corporate priority. However, such are the phases moving that it can be seen that there is scope within the department for the focus to really change on the fundamental information imperatives. The report of the audit will assist ultimately in this library achieving a sounder budget and increased staffing. These would have been so much harder to achieve had it not been for this report being in place and it provided an objective base to determine the current information gaps within the organization.

Case study 3: The Information Inventory Project in an Australian government department (contributed by AIMA Training and Consultancy Services, Canberra, Australia)

Introduction

Organizations that are at the leading edge of their business have well-understood and cohesive information systems. Organizations that aspire to being at the cutting edge of the information economy also pay particular attention to ensuring that these information systems are integrated

into the work practices of the staff, and that information contained in them is reliable and easily accessible.

In Australia, projects requiring government departments to embrace electronic information and electronic service delivery have been set in place. It was intended that this project would provide the department with critical business intelligence about its progress in relation to these initiatives and identify those tasks that still needed to be done.

The Information Inventory Project was an extension of the work that had been undertaken for another information area of the department. It became apparent during that project that there were some department-wide issues that needed to be resolved. These issues affected the ability to access and share information which would lead to a more knowledge-based organization.

A clear understanding of the data and information base of the department was necessary before knowledge management improvements could be achieved – for example, through the use of tools such as a functional thesaurus and the use of metadata applied consistently across departmental information holdings.

Objectives of the information audit

The main aim of the information audit was to assist the department in evaluating its information assets as part of the development of a broader knowledge management strategy. It was intended to assist the department achieve the following outcomes:

- improved sharing of information and knowledge
- a sound basis for knowledge management improvement
- improved business effectiveness through timely access to reliable and relevant information and knowledge
- increased understanding and integration of the department's information and knowledge.

Scope

The project's main objective was to identify the department's information holdings. In addition to this, information in the following areas was to be sought and collated:

- the business and purpose of the information holdings
- who was responsible for the information holdings
- who had access to the information holdings
- on which systems the information holdings ran

- what maintenance was required

- how the information and data were stored

- what links there were from the information holdings to other data and information sources

- what links there should be to other data and information sources

- what software and hardware were required to run the information holdings.

Methodology

At the commencement of the project it was anticipated that the desired outcomes and the implementation of future knowledge management strategies could be achieved in three phases, with the first phase being an information audit. The objectives of the audit were to compile the information inventory, map relationships and report on governance, gaps and strategic information management issues.

The following outputs were created in phase one:

- an inventory of information holdings used and held by the department. The inventory included:

 - information sources

 - information use

 - information link

- an assessment report of the department's information assets as part of the development of its knowledge management strategy.

The consultants worked in partnership with the departmental staff on this project. Data collection, collation and analysis activities were undertaken:

- staff with responsibility for data and information holdings were interviewed

- all of the department's business systems were identified and analysed to ensure full coverage for the inventory

- a draft inventory was prepared for validation across the organization

- a final inventory was prepared.

Data collection – the interviews The focus of the interviews was on business processes and the identification of the information sources that were important to the business. All information in all formats was considered

and an attempt was made to identify the links between holdings and the information flowing in and out of the organization. In many cases the detailed supplementary data such as the volume of the information and associated technology were not collected as the information was not readily available.

<u>Data analysis – compiling the information inventory</u> The information inventory was compiled as a spreadsheet using Microsoft Excel. Simple, common-use technology was used as an interim strategy to support ready access, and easy loading of the information into more sophisticated knowledge-based tools.

To support the validation of the information collected, the entries in the spreadsheet were linked to a database and then published in HTML format to present the information in a form suitable for easy viewing for validation.

Interpreting the information in the inventory

Functional keywords were assigned to each entry to group and manage the information in the inventory as it was compiled. This assignment of high-level business function terms enabled like information holdings to be grouped together, and alleviated problems with information holdings that spanned organizational boundaries, or information holdings that were managed totally or partially by external service providers.

Results

The information inventory was a detailed source of information compiled to provide management with a better understanding of what information the department held and the issues associated with managing that information. The analysis and recommendations from this project were to be fed into the development of the department's knowledge management strategy. The information itself was summarized in a number of information maps to provide different perspectives and an overview of the department's information assets. An analysis of the information maps provided opportunities to identify information use, links and management.

The information inventory was examined in three main ways:

1. Summary of information holdings by business function

2. Business use of information

3. Integration of information holdings.

Inefficient use of information and knowledge in organizations
Davenport and Prusak (1997) highlight three factors that cause knowledge markets to operate inefficiently:

1. Incompleteness of information

2. Asymmetry of information

3. Localness of knowledge.

Incompleteness of information Much of the interest in knowledge management has sprung from the realization that organizations do not know where to find information. The scenario described above, where individuals surrounded themselves with limited information sources, provided an example where there was the potential for staff to have insufficient access to information to make appropriate decisions in a highly competitive, rapidly changing business-oriented environment. There was much information in the department that could readily be at hand if only the appropriate tools and management regime were in place. In many cases staff simply did not know of the existence of information that could have helped them.

Asymmetry of information As discussed above it was important that the information available to staff was well balanced to support informed decision-making. An information sharing culture needed to be established and appropriate systems and tools provided to support the flow of information to areas where information was scarce. The analysis and linking of information through the use of knowledge management tools would enable the balance between 'hard' and 'soft' information to be addressed.

Localness of knowledge The cultural and technological barriers that restricted the sharing of information, and thus an increase in knowledge, meant that staff perceived that there was a high 'cost' to themselves in going in search of the information and knowledge that would assist them in their work. In this environment staff would adapt to survive on less than adequate information for their business purposes. They would make adequate decisions and develop reasonable policy but they would not excel; nor would they help the organization to achieve its goals of excellence and best practice. Staff who were reliant on their 'ten latest registry files' were operating in 'local mode' and were not drawing on, or contributing to, the knowledge base of the organization.

Issues raised during the compilation of the information inventory

The compilation of the information inventory was based on a series of interviews with various staff in each of the department's major business units. During those interviews a number of issues were raised that related to the department's current and future information and knowledge

management requirements. These issues were discussed under the following headings:

1. Governance

2. Electronic document management

3. Information access and retrieval

4. Record-keeping and access

5. Information and knowledge management

6. Information management tools and infrastructure.

Conclusion and recommendations

The compilation of the information inventory provided a good overview of the department's information holdings and was a valuable tool for informing interested parties about the range and focus of the organization's information. The inventory also provided a valuable source of information for analysis.

The utilization of the information inventory as an information source had already begun with the development of the department's IT Strategic Investment Plan. The next step in developing the department's information and knowledge management strategy should contain the following principal elements:

● the development of a definition of knowledge management that is appropriate to the organization and its business, and the development of a set of knowledge management principles that establishes a knowledge management infrastructure for the department. The infrastructure should integrate existing records and information management initiatives into a single, cohesive strategy

● the development of a functional thesaurus and a function-based records disposal authority to support the effective management and access of electronic records and information over time

● the investigation of the capabilities of knowledge management software that could be integrated into the current office software environment. The results of the investigation would assist in the formulation of requirements for the department's knowledge management tool set.

As well as the inventory itself, the compilation of the inventory revealed a number of issues related to record-keeping, information management and knowledge management.

References

Davenport, T.H. and Prusak, L. (1997) *Working knowledge: how organizations manage what they know.* Harvard Business School Press

Extracts from the research

Introduction

The research on which this section is based was conducted in partial fulfilment of the Master of Business (Information Technology) degree at RMIT University in Melbourne, Australia. The research was entitled *Evaluating the effectiveness of an information audit in a corporate environment* and was conducted in 1997 in two parts. The first part was a survey of information professionals who had conducted information audits in their organizations. The second part was a survey of consultants who conducted information audits on behalf of organizations. Comparisons were made between the findings of both parts and conclusions were drawn. This Appendix contains the two parts as separate extracts.

Objectives of the study

The objective of the research was to examine the effectiveness of an information audit as a means of matching information services to user needs in a corporate environment, and as a means of raising the strategic position of a corporate information unit within its organization. The key research questions to be answered were:

- does a relationship exist between the conduct of an information audit and an improvement in the matching of an information service to user needs? For example, did the information audit result in changes to existing services? Were new services introduced or existing services discontinued as a result of the audit?

- does the conducting of an information audit result in a corporate information unit having a more strategic role within the organization?

Part One: Information professionals

Details of the data and analysis that relate to information professionals have been extracted from the research for inclusion in this section. It has been included here as I feel it gives a level of insight into how a selection of information professionals within organizations have used the information audit process, and the types of results that they have achieved by conducting the information audit using in-house resources, or by managing the process themselves and partially outsourcing selected tasks.

Methodology

The study investigated the reasons why an information audit was conducted, the process used and the outcomes of information audits recently conducted by information professionals in corporate information units in Australia and overseas. The data extracted from the research for inclusion in this section relate to the information audits that were conducted by information professionals within organizations using in-house resources or the services of external consultants for selected components of the process.

Selection of participants For the purposes of the study survey participants were sought from information professionals who had conducted an information audit within their organization, both locally and overseas. The review of the literature on the information audit concept and process indicates that both the concept and its relationship to the development of information policy and information resources management (IRM) are relatively new to Australian libraries. The literature reflects a growing awareness of the concept in the USA and Canada, while most of the practical utilization of the process appears to have been in the UK. For this reason it was decided not to restrict the study to local participants and to include corporate information professionals in the USA and the UK that have conducted information audits.

Three methods were used to locate corporate information professionals that had conducted an information audit in their organizations in Australia. First, potential local participants were contacted using details from a listing of delegates who attended an Information Audit Seminar conducted by Guy St. Clair in Melbourne in May 1996. Second, a message was posted to four Australian Library and Information Association (ALIA) listservs and third, personal contacts were approached.

Overseas information professionals were located using the Special Libraries Association (SLA) listservs and personal contacts.

Potential participants were contacted in order to ascertain whether they had conducted an information audit and whether they were interested in participating in the study.

The messages posted to listservs resulted in an enormous number of requests for more information about the information audit process and how it could be applied to specific organizations. Responses ranged from simple questions such as 'What is an information audit?' and 'How could I use this process in my organization?' to requests for copies of the survey results in order to determine whether or not the time and cost involved in conducting an information audit could be justified.

Information professionals were selected according to the following criteria:

- they had conducted an information audit within their organization within the last 12–18 months

- they were willing to complete a questionnaire and be interviewed about the process they used and its outcomes.

Two Australian participants and two UK participants were selected. Their profiles are detailed in Table A.1.

Data collection

Instrument design Questionnaires were designed for the information professionals using a combination of open and closed questions to provide the data necessary to answer the key research questions (Jackson, 1993).

Each questionnaire was divided into four sections. Section One consisted of general questions about the organization, why they decided to conduct an information audit and why they chose the information audit process over other methodologies. It contained questions about whether they had an information policy and if the information audit was conducted as part of a larger information resources management strategy. Section

Table A.1 Profiles of selected information professional participants

Participant	A	B	C	D
Location	Australia	Australia	UK	UK
Type	Special (Medical)	Special (Government)	Special (Government)	Special (Business)
Employees in Organization	800	2500	6000	450
Information Unit users – actual	100	1000	Unknown	Unknown
Information unit users – potential	700	2500	6000	450

Two consisted of questions relating to the information audit process used and the scope of the audit. Section Three consisted of questions that related to how the data was analysed and how helpful it was in identifying the need for changes to existing services. Section Four related to the outcomes of the information audit process, including whether the information audit resulted in changes to existing services or an increase in business for the library. Section Four also included an attitudinal question whereby participants could rate the information audit process as a means of achieving various objectives on a scale from zero to five.

Pilot test It was decided that a pilot test of the questionnaires was necessary to ensure that all questions were relevant and that the questionnaires were comprehensive in their coverage of all possible variables. Guy St. Clair kindly agreed to pilot test the questionnaire designed for the library participants. His only recommendation was that one question that dealt with two separate issues should be split into two separate questions in order to provide more concise responses.

Data analysis

The data collected for this study were analysed manually. Master sheets were prepared to consolidate the replies and these were used as the basis for analysis. By using interpretational analysis as suggested by Gall, Borg and Gall (1996) themes and patterns were identified in the responses and reflective analysis related these themes and patterns back to the process used and the original objectives of survey participants.

By examining the scope of the information audits that were conducted, how the process was modified and the outcomes, judgements could be made as to the usefulness of the information audit process in increasing the relevance of an information service within an organization. The data collected also allowed the examination of subsidiary benefits of the information audit process such as marketing and promotion, benefits for the information professionals themselves and the development of information management policies. The survey data was analysed in three sections:

1. The purpose of conducting the information audit

2. The information audit process used

3. Evaluation of the process by the participants.

The purpose of conducting the information audit The literature suggests that an information audit conducted with management support can enhance an information service within an organization. It can achieve this by matching services to needs, identifying duplications and gaps in information resources, mapping formal and informal flows of information that

would otherwise be disregarded and by ensuring that the information professional is seen as a key player in the achievement of the strategic objectives of the organization.

Survey participants were asked why they conducted the information audit. Their reasons were varied but in all cases were focused on improving services, facilitating access to resources and enabling planning for future needs. This involved being able to determine which services and resources were being used, how they were being used and by whom. It also involved being able to detect gaps and duplications in existing services and resources.

Participant A's information unit was moving to a new site and they recognized this as an opportunity to restructure an information service that had been neglected for more than ten years. The Librarian felt that the current service was antiquated and out of touch with staff needs and consequently collection usage was low. The library had also suffered a high theft rate due to the lack of security and staffing so many key resources needed to be replaced. Information unit staff saw the information audit as a process that would help them to identify those resources and services that were important to their organization, and enable them to redesign a new information service at their new location. When asked what their expectations were of the process and what outcomes they anticipated, they responded that they had no expectations. This could be explained by the fact that the service had been neglected for so long and the staff were so out of touch with the organization's information needs that the results of the information audit could not be anticipated. This could be explained further by the fact that although the process is widely promoted in the literature there are very few evaluative works that discuss real outcomes and results of the process.

Participant B conducted the information audit in order to facilitate planning for the future and to evaluate staffing needs. The information unit was already servicing a relatively large percentage (40 per cent) of its potential clientele but was operating with limited staffing and resources. It was positioned within a state government department and a level of forward planning was mandatory. It was anticipated that the information audit process would enable them to prepare plans for developing future resources and services that would form the basis for future staff planning. When asked about expectations and outcomes of the process, this participant responded that they hoped to be able to determine customer requirements and also to anticipate the future direction of these requirements.

Participant C conducted the information audit following the installation of an automated computer system that was designed to facilitate the sharing of information between divisions of the organization. The audit was conducted to identify which information resources were held and to determine how the new technology could be used to facilitate the sharing

of the information resources. The participant used the audit to identify how the current resources were stored, shared, retrieved and circulated throughout the organization in order to evaluate how the new technology could be used to facilitate these functions. When asked what were their expectations of the process and outcomes their response indicated that they had high expectations of the process and anticipated results that would enable current and future planning. These included an improvement in the way divisions use information, the identification of under-utilized information and gaps in information provision. They antic-ipated that the results of the audit would enable them to identify training needs, facilitate the sharing of information throughout the organization and contribute to the shaping of other projects such as intranet studies.

Participant D conducted the information audit to identify information resources held by staff within the organization and to determine the staff's information needs. It was anticipated that the audit process would open up communication channels both within departments and between depart-ments to facilitate the flows of information throughout the organization. Their expectations of the process were that it would enable information needs to be determined and identify information resources within the orga-nization. Their anticipated outcomes included the increased sharing of information across departments and an improvement in the ability to manage information needs and resources.

Participants chose to use the information audit process rather than other methodologies because of its scope and its acceptability as a management tool. Participants indicated that they consider the information audit process to be flexible and thorough. It can be designed to encompass the entire organization, or can be restricted to specific parts of the organization. The process can be modified to suit the human and financial resources that are available and can be conducted using in-house resources, outsourced to consultants or a combination of both.

Responses to this question also indicated that the information audit process is considered to be an extension of the needs analysis method-ology. One participant responded that they incorporated a needs analysis as part of their information audit process.

The literature refers to the information audit process as a recognized library management methodology because of its links with information resource management and strategic information management. This was the main reason for participant B choosing the process as it ensured that the information manager was seen to be using accepted manage-ment tools and was making an effort to align the practices of the corpo-rate information unit with those of other managerial activities within the organization.

The information audit is also promoted in the literature as being an inte-gral component of information policy development. The results of this study indicate that regardless of whether a library has an information

policy prior to conducting the audit, the audit does influence the development of an information policy for the organization.

Participants A and C did not conduct their information audits as part of a larger IRM strategy. Participant A did not have an information policy and the information audit did not result in changes to this situation. Participant C began with a formal information policy and as a result of the information audit, updated their formal information policy to suit the current information needs of the organization.

Participants B and D conducted their information audits within the framework of the development of a larger information resources strategy. Library B began with an informal information policy and as a result of the information audit developed a formal information policy. Library D began with no information policy and developed a formal information policy by analysing data collected from the information audit.

The research has shown that the information audit process resulted in an increase in the level of information policy development, regardless of whether it was conducted as part of a larger IRM strategy or not (Figure A.1).

The information audit process used Participants were asked questions that related to the length of time it took to complete their information audit, the scope of the audit within their organization and whether the audit was conducted using in-house staff, external consultants or a combination of both. Participants were also questioned regarding the components of the process that they used, how they analysed their data and results of their information audits.

<u>Timeframe</u> The review of the literature did not find any works that discuss the information audit process in terms of an expected or optimum

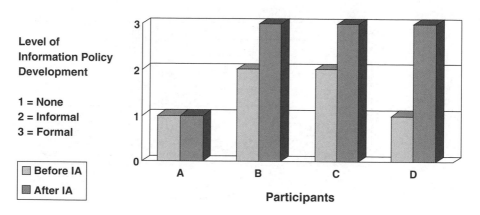

Figure A.1 Information policy development as a result of the information audit process

timeframe for its completion. There are many variables that could affect the time required to prepare for and complete an information audit, including the availability of both human and financial resources, the size and structure of the organization and the changing environment within the organization.

When asked how long it took to complete the information audit process the responses from the participants ranged from 1–3 months to longer than six months. Three of the four participants took longer than six months to complete the process with one taking two years due to an organizational restructure which occurred at the same time.

Participant B responded that it took them 1–3 months to complete the process using information unit staff to survey 80 people across an organization having a total of 2500 employees. They formed focus groups and conducted structured personal interviews.

Participants A and D took six months or longer to complete the information audit process. Both targeted selected departments within their organizations with participant A using information unit staff and participant D using a consultant who was a former employee of the organization.

Participant A surveyed 29 employees out of a total of 800. They surveyed both users and non-users of the information unit. They did not form focus groups as part of the information audit process, but did conduct structured personal interviews.

Participant D surveyed 450 employees, which was the total number of employees in the organization. All employees were surveyed regardless of whether or not they were users of the information unit as it was considered that all employees were potential information users. They did not form focus groups as part of the information audit process, but did conduct structured personal interviews.

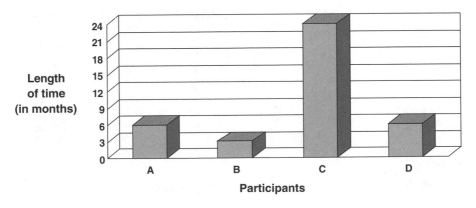

Figure A.2 Length of time taken by participants to complete the information audit process

Participant C took longer than two years to complete the information audit process. They used a consultant to manage the project and conducted the information audit using information unit staff. The process covered the entire organization and 15–20 per cent of staff were surveyed regardless of whether they were users or non-users of the information unit. They formed focus groups as part of the information audit process, and conducted structured personal interviews.

The research shows that there is no relationship between the time taken to complete the information audit and the components included in the process undertaken by the participants (Figure A.2).

<u>Scope</u> The review of the literature found many works that discussed the fact that the information audit process could be modified to suit the structure of an organization. Many discussed the fact that an information audit could be conducted across an entire organization or could be restricted to specific departments or sections of the organization. However, no works were found that described an optimum approach for specific types of organizations or for organizations of a specific size or structure.

Two participants responded that they conducted the information audit throughout the entire organization, while two participants responded that they restricted the information audit to specific departments or sections of the organization.

Participant A restricted the information audit to those departments that were seen as key users or potential users of the information service. They excluded departments such as Human Resources and Information Technology who were not considered to be key users or potential users of the information service.

Participant D is part of an organization that has 450 employees and over 110 000 members. They conducted the information audit throughout their entire organization, but excluded external members. They therefore considered that they had excluded sections of their organization and responded to the questionnaire accordingly.

The research shows that there is no relationship between the scope of the information audit conducted and the rating of the information audit process as a means of achieving specific objectives.

The research also shows that there is no relationship between the scope of the information audit conducted and the timeframe taken for its completion.

<u>Who conducted the information audit?</u> The review of the literature found many works that discuss the benefits of using either in-house staff or consultants to conduct the information audit. It also found works that discussed the benefits of using a combination of both in-house staff and consultants.

Participants A and B used internal staff to conduct their information audit. All staff used were library staff. This situation allows in-house staff

to broaden their knowledge-base about the organization and develop skills in areas such as interviewing techniques, the preparation of survey questionnaires, data analysis and report presentation. It also gives them the opportunity to communicate with employees throughout the organization which increases their visibility and may raise their profile within the organization. The disadvantages of using in-house staff are cited in the literature as being a lack of objectivity and a lack of skills in survey design and preparation, interviewing and reporting. Another disadvantage is the fact that unless extra staff are recruited for the project, then routine tasks and other responsibilities may be neglected during the audit process.

The literature cites one of the disadvantages of choosing a consultant over in-house staff as being the consultant's relative lack of knowledge of the organization. Although participant D used a consultant to conduct the information audit the consultant had formerly been employed on a temporary basis by the organization and was considered to have a good knowledge of the organization.

Participant C used a combination of both internal staff and a consultant. A consultant was brought into the organization to manage the information audit process with the use of internal staff to assist with preliminary research, interviews and the preparation of reports. This decision was made as it was felt that the organization did not have sufficient expertise in-house to conduct the information audit successfully. This situation benefits in-house staff by allowing them to become involved in the process and build on their knowledge-base and skills whilst incorporating the objectivity and professional auditing skills of the consultant.

The research indicated that there is no relationship between whether the information audit was conducted using in-house staff or by consultants and the rating of the information audit process as a means of achieving specific objectives, from the libraries' perspective. The consultants, however, rate the information audit process as a means of achieving specific objectives consistently higher than did the libraries. This shows that they regarded the information audit process as an excellent means of achieving most of the objectives listed. This could be due to a number of factors including their experience in using the information audit process and their skills in questionnaire design, interviewing techniques and data analysis. It could also be due to the higher levels of objectivity that enable them to visualize the potential for an information service.

Components of the information audit process The literature cites the three standard components of the data collection stage of the information audit process as being the user survey using a written questionnaire, the formation of focus groups and the holding of personal interviews. Many works discuss the flexibility of the information audit process and the fact that any combination of these three components can be used effectively.

The literature presents the user survey using a written questionnaire as one of the standard components of the information audit process, although it does not discuss whether the sampling method of survey research or the census method of survey research should be used in the context of the information audit process. All participants included a user survey as the initial component of their information audit and surveyed both library users and non-users.

Participants A, B and C chose to survey a sample of the total employees in their organizations. Participant A surveyed 29 employees out of a total of 800, which equates to just less than 4 per cent of potential library users. Participant B surveyed 80 out of a total of 2500, which also equates to just less than 4 per cent of potential library users. Participant C surveyed 15–20 per cent of the total employees in their organization. Participant D included all employees in their organization in the survey and therefore surveyed 450 employees.

Participants A, C and D used a standard questionnaire while participant B varied the questions according to the focus of the specific departments.

The literature discusses the effectiveness of the use of survey questionnaires for large or geographically diverse groups and when data are to be collected on 'sensitive' issues. This makes their use ideal for both centralized and decentralized organizations, and when collecting data from those who support and use the organizations information services as well as those who regard them negatively.

Although the literature discusses the use of focus groups as a standard component of the information audit process, only two out of the four libraries responded that they used focus groups. Only one consultant participant responded that they routinely use focus groups in their information audit process.

Participants A and D did not use focus groups as a component of their information audit processes while participants B and C did. Library B formed groups from representatives of core business and geographically diverse locations. Participant C formed focus groups from those whose jobs involved a high level of information handling. Participant C used focus groups when time was an issue and when the nature of the department was in some way non-standard such that the questions in the standard questionnaire were less relevant.

The work of Widdows, Hensler and Wyncott (1991) found that the use of focus groups can lead to issues being raised that were important to group members but had not been considered by the interviewers. This will result in the generation of data that might not have been gleaned otherwise. Connaway, Johnson and Searing (1997, p.405) support this view when they discuss the use of focus group interviews in a library context and describe it as 'an evaluation and research technique that allows the interviewees an opportunity to comment, explain and share experiences and attitudes. It permits the assessment of non-verbal responses and by

enabling free-flowing discussion can provide in-depth feedback on issues and ideas.' Focus groups can be used as part of the information audit process to allow the in-depth probing of interviewees' responses, which may uncover more detail about expectations, attitudes and behaviours. They can also be used to acquire data on aspects of information usage and other related issues that may not have been considered when preparing survey and interview questionnaires.

Additional benefits of focus group research are that it is relatively inexpensive and can be carried out quickly. Participant C listed the time factor as a reason for the inclusion of focus groups in their information audit process.

Focus group research is reported in the literature to be more effective when group members have common interests and attitudes and therefore can be of considerable benefit when dealing with groups with particular needs or specialist skills. Both participants B and C used focus groups to deal with groups whose needs were either non-standard or specialized.

Focus group research is reported in the literature to be an appropriate method of supplementing survey data. All participants used surveys as a component of their information audit process, yet not all felt it was necessary to supplement the survey data by forming focus groups.

Despite the documented advantages of using focus groups, the research has shown that they are not always used as a component of the information audit process. The decision not to use focus groups could be due to such factors as the difficulties involved in documenting and analysing the responses. Whether a qualitative approach such as an ethnographic summary or a content analysis approach is used to analyse the data there can still be difficulties in categorizing and classifying the data.

The review of the literature found many works that discuss the use of personal interviews as a vital component of the information audit process. Its value lies in the fact that in-depth data can be collected that will supplement the data collected in the user surveys.

All participants used personal interviews as a component of their information audit process and structured interview sheets for their personal interviews. The literature suggests that by using structured interview sheets the value of the data collected by this method is increased due to a greater level of comparability as well as an increased level of consistency when more than one interviewer is used. It also suggests that the use of structured interview sheets requires fewer interviewing skills on the part of the interviewer.

The research has shown that there are many ways in which the information audit process could be varied according to the needs and objectives of the organization and the resources available. Decisions were made as to the appropriateness of each component based on the specific objectives of those managing the project.

No conclusions can be drawn concerning the optimum combination of components for specific types of organizations, the ideal scope or by whom it should be conducted.

The works of Booth (1994) and Booth and Haines (1993) discuss the use of software for analysing survey results and the difficulties of processing a mixture of free text and coded responses but fall short of providing a detailed plan for the analysis. Kumar (1996) and Leedy (1997) are among many who discuss the various methods for analysing both quantitative and qualitative data in a general context.

The research has shown that all the information audits resulted in both qualitative and quantitative data collected by various methods including structured and unstructured questionnaires, focus group interviews and structured and unstructured personal interviews.

Participants were asked questions relating to how they processed and analysed their survey and interview data. All of the participants processed their information audit data in-house. It is not known whether they processed the data manually or by using computer programs.

The evaluation of the process by the participants The participants were asked to rate how helpful the collected data were in identifying the need for a modification of existing services, the cessation of existing services or the development of new services. They were asked to rate these points using an attitudinal scale that ranged from zero (not at all) to five (completely).

When asked how helpful the data was in identifying the need for the modification of existing services, i.e. the changes needed to improve efficiency and effectiveness of current resources and services, the responses of the participants ranged from three (average) to five (very high) with two participants rating it as four (high) (Figure A.3). Participant A rated it as 'very high' at five, as the audit had provided the opportunity to redevelop the library's services, and they had conducted the information audit with no real expectations of what the outcome might be of the information audit process. Participants B and D rated it as 'high' at four. They both conducted the information audit with specific expectations regarding its ability to assist in the identification of information needs and expected that it would facilitate the planning of future information services and staffing. Participant C rated it as 'medium' at three. This participant had the highest expectation of the information audit process and the most specific criteria to address when rating the process. Although they aimed to identify under-utilized information sources and identify gaps in information provision, they were focused more on the sharing of information using new technology than the modification of information unit services.

When asked how helpful the data were in identifying the need for the cessation of existing services, i.e. low demand for existing services or services without strategic significance, all participants rated it as low with

responses ranging from zero (not at all) to three (average) (Figure A.3). Participant A rated this 'not at all' at zero and rated the other two options – modification of existing services and development of new services – as 'very high' at five. Since this library had been neglected for some years and was embarking upon a programme of redevelopment it may be safe to assume that any services or resources that were not being used had already been discontinued. Similarly, with the other participants also rating this option as comparatively low it may be an indication that under-utilized services or resources have previously been identified by other means and discontinued and that all remaining services have been identified as viable. This response could also be due to a lack of objectivity on the part of the libraries. Many existing services are those that have been traditionally associated with corporate information units and there is often a reluctance to discontinue services that are perceived as integral to a corporate information service.

When asked how helpful the data were in identifying the need for the development of new services, i.e. some identified needs were not being met by existing services or resources, the responses of the participants ranged from three (average) to five (very high) with two participants rating it as four (high) (Figure A.3). This result would indicate that the process facilitated the identification of gaps in information provision and identified where there was a need for new services.

Reporting the results of the information audit process

The review of the literature found many works that discuss the importance of reporting formally the results of the audit both to those who participated in the process and to those in management who supported the process.

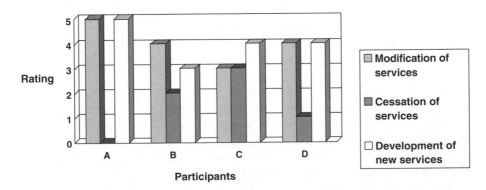

Figure A.3 How helpful the data was in identifying the need to change existing services

All participants responded that their information audits resulted in the preparation of a written report. The reports produced ranged from general strategy documents that were presented to management to individual reports produced for specific departments detailing how their information use could be improved. In some cases audit participants were contacted by those who conducted the information audit, while in other cases the reports were disseminated to staff by managers.

Participant A produced a summary of responses which was not distributed but which formed the basis for documents such as a journal review, an upgrade brief, a review of centralization policy and recommended purchases. Participants B, C and D produced strategy documents with participant D including an assessment of business risks if the recommendations were not implemented. Participant C also produced reports for individual divisions as well as consolidated reports focusing on information management strategy formation.

The research has shown that the production of a written report or reports is a standard outcome of the information audit process. Some participants produced only one report, while others produced reports that were specifically aimed at key sections of their organizations. It has shown that these reports can be used as a basis for further reports that discuss changes in services or the introduction of new services, or as a basis for decision-making in areas such as collection development and policy review.

The research has also shown that regardless of the time taken to conduct an information audit, its scope and which components of the process are used, it is an efficient way of identifying those services that need to be changed and where new services need to be developed. It is also useful for identifying those services for which there is a low demand or that do not have strategic significance. The information audit process used by an organization can therefore be varied to suit the resources and time available and still achieve its objectives.

Participants A, C and D responded that they modified existing services as a result of conducting the information audit. Many of the modifications related to the introduction of new technology or the development of existing technology. Examples included improved database access, automated loans and access to services via the corporate intranet. Other modifications included the redesign of a collection development policy, introduction of after-hours access, increased professional staffing and the introduction of loans of audio-visual material.

Participant C indicated that the audit resulted in a reorganization of divisional contacts within the information unit so that the expertise matched better the needs of the client.

Participant C responded that a service was discontinued as a result of conducting the information audit. The audit identified that the particular service was not meeting the needs of the group for which it had been developed, and therefore the decision was made to discontinue it.

Participants A, C and D indicated that they developed new services as a result of conducting the information audit. New services included the development of user education and orientation programmes, the introduction of a weekly bulletin, the development of a web site and the introduction of electronic books and journals.

The research has shown that the results of the information audit were used by the information units to modify existing services to match them more closely to the needs of the organization, to discontinue existing services where they were no longer needed or where they did not support organizational objectives and introduce new services where a need was identified.

Participant A indicated that statistics will be kept to measure the impact of the changes and a follow-up audit is planned to monitor the effect of any changes. Participant C indicated that six-monthly feedback sessions are planned to monitor the effect of the changes to services.

The research results have shown that the information audit is an effective method of matching the information services to the needs of the organization. This was supported by the fact that the results enabled the identification of services that needed to be modified or discontinued as well as areas where new services needed to be introduced.

Rating the information audit process as a means of achieving various objectives

All participants were asked to rate the information audit process on specific objectives to determine the effectiveness of the information audit process as a means of matching information services and resources to users' needs, and as a means of aligning the information services to the objectives of the organization. These objectives were:

- justifying, evaluating and promoting existing services and resources
- maintaining current staffing and funding levels and supporting requests for additional funding and staffing
- identifying user needs
- identifying gaps and duplications in the provision of services and resources
- mapping information flows throughout the organization
- ensuring that information services support organizational goals, raising the profile of information as a strategic asset and linking information to management processes
- supporting the restructure of information services
- improving the efficiency and effectiveness of information services.

Participants were asked to rate the effectiveness of the information audit process as a means of achieving these objectives using a scale of zero (not at all) to five (completely).

When responding to these questions, participants B and D rated all objectives as 'average' at three, which indicated that they consider the information audit process to be an average means of achieving all of the objectives listed. It also indicated that they did not consider the process to be exceptionally effective or ineffective at achieving any specific objective. Participants A and C varied their ratings between 'not at all' at zero and 'very high' at five, often giving very different ratings for specific objectives.

Justifying, evaluating and promoting existing services and resources
When asked to rate the information audit process as a means of justifying existing services and resources participants A, B, and D rated it at three or higher. Participant C rated it as 'very low' at one. This can possibly be explained by the fact that participant C conducted the audit to evaluate a new automated information system and therefore justifying existing services and resources was not an important consideration. Participants A, B and D used the audit process to match information needs with information resources and services, and therefore needed to determine whether or not the existing services were relevant to their users' needs.

These results indicate that the participants considered the information audit process to be an effective means of justifying existing information resources and services (Figure A.4).

When asked to rate the information audit process as a means of evaluating existing information services and resources all four participants rated it as 'average' at 3 or higher, with participant A rating it at five.

These results indicate that the participants considered the information audit process to be an effective means of evaluating existing resources and services (Figure A.4).

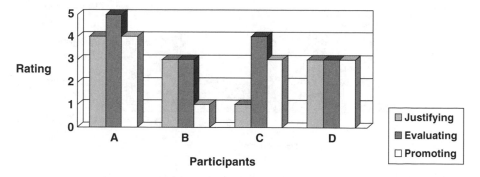

Figure A.4 Rating the information audit process as a means of justifying, evaluating and promoting information services and resources

When asked to rate the information audit process as a means of promoting existing information services and resources participants A, B and D rated it as 'average' at three or higher, while the participant C rated it at one (Figure A.4). The low rating by participant C could be due to the fact that they did not regard the information audit process as an exercise in promotion, whereas the other participants found that this happened without them anticipating it.

The literature suggests that the information audit process is an effective marketing tool as it provides the information professional with the opportunity to discuss the resources and services with both users and non-users within an organization.

These results indicate that the participants considered the information audit process to be an effective means of promoting existing resources and services. None of the participants mentioned the promotion of information services as one of the major objectives, yet three of them rated the information audit process highly as an effective means of promoting information services.

Maintaining current staffing and funding levels and supporting requests for additional staff and funding (Figure A.5). Three of the four participants rated these four points equally, with participants B and D both rating them all as 'average' at three. Participant C rated them all as 'very low' at one which could be due to the differing nature of their information audit. Participant A rated the maintenance of current staffing levels and funding as 'not at all' at zero and rated the support for requests for additional staff and funding as 'very high' at five. This participant was from an information unit that has been understaffed for a long period of time, and one of their main objectives in conducting the information audit was to request additional staff and funding to enable a restructure of information services. Participants B and D both belong to organizations that could possibly

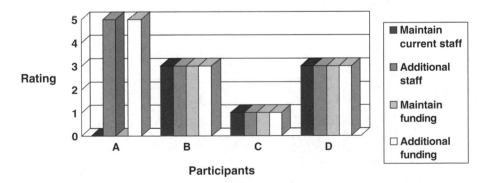

Figure A.5 Rating the information audit process as a means of maintaining current staffing and funding levels, and supporting requests for additional staff and funding

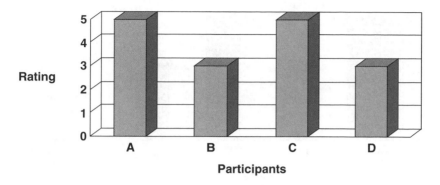

Figure A.6 Rating the information audit process as a means of identifying user needs

downsize or restructure and may be called upon to justify their existing staffing and funding levels. They therefore rated it more highly at three.

Identifying user needs Identifying the needs of users is one of the major features of the information audit process that is discussed in the literature and was an objective of all four participants prior to conducting their audits. It was vital for participant A to be able to identify its users needs prior to the development of new services and the restructure of information services. It was also vital for participant C to identify which information and resources needed to be available to the employees via their new automated system. This feature was rated very highly at five by both of these participants. Participants B and D rated this feature as 'average' at three.

The results indicate that the information audit process is an effective means of identifying user needs (Figure A.6).

Identifying gaps and duplications in the provision of services and resources When asked how they rated the information audit process as a means of identifying gaps and duplications in resources and service provision both participants A and C rated this feature very highly at five. Participants B and D rated this feature as 'average' at three.

These results indicate that the information audit process is an effective means of identifying gaps and duplications in information service provision (Figure A.7).

Mapping information flows throughout the organization The mapping of information flows both within the organization and to and from external sources is discussed in the literature as a major benefit of the information audit methodology. When asked to rate the information audit process as a means of mapping information flows throughout the

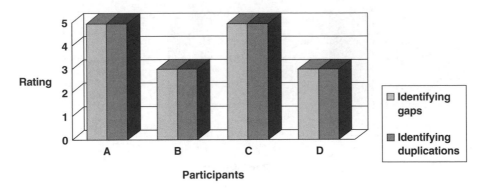

Figure A.7 Rating the information audit process as a means of identifying gaps and duplications in information services and resources

organization all participants rated this feature as 'average' at three. According to their stated expectations and anticipated outcomes the mapping of information flows was not a major objective for any of the four participants.

Ensuring that information supports organizational goals, raisng the profile of information as a strategic asset and linking information to management processes (Figure A.8). When asked to rate the information audit process as a means of ensuring that information supports organizational goals both participants A and C rated this very highly at five. Participant A had the opportunity to restructure the information services and develop new services, and therefore had the opportunity to align information services with organizational objectives. Participant C reported that it was bringing all of the corporate information resources together in an automated system, and therefore could prioritize resources according to their alignment with organizational objectives. Participants B and D were able to use the data produced as a result of the information audit process to identify resources and services that supported organizational goals, but had limited opportunity to restructure existing services and develop new services.

Variations in the responses to this feature could possibly relate to the clarity of organizational goals within each organization. If the organizational goals are unclear, or even unstated, then the alignment of information resources and services is not possible.

When asked to rate the information audit process as a means of raising the profile of information as a strategic asset participant A rated this feature highly at four. Participants B, C and D rated it as 'average' at three. The complete restructure of the information services of participant A enabled them to use the information audit as a marketing tool to promote the importance of information to the organization and to demonstrate how it

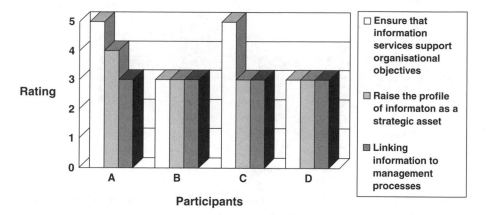

Figure A.8 Rating the information audit process as a means of ensuring that information services

contributed to its success. Once again, the objectives of the organization must be clearly understood for the strategic value of information resources and services to be recognized.

When asked to rate the information audit process as a means of linking the information in an organization to management processes, all participants rated this feature as 'average'at three.

The understanding of management processes within the organization is vital to the rating of this feature. These processes are often unclear and inconsistent so the effectiveness of the information audit process as a means of linking information to management processes will depend on the situation within each organization.

Supporting the restructure of information services When asked to rate the information audit process as a means of supporting the restructure of information services responses ranged from 'average' at three to 'very high' at five with participants B and D rating this feature as 'average' at three. Participant A rated this 'high' at four, and participant C rated it 'very high' at five.

Participants A and C had the opportunity to restructure their information services. While participant A was able to develop a new information service based on identified needs, participant C was able to use the information audit to determine how the new automated system would be used within their organization. They found the information audit process to be an effective means of supporting the restructure of information services (Figure A.9).

Improving the efficiency and effectiveness of information services When asked to rate the information audit process as a means of improving the efficiency and effectiveness of information services responses ranged

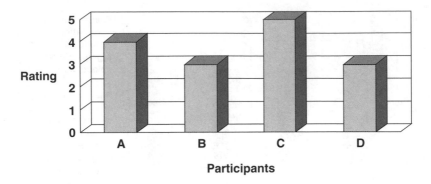

Figure A.9 Rating the information audit process as a means of supporting the restructure of information services

from 'below average' at two to a 'very high' five with participants B and D rating this feature as 'average' at three.

It is interesting that all participants chose to rate these two features equally. This could be due to the fact that they consider the terms to be synonymous, or that they consider that one always matches the other (Figure A.10).

Overall satisfaction with the information audit process

The overall satisfaction with the information audit process was based on how well it assisted the participants in achieving their original objectives.

Participant A responded that it more than achieved their original objectives. Their budget was increased by 30 per cent with a possible further increase of 25 per cent. There is increased support from a Library Sub-committee. The current information needs of their organization have been

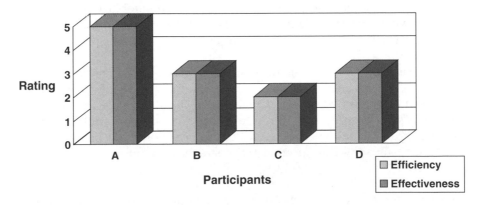

Figure A.10 Rating the information audit process as a means of improving the efficiency and effectiveness of information services

identified and short-term and long-term plans have been developed to ensure that these needs are satisfied. They have the opportunity to improve all of their services and increase staffing by creating more full-time positions.

Participants B and D responded that the information audit process assisted them in achieving successfully their original objectives. Neither participant elaborated on this point.

Participant C responded that the information audit process assisted them in achieving their original objectives very well; however, organization structural changes made the consolidation of the results more difficult. This also added to the time taken to conduct the audit which extended to over two years. They felt that the restructure of the organization lessened the effectiveness of the information audit results.

As well as achieving their original objectives, participants A, C and D found that the information audit process itself resulted in an increase in business for the corporate information unit. Participant C responded that this was possibly due to an increased awareness of information services within the organization and a desire by individuals to make better informed decisions regarding information use. The research indicated that regardless of whether the audit was conducted across the entire organization or was limited to selected departments it increased the employees' awareness of the resources and services of the corporate information unit.

Participants B and C indicated that the information audit process did not result in an increase in workload for the information unit staff. However one participant did indicate that priorities had changed as a result of the process. Participant A indicated that the workload would increase once the modifications were made to existing services and the new services were in place, but that this would be offset by the addition of more full-time staff positions.

Part Two: Consultants

Details of the data and analysis that relate to consultants have been extracted from the research for inclusion in this section. It has been included here as I felt it gives a level of insight into how a selection of consultants use the information audit process, and the types of results that information professionals and organizations can expect when the process is partially or wholly outsourced.

Consultants were chosen as participants to determine how they conduct an information audit – how they collect, analyse and evaluate the data, how they present the findings and recommendations and how they ensure that their recommendations are implemented. It would also enable a comparison of how the information audit process is used by consultants and how it is used by information professionals who conduct the audit

using internal resources, as well as how the use of internal and external resources can be combined.

Methodology

Selection of participants Email and personal contacts were the primary methods used to locate and recruit survey participants. A call for consultants to participate in the research was posted to library-associated listservs in the UK, USA and Australia. The posting generated enormous interest and resulted in over 350 messages requesting more information about the information audit and how to conduct one. One of the major difficulties experienced in selecting participants was the lack of a universal definition of what exactly is an information audit. Many responses were received from information professionals and consultants who wished to participate but after evaluation of what they had done it was clear that they had conducted a library survey or a needs analysis rather than an information audit.

Five participants were selected according to the following criteria:

- they conduct information audits on behalf of clients and have conducted audits within the last 12–18 months
- they were willing to complete a questionnaire and to be interviewed about the process they used and its outcomes.

One Australian participant, two from the USA and one from the UK were selected. Their profiles are detailed in Table A2.

Data Collection

The survey method of data collection was used. A questionnaire was used to gather data from participants.

Instrument design Questionnaires were designed using a combination of open and closed questions to provide the data necessary to answer the key research questions (Jackson, 1993). The questionnaire contained four distinct sections.

Section One contained questions relating to the level of information policy development in the organizations which employ the consultants

Table A.2 Profiles of selected participants

Consultant participant	A	B	C	D	E
Location	USA	Australia	USA	USA	UK
Type	Company	Company	Individual	Company	Individual

and whether the information audits conducted by the consultants were generally part of a larger information resources management strategy.

Section Two consisted of questions relating to the information audit process used and the scope of the audit which they conducted.

Section Three consisted of questions relating to how the data was analysed and how helpful it was in identifying the need for changes to existing services.

Section Four related to the outcomes of the information audit process, including whether the information audits generally resulted in changes to existing services or an increase in business for the information unit. This section also included an attitudinal question whereby participants could rate the information audit process as a means of achieving various objectives on a scale of zero to five.

Data collection The questionnaire was distributed by email, fax and mail according to the preferences of the participant.

Data analysis

On receipt of the completed questionnaires, the data were analysed manually using an Excel spreadsheet to store and manipulate the data. The survey data was analysed and evaluated in three sections:

1. The information audit and information policy development

2. The information audit process used

3. Evaluation of the process by the participants.

The information audit and information policy development The information audit is promoted in the literature as being an integral component of information policy development. The results of this study indicate that regardless of whether an organization has an information policy prior to conducting the information audit, the process resulted in an increase in the level of information policy development, regardless of whether it was conducted as part of a larger IRM strategy or not.

The consultants responded that prior to their conducting an information audit for an organization, the organization either had an informal information policy (two responses) or no information policy at all (three responses). There was a greater variation in their responses regarding the percentages of information audits that are part of the development of a larger information resources management (IRM) strategy. Their responses ranged from that of Consultant C where only 20 per cent of their clients conducted the information audit process as part of a larger IRM strategy to Consultants B, D and E who responded that 80 per cent of their audits are conducted as part of a larger IRM strategy (Figure A.11).

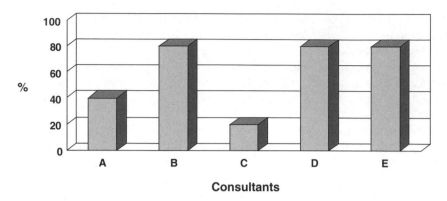

Figure A.11 Percentage of information audits conducted as part of a larger IRM strategy

The information audit process used Survey participants were asked questions that related to the length of time it took to complete their information audit, the scope of the audit within their organization and whether the audit was conducted using in-house staff, external consultants, or a combination of both. They were also asked about the information audit process they used.

Timeframe The review of the literature did not find any works that discuss the information audit process in terms of an expected or optimum timeframe for its completion. There are many variables that could affect the time required to prepare for and complete an information audit, including the availability of both human and financial resources, the size and structure of the organization and the changing environment within the organization.

The consultants indicated that they generally complete the process in a relatively short timeframe, with their responses ranging from less than one month (Consultant B) to six months (Consultant C), with the average being between one and three months (Consultants A and D). Consultant E responded that the time taken to complete the process related directly to the size of the organization and would not limit their response to a particular timeframe option.

The comparatively shorter timeframe taken by consultants compared with that taken by information professionals could be due to the fact that they are contracted to complete the process within a defined period and therefore must meet deadlines. It could also be due to the fact that they can allocate resources exclusively to the project, which may not be the case when using in-house staff to conduct the audit as they are often in demand elsewhere and have conflicting responsibilities. Consultants who

conduct information audits on behalf of clients are also likely to have a defined audit process that they use for each organization, which will result in faster completion.

The research shows that there is no relationship between the time taken to complete the information audit and the components included in the process undertaken by the participants.

Scope The review of the literature found many works that discussed the fact that the information audit process could be conducted across an entire organization or could be restricted to specific departments or sections of the organization. However no works were found that described an optimum approach for specific types of organizations or for organizations of a specific size or structure. The research shows that there is no relationship between the scope of the information audit conducted and the timeframe taken for its completion. The research also shows that there is no relationship between the scope of the information audit conducted and the rating of the information audit process as a means of achieving specific objectives.

The research has shown that regardless of the time taken to conduct an information audit, its scope and the components of the process are used, it is an efficient way of identifying those services that need to be changed and where new services need to be developed. It is also useful for identifying those services for which there is a low demand or that do not have strategic significance.

Data collection The literature cites the survey method of data collection as the most common, with the three standard components of the data collection stage being the questionnaire, the formation of focus groups and personal interviews. Many works discuss the flexibility of the information audit process and the fact that any combination of these three components can be used effectively.

The literature presents the user survey using a written questionnaire as one of the standard components of the information audit process, although it does not discuss whether the sampling method or the census method of survey research should be used in the context of the information audit process. Four out of five participants routinely used a user survey as a component of their information audit process. When choosing survey participants they generally consult with an organizational representative or planning committee. Survey participants were chosen from both information unit users and non-users. Two participants used a structured questionnaire while two relied on semi-structured questionnaires.

The literature discusses the effectiveness of the use of survey questionnaires for large or geographically diverse groups and when data are to be collected on 'sensitive' issues. This makes their use ideal for both centralized and decentralized organizations, and when collecting data from

those who support and use the organization's information services as well as those who regard them negatively.

Connaway, Johnson and Searing (1997, pp.405) discuss the use of focus group interviews in a library context and describe it as 'an evaluation and research technique that allows the interviewees an opportunity to comment, explain and share experiences and attitudes. It permits the assessment of non-verbal responses and by enabling free-flowing discussion can provide in-depth feedback on issues and ideas'. Focus groups can be used as part of the information audit process to allow the in-depth probing of interviewees' responses, which may uncover more detail about expectations, attitudes and behaviours. They can also be used to acquire data on aspects of information use and other related issues that may not have been considered when preparing survey and interview questionnaires. These views are supported by the work of Widdows, Hensler and Wyncott (1991) who found that the use of focus groups can lead to issues being raised that were important to group members but had not been considered by the interviewers. This will result in the generation of data that might not have been gleaned otherwise. Additional benefits of focus group research are that it is relatively inexpensive and can be carried out quickly.

Focus group research is reported in the literature to be more effective when group members have common interests and attitudes and therefore can be of considerable benefit when dealing with groups with particular needs or specialist skills. Consultants A, B and D responded that when they used focus groups they formed homogeneous groups by profession, organizational function or according to the type of information they used in their work.

Although the literature discusses the use of focus groups as a standard component of the information audit process, only one participant (consultant A) responded that they routinely use focus groups in their information audit process. The groups were formed in consultation with a client representative and usually according to organizational function. Consultants B and D responded that they sometimes used focus groups, while Consultants C and E responded that they did not use focus groups as a component of their information audit process.

Focus group research is reported in the literature as being an appropriate method of supplementing survey data. Four of the five consultants used surveys as a component of their information audit process, yet not all felt it necessary to supplement the survey data by forming focus groups.

Despite the documented advantages of using focus groups, the research has shown that they are not always used as a component of the information audit process. The decision not to use focus groups could be due to such factors as the difficulties involved in documenting and analysing the responses. Whether a qualitative approach such as an ethnographic summary or a content analysis approach is used to analyse the data there can still be difficulties in categorizing and classifying the data.

The review of the literature found many works that discuss the use of personal interviews as a vital component of the information audit process. Its value lies in the fact that in-depth data can be collected that will supplement the data collected in the user surveys.

All participants routinely used personal interviews as a component of their information audit process. Three consultants use structured interview sheets for the personal interviews, while two consultants did not. The literature suggests that by using structured interview sheets the value of the data collected by this method is increased due to a greater level of comparability as well as an increased level of consistency when more than one interviewer is used. It also suggests that the use of structured interview sheets requires fewer interviewing skills on the part of the interviewer.

The research has shown that there are many ways in which the information audit process can be varied according to the needs and objectives of the organization and the resources available. Decisions were made as to the appropriateness of each component based on the specific objectives of those managing the project.

Conclusions cannot be drawn concerning the optimum combination of components for specific types of organizations, the ideal scope or by whom it should be conducted.

Data analysis All of the participants processed their information audit data themselves, with two of the five consultants using computer programs to process their data.

The evaluation of the process by the participants The participants were asked to rate how helpful the collected data were in identifying the need for the modification of existing services, the cessation of existing services or the development of new services. They were asked to rate these points using an attitudinal scale that ranged from zero (not at all) to five (completely).

When asked how helpful the data were in identifying the need for the modification of existing services, i.e. changes needed to improve efficiency and effectiveness of current services and resources, all participants rated it highly with three rating it very highly at five and two rating it highly at four.

When asked how helpful the data were in identifying the need for the cessation of existing services, i.e. low demand for existing services or services without strategic significance, the response was the same, with three rating it very highly at five and two rating it highly at four.

When asked how helpful the data were in identifying the need for the development of new services, i.e. some identified needs were not being met by existing services and resources, Consultants A, C and E rated it very highly at five, Consultant D rated it highly at four and Consultant B relatively low at two. Consultant B explained this response by adding that

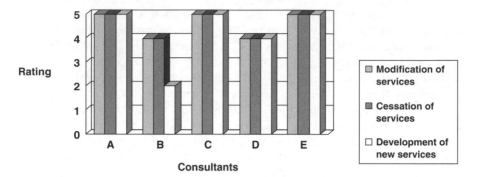

Figure A.12 How helpful the data was in identifying the need to change existing services

they thought that the collected data were not particularly helpful in this area as it depended on the services already being provided. If a full range of services was already being provided, then the process was unable to identify the potential for the development of new services (Figure A.12).

The participants had a great deal of confidence in the data that they collected. They are 'practised auditors' and when preparing surveys and interview questionnaires they ask questions that can easily be related back to existing or potential new services and resources. Their objectivity enables them to recognize trends in the data without personal bias.

Reporting the results of the information audit process

The review of the literature found many works that discuss the importance of reporting formally the results of the audit both to those who participated in the process and to those in management who supported the process.

All participants produced a written report detailing the results of the information audit conducted for an organization. Consultants A and E responded that they also conduct oral presentations for organizational representatives if requested, but this was not a standard procedure. It was then up to the client representatives as to how the audit results were communicated back to survey participants, focus groups and interviewees.

The research has shown that the production of a written report or reports is a standard outcome of the information audit process.

Rating the information audit process as a means of achieving various objectives

The participants were inconsistent in the way they rated the information audit process as a means of achieving various objectives, rating more of them highly at five, but also rating many of the features at the lower end of the scale at zero.

Justifying, evaluating and promoting existing services and resources (Figure A.13). When asked to rate the information audit as a means of justifying existing resources, Consultants C and E rated this feature very highly at five, with the responses of the other consultants ranging from 'average' at three to 'high' at four.

When asked to rate the information audit process as a means of evaluating existing information services and resources four of the consultants rated this very highly at five with Consultant D rating it highly at four.

When asked to rate the information audit as a means of justifying existing resources, Consultants C and E rated this feature very highly at five, with the responses of the other consultants ranging from 'average' at three to 'high' at four.

These results indicate that the participants considered the information audit process to be an effective means of justifying existing information resources and services.

When asked to rate the information audit process as a means of evaluating existing information services and resources four of the consultants rated this very highly at five with Consultant D rating it highly at four.

These results indicate that the participants considered the information audit process to be an effective means of evaluating existing resources and services. The high rating by the consultants could be indicative of their confidence in the process or their high proficiency at 'asking the right questions'. Their high level of objectivity may facilitate their assessment of existing services and resources.

When asked to rate the information audit process as a means of promoting existing information services and resources the participants' responses ranged from 'average' at three to 'very high' at five.

The literature suggests that the information audit process is an effective marketing tool as it provides the information professional with the opportunity to discuss the resources and services with both users and non-users within an organization.

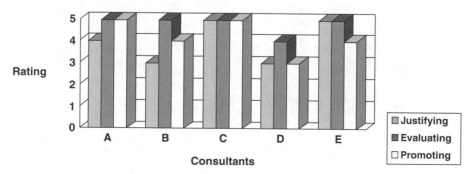

Figure A.13 Rating the information audit process as a means of justifying, evaluating and promoting information services and resources

These results indicate that the participants considered the information audit process to be an effective means of promoting existing resources and services. The fact that the participants rated more highly here could possibly be due to the fact that they have a good understanding of the additional benefits of the information audit process.

Maintaining current staffing and funding levels and supporting and requests for additional staff and funding (Figure A.14). When asked to rate the information audit process as a means of maintaining current staffing levels and funding, and supporting requests for additional staff and funding, the participants responses were varied. Consultant A rated all at above average at four and Consultant C rated them all at a very high five. The responses of the other consultants were less consistent. Consultants B, D and E responded that the information audit process did not support requests for additional staff and rated this at a 'not at all' zero. Consultants D and E rated it 'not at all' at zero for maintaining current staffing levels. All consultants rated the process higher in supporting requests for additional funding with responses ranging from a below average two to a very high five.

The responses of the participants here were extremely varied, especially regarding future staffing and funding which could possibly be due to the fact that some consultants may not consider fully the future use of information audit data. Any changes in resources and services that occur as a result of the information audit will have to be matched with the appropriate staffing and funding levels, which is of little concern to a consultant who is only employed to conduct the information audit.

Identifying user needs Identifying the needs of users is one of the major features of the information audit process that is discussed in the literature and when asked to rate the information audit process as a means

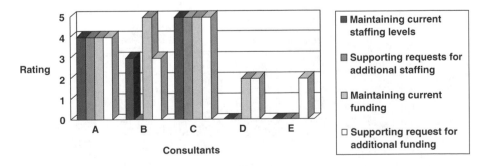

Figure A.14 Rating the information audit process as a means of maintaining current staffing and funding levels and supporting requests for additional staff and funding

Figure A.15 Rating the information audit process as a means of identifying user needs

of identifying user needs, all participants rated this feature 'high' (four) or 'very high' (five). The results indicate that the participants believe that the information audit process is an effective means of identifying user needs (Figure A.15).

Identifying gaps and duplications in the provision of services and resources When asked how well the information audit identifies gaps and duplications in service and resource provision all participants rated this highly with Consultants A, C and E rating it very highly at five. Consultant D rated the identification of duplications below average at two and the identification of gaps highly at four. These results indicate that the participants believe the information audit to be an effective means of identifying gaps and duplications in information service provision (Figure A.16).

Mapping information flows throughout the organization The mapping of information flows both within the organization and to and from

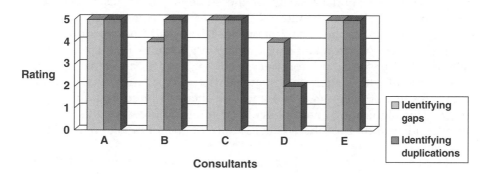

Figure A.16 Rating the information audit process as a means of identifying gaps and duplications in information services and resources

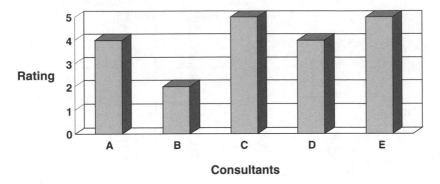

Figure A.17 Rating the information audit process as a means of mapping information flows within an organization

external sources is discussed in the literature as a major benefit of the information audit methodology. When asked to rate the information audit process as a means of mapping information flows Consultants A and D rated this feature highly at four and Consultants C and E very highly at five. Consultant B rated this feature below average at two (Figure A.17). The fact that the participants generally rated this feature highly could be due to their understanding of the implications of information flow within an organization.

Ensuring that information supports organizational goals, raising the profile of information as a strategic asset and linking information to management processes (Figure A.18). When asked to rate the information audit process as a means of ensuring that information supports organizational goals Consultants A, B, C and E rated this feature very highly at five. Consultant D rated this feature at as 'average' at three. The fact that the participants rated this feature highly could indicate that they had a good understanding of the strategic objectives of the organization in which they conducted their information audits.

The objectives of the organization must be clearly understood for the strategic value of information resources and services to be recognized. When asked to rate the information audit process as a means of raising the profile of information as a strategic asset Consultants A, B, C and E rated this feature 'very high' at 5 and Consultant D rated it as 'average' at three. This high rating could possibly be due to the consultants having a good understanding of the strategic value of the information within the organization.

When asked to rate the information audit process as a means of linking information to management processes this feature was rated very highly at five by Consultants C and E, highly at four by A and D and 'average' at three by Consultant B. The consultants are in a position to observe

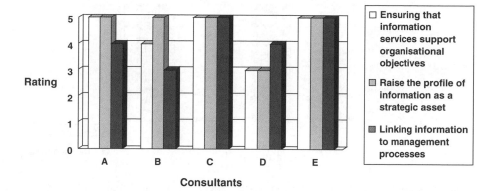

Figure A.18 Rating the information audit process as a means of ensuring that information services support organizational goals, raising the profile of information as a strategic asset and linking information to management processes

objectively and examine the management processes within an organization, and evaluate objectively the information resources and services.

Supporting the restructure of information services When asked to rate the information audit process as a means of supporting the restructure of information services Consultants A, B and D rated this feature highly at four and Consultants C and E rated it very highly at five (Figure A.19).

The high rating by the participants could be due to the fact that they have a more objective view of how information services could be restructured within the organization.

Improving the efficiency and effectiveness of information services When asked to rate the information audit process as a means of improving

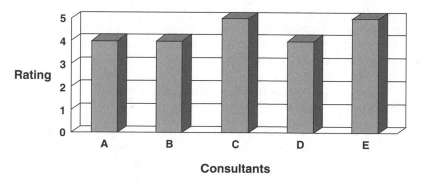

Figure A.19 Rating the information audit process as a means of supporting the restructure of information services

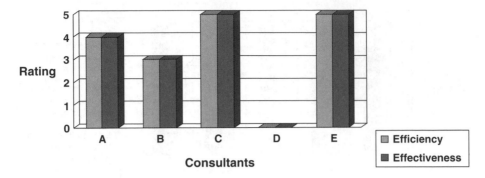

Figure A.20 Rating the information audit process as a means of improving the efficiency and effectiveness of information services Overall satisfaction with the information audit process

the efficiency and effectiveness of an information service this feature was rated as 'average' at three by Consultant B, highly at four by Consultant A and very highly at five by Consultants C and E. Consultant D rated this feature as 'not at all' at zero.

The overall satisfaction with the information audit process was based on how well it assisted the participants in achieving their original objectives. As the objectives of the consultants differ with each information audit they conducted they were not asked this question. Their rating of the features of the information audit process indicate that they generally regard it as an effective method of achieving all of the objectives listed (Figure A.20).

Parts One and Two: Key findings and conclusions

The key findings of this study focus on the effectiveness of the information audit process as a means of achieving specific objectives. They relate to the purpose of conducting the information audit, the process used and the evaluation of the process by the participants. The conclusion relates the key findings to the key research questions.

Purpose – what is the rationale for conducting an information audit?

The reasons for conducting an information audit will vary according to the specific needs of an organization. The participants' reasons for conducting an information audit were varied but in all cases were focused on improving services, facilitating access to resources and enabling planning for future needs. This involved being able to determine which services and resources were being used, how they were being used and

by whom. It also involved being able to detect gaps and duplications in existing services and resources.

The literature established the information audit as an integral component of information policy development. Some of the participating libraries and most of the participating consultants conducted the information audit as part of a larger information resources management strategy. The research has shown that an information audit will affect information policy development regardless of whether it is conducted as part of a larger information resources management strategy.

Process – how was it done?

There is no optimum timeframe for conducting an information audit. Those conducted by consultants were generally completed over a shorter timeframe. However the changing environment of the organization can affect the time taken to complete the information audit regardless of whether its conducted using in-house staff or consultants.

There is no optimum scope for conducting an information audit. Whether the information audit is conducted across the entire organization, or is limited to selected departments, will depend upon the objectives of those conducting the audit and the resources available.

No relationship was evident between the size and type of the organization and the information audit process used.

The user survey and personal interviews are considered to be integral to the information audit process. The use of focus groups was used when it was necessary to complete the process in a shorter timeframe, or when specific groups were considered to have unique requirements that could not easily be integrated into the structured audit process.

The user survey can be either sample or census based. The same questionnaire can be used for all survey participants, or specific questionnaires can be designed to suit the needs of specific groups within the organization.

Personal interviews can be conducted using structured interview sheets or can be unstructured to meet the needs of specific users.

The information audit can be conducted successfully using in-house staff, consultants or both. The consultants rated the information audit process more highly as a means of achieving specific objectives and generally completed the process more quickly. They also found the data collected as a result of the information audit more useful in identifying where changes were needed.

The data collected as a result of the information audit process were analysed in-house by all participants. The data easily identified those services that needed to be modified, those that needed to be discontinued and where there was a need for the development of new services. The consultants found the data easier to analyse than did the information

professional participants. All information professionals modified their existing services and developed new services as a result of the information audit process.

The data collected as a result of the information audit process can be used as a basis for further reports and planning and strategy documents. All participants produced a written report after conducting the information audit. Reports relating to specific aspects of information services were then prepared using the same data.

The information audit process itself can result in an increase in business for the corporate information unit. All participants reported an increase in business due to the increase in awareness of the resources and services available, and the increased emphasis on information within the organization.

Evaluation – how is the process rated?

When asked to rate the information audit process as a means of achieving specific objectives the consultants rated it more highly than did the libraries. This could be due to their greater objectivity and vision when analysing the information situation within an organization. It could also be a result of how they are briefed by an organization when employed to conduct an information audit. If they are given specific objectives they can concentrate on achieving those objectives without being concerned with the impact of any changes elsewhere in the organization. If their focus is too narrow it could cause them to disregard other important issues that may be affected by outcomes of the information audit process. This could explain why the results indicate that the consultants are less concerned with staffing and funding than are the libraries, and place more emphasis on the strategic implications of information management.

The literature suggests that the information audit process is a marketing tool and can be used to promote information services within an organization. The research has shown that the information audit process itself could be considered a marketing exercise as it increased the awareness of information within the organizations studied. Three out of four information professional participants indicated that the information audit process resulted in an increase in business for the corporate information unit. All participants rated the information audit process highly as a means of promoting existing information resources and services.

All participants reported that the information audit process enabled them to achieve their original objectives.

Limitations of the information audit process

There is no standard approach to using the information audit process. Although the literature discusses the objectives, components, scope and timeframe of the information audit process, it does not recommend

a standard approach that can be adopted by an organization to suit their specific objectives. The fact that it is promoted as a flexible approach which can be adapted to suit all situations makes this problem worse. This presents difficulties for information professionals and consultants when deciding how best to conduct an audit for a specific organization.

The information professional participants chose an approach that suited their objectives and the resources available to them. The consultants also varied the approach used according to the objectives of the organization. It is not known whether the approaches used by any of the participants in this study were the optimum approaches to enable them to achieve most successfully their objectives in their given situation.

Limitations of the study

This study did not attempt to determine how many organizations in total have conducted information audits. Therefore the relative percentage of the total organizations is unknown and the results of this study may not be indicative of the information audit process overall.

The results of this study are viewed from the perspective of the information professionals and the consultants who conducted the information audits. They do not consider how the results of the information audit process were viewed by the management of the organizations in which the information audits were conducted.

Conclusion

The research has shown that a relationship does exist between the information audit process and an improvement in the matching of information services and resources to user needs. The information audit enables the identification of the information that is necessary for an organization to achieve its objectives. It then enables the matching of those information needs to the services and resources offered by the corporate information unit. Although this may require changes to existing services, the discontinuation of services that are no longer relevant or the introduction of new services, it will result in an improvement in the matching of information services and resources to users' needs.

Both the library and consultant participants rated the information audit process highly as a means of identifying user needs, identifying gaps and duplications in existing services and resources and mapping information flows throughout the organization. The data collected as a result of the information audit were used to identify those services that needed to be changed, those that needed to be discontinued and areas where new services needed to be developed. All participants responded that they modified existing services and developed new services as a result of the information audit, which culminated in a better matching of information services and resources to users' needs.

The research has also shown that a relationship does exist between the information audit process and the strategic role of the corporate information unit within an organization. For the information unit to establish itself as having a strategic role within an organization it is necessary for the organization to recognize the value of information to its success. The information audit enables the identification of that information which is vital for the organization to achieve its objectives. By ensuring that all of the services and resources offered by the information unit support these objectives the information unit is recognized as having a vital role within the organization.

Both information professional participants and consultant participants rated the information audit process highly as a means of linking information to management processes, raising the profile of information as a strategic asset and ensuring that information resources and services support organizational goals. By restructuring the information services to ensure that they support the objectives of the organization, the information professional within an organization can be regarded as a key player in achieving organizational success.

References

Booth, A. (1994) Information audit in a regional health authority. In *The value of information to the intelligent organisation*, 4, pp.123–136. Hatfield: University of Hertfordshire Press

Booth, A. and Haines, M. (1993) Information audit: whose line is it anyway? *Health Libraries Review*, **10**(4), 224 – 23

Connaway, L.S., Johnson, D.W. and Searing, S.E. (1997) Online catalogs from the users' perspective: the use of focus group interviews. *College & Research Libraries*, **58**(5), 403–20.

Gall, M.D., Borg, W.R. and Gall, J.P. (1996) *Educational research: an introduction*. White Plains, NY: Longman

Jackson, S. (1993) *An introduction to sample surveys: a user's guide.* Melbourne: Australian Bureau of Statistics

Widdows, R., Hensler, T.A. and Wyncott, M.H. (1991) The focus group interview: a method for assessing users' evaluation of library service. *College & Research Libraries*, **52**(4), 352–359

Glossary

Business case A proposal developed for management to secure the approval to proceed with a project and the resources needed to complete it successfully

Corporate culture *see* Organizational culture

Information audit A process that will determine effectively the current information environment by identifying what information is required to meet the needs of the organization and establishing what information is currently supplied. It allows a matching of the two to identify gaps, inconsistencies and duplications. The process also facilitates the mapping of information flows throughout the organization and between the organization and its external environment to enable the identification of bottlenecks and inefficiencies

Information culture An organizational culture that has a high regard for the value of information and that recognizes how information contributes to organizational success

Information custodian *see* Information gatekeeper

Information flow The movement of information between departments and individuals within an organization, and between an organization and its external environment

Information gatekeeper A person or department who brings information into the organization or who disseminates information throughout the organization

Information management The management of the acquisition, use and storage of information, and the movement of information within an organization and between an organization and its external environment

Information policy A document that states the <u>principles</u> of how information will be used and managed within an organization

Information strategy The <u>details</u> of how information will be used and managed within an organization for a defined period. Based on the *information policy* the strategy will include objectives, projects, plans etc.

Information overload The provision of too much information for a particular task or activity

Information unit The primary provider of information services and resources within an organization. Also known as the corporate library

Knowledge management The management of that which employees within an organization need to know to perform their jobs. It incorporates information resources and services, company records and the expertise of employees

Organizational culture The system of beliefs and values within an organization

Strategic business unit A unit within an organization that has its own distinct client group

Strategic information management *see* Information strategy

Appendix C

Selected bibliography

Angus, J. (1998) The organization and knowledge. *Informationweek*, (700) Sept. 14, 14–16

Banks, E. (1999) Creating a knowledge culture. *Work Study*, **48**(1), 18–20

Bates, M.E. (1997) Information audits: what do we know and when do we know it. *Library Management Briefings*, **9**(3), 1–7

Bentley, T.J. (1997) *Defining management's information needs*. Information Management Series, ed. S. Nugus. Ontario: Chartered Institute of Management Accountants

Berkman, R.I. (1995) *Rethinking the corporate information center: a blueprint for the 21st century*. New York: Find/SVP

Bertolucci, K. (1996) The information audit: an important management tool. *Managing Information*, **3**(6), 34–35

Best, D. (1995) *The fourth resource: information and its management*. Aldershot: Aslib/Gower

Blom, A. (1987) The development of a methodology to determine the information needs of industry and business. *South African Journal of Library and Information Science*, **55**(3), 153–160

Booth, A. (1994) Information audit in a regional health authority. In *The value of information to the intelligent organisation*, 4, pp.123–136. Hatfield: University of Hertfordshire Press

Booth, A. and Haines, M. (1993) Information audit: whose line is it anyway? *Health Libraries Review*, **10**(4), 224–23

Brache, A.P. and Rummler, G.A. (1997) Managing an organization as a system. *Training*, **34**(2), 68–74

Buchanan, S.J. (1998) *The information audit: an integrated strategic approach*. Available at www.strath.ac.uk/Departments/InfoStrategy/

Buchanan, S. and Gibb, F. (1998) The information audit: an integrated strategic approach. *International Journal of Information Management*, **18**(1), 29–47

Burk, C.F. and Horton, F.W. (1988) *InfoMap: a complete guide to discovering corporate information resources.* Englewood Cliffs, NJ: Prentice Hall

Chait, L.P. (1999) Creating a successful knowledge management system. *Journal of Business Strategy*, **20**(2), 23–26

Connaway, L.S., Johnson, D.W. and Searing, S.E. (1997) Online catalogs from the users' perspective: the use of focus group interviews. *College & Research Libraries*, 58(5), 403–20.

Cortez, E.M. and Kazlauskas, E.J. (1996) Information policy audit: a case study of an organizational analysis tool. *Special Libraries*, **87**(2), 88–98

Crawford, J. (1996) *Evaluation of library and information services.* Aslib Knowhow Series, ed. S.P. Webb. London: Aslib

Curzon, S.C. (1989) *Managing change: a how-to-do-it manual for planning, implementing, and evaluating change in libraries.* How-to-do-it manuals for libraries: number 2, ed. B. Katz. New York: Neal-Schuman

Cwiklo, W. (1989) Learning how to look ahead: information management planning. *Inform*, **4**(10), 10–14

Dalton, P. (1999) Investigating information auditing. *Library & Information Research News*, **23**(74), 45–50

Darling, M.S. (1997) Knowledge cultures. *Executive Excellence*, **14**(2), 10–11

de Vaal, I. and du Toit, A. (1995) Information audit to identify strategic business resources in an insurance enterprise. *South African Journal of Library and Information Science*, **63**(3), 122–128

Didis, S.K. (1997) Communicating audit results. *The Internal Auditor*, **54**(5), 36

Dougherty, R.M. (1997) Getting a grip on change. *American Libraries*, **28**(7), 40–42

Dubois, C.P.R. (1995) The information audit: its contribution to decision making. *Library Management*, **16**(7), 20–24

Duhon, B. (1998) It's all in our heads. *Inform*, **12**(8), 8–13

Eddison, B. (1990) Strategies for success (or opportunities galore). *Special Libraries*, **81**(2), 111–117

Eddison, B. (1992) Information audit II: another perspective. *Library Management Quarterly*, **15**(1), 8–9

Edwards, J.E. *et al.* (1997) *How to conduct organizational surveys: a step-by-step guide.* Thousand Oaks: Sage

Ellis, D. *et al.* (1993) Information audits, communication audits and information mapping: a review and survey. *International Journal of Information Management*, **13**, 134–151

Gall, M.D., Borg, W.R. and Gall, J.P. (1996) *Educational research: an introduction.* White Plains, NY: Longman

Gorman, G.E. and Clayton, P. (1997) *Qualitative research for the information professional.* London: Library Association

Grieves, M. (1998) The impact of information use on decision making: studies in five sectors – introduction, summary and conclusions. *Library Management,* **19**(2), 78–85

Griffiths, J.M. and King, D. (1993) *Special libraries: increasing the information edge.* Washington, DC: Special Libraries Association

Gunner, H. and Gulden, G.K. (1986) Partnerships between executives and information professionals speed business strategy execution. *Information Management Review,* **1**(4), 11-23

Hamilton, F. (1993) The information audit. In *Management skills for the information manager,* ed. A. Lawes. Aldershot: Ashgate

Hansen, M.T., Nohria, N. and Tuerney, T. (1999) What's your strategy for managing knowledge? *Harvard Business Review,* March–April, 106–116

Hawley Committee (1995) *Information as an asset: the board agenda: a consultative report.* London: KPMG IMPACT

Hawley Committee (1995) *Information as an asset: the board agenda: checklist and explanatory notes.* London: KPMG IMPACT

Haynes, D. (1995) Business process reengineering and information audits. *Managing Information,* **2**(6), 30–32

Henczel, S.M. (1998) *Evaluating the effectiveness of an information audit in a corporate environment.* Minor Thesis, Faculty of Business, RMIT University, Melbourne

Henczel, S.M. (2000) The information audit as a first step towards effective knowledge management. The Information Age: Challenges and Opportunities, Worldwide Conference on Special Librarianship, Brighton UK, 16–19 October 2000. International Contributed Papers. SLA Publishing, Washington DC

Henczel, S.M. (2000) Using the information audit to build an effective knowledge management strategy. *TOUR: The One Umbrella Report* 4, 2000.

Hepworth, J.B. *et al.* (1992) The enhancement of information systems through user involvement in system design. *International Journal of Information Management,* (12), 120–129

The Information audit: methods for managing information: tackling information overload (1995). *The Information Advisor,* **7**(1), 2

Information systems not meeting the needs of executives (1993). *Industrial Engineering,* **25**(7), 8

Institute of Management Foundation (1998) *Carrying out an information audit.* Management checklists: 013. Corby: The Institute of Management Foundation

Institute of Management Foundation (1998) *Handling information – avoiding overload.* Management checklists: 150. Corby: The Institute of Management Foundation

International Council of Systems Engineering (INCOSE) (1998) *The INCOSE handbook: a 'how to' guide for all engineers,* Release 1.0 edn. Seattle: INCOSE

Jackson, S. (1993) *An introduction to sample surveys: a user's guide.* Melbourne: Australian Bureau of Statistics

Jacob, M.E.L. (1990) *Strategic planning: a how-to-do-it manual for librarians.* How-to-do-it manuals for libraries: number 9, ed. B. Katz. New York: Neal-Schuman

Kennedy, M.L. (1996) Positioning strategic information: partnering for the information advantage. *Special Libraries,* **87**(2), 120–131

Klein, M. (1999) Managing knowledge drives key decisions. *National Underwriter,* **103**(13), 17–19

Koenig, M. (1992) The importance of information services for productivity 'under-recognized' and under-invested. *Special Libraries,* **83**(4), 199–210

LaRosa, S. (1991) The corporate information audit. *Library Management Quarterly,* **14**(2), 7–9

Line, M.B. (1974) Draft definitions: information and library needs, wants, demands and uses. *Aslib Proceedings,* **26**(2), 877

Martin, B. (1996) Corporate libraries in the digital age: threats and opportunities. *Vic Specials,* **13**(2), 4

Matarazzo, J.M. and Prusak, L. (1990) Valuing corporate libraries: a senior management survey. *Special Libraries,* **81**(2), 102–110

Matarazzo, J.M. and Prusak, L. (1995) *The value of corporate libraries: findings from a 1995 survey of senior management.* Washington DC: Special Libraries Association

Matthews, P. (1997) *Strategic research and comparative advantage: a new role for the re-invented librarian.* Available at www.csu.edu.au/special/online97/proceedings/onl304.htm

Miller, K. (1998) Librarians getting a handle on knowledge. *Information World Review,* **137**(June), 25–26

Mizrachi, Y. (1998) The knowledge smiths: librarianship as craftship of knowledge. *New Library World,* **99**(1143), 176–184

Muelken, L. (1996) Companies learn knowledge more than just information: this most basic business resource must be leveraged for advantage. *Minneapolis Star Tribune,* 16 December 1996

Newman, W.B. (1999) Knowledge management research and end user work environments 2010. Paper presented at the *65th IFLA Council and General Conference,* Bangkok, Thailand, 1999. Also available at www.ifla.org/IV/ifla65/papers/057-84_e.htm

Nicholas, D. (1996) *Assessing information needs: tools and techniques.* Aslib Knowhow Guides, ed. S.P. Webb. London: Aslib

O'Dell, C., Grayson, C.J. and Essaides, N. (1998) *If only we knew what we know: the transfer of internal knowledge and best practice.* New York: The Free Press

Orna, E. (1990) *Practical information policies: how to manage information flow in organizations.* Aldershot: Gower

Orna, E. (1996) Information auditing. *Singapore Libraries*, **25**(2), 69–82

Orna, E. (1999) *Practical information policies* 2nd edn. Aldershot: Gower

Orna, L. (1993) Why you need an information policy: and how to sell it. *Aslib Information*, **21**(5), 196–200

Pennimen, W.D. (1997) Strategic positioning of information services in a competitive environment. *Bulletin of the American Society for Information Science*, **23**(4), 11–17

Reid, C., Thomson, J. and Wallace-Smith, J. (1998) Impact of information on corporate decision making: the UK banking sector. *Library Management*, **19**(2), 86–109

Robertson, G. (1994) The information audit: a broader perspective. *Managing Information*, **1**(4), 33–35

Rundle-Thiele, S. (1997) *ALIA market research report.* Adelaide: University of South Australia

Shapiro, C. and Varian, H.R. (1998) *Information rules: a strategic guide to the network economy.* Boston: Harvard Business School Press

Shiemann, W.A. (1991) Using employee surveys to increase organizational effectiveness. In *Applying Psychology In Business*, pp.632–639. Lexington: Lexington Books

Skryme, D. (1992) Knowledge networking: creating wealth through people and technology. *The Intelligent Enterprise*, **1**(11/12), 9–15

Skyrme, D. (1995) Information resources management (IRM). *Management Insight*, (8), 4. Available at www.skyrme.com/insights/8irm.htm

Soy, C. and Bustello, C. (1999) A practical approach to information audit: case study. *Managing Information*, **6**(9), 30–36

Soy, C. and Bustelo, C. (1999) A practical approach to information audit: case study (Part 2). *Managing Information*, **6**(10), 60–61

Special Libraries Association (1995) *The information audit: an SLA information kit.* Washington DC: Special Libraries Association

St. Clair, G. (1993) *Customer service in the information environment.* Information Services Management, ed. G. St. Clair. London: Bowker-Saur

St. Clair, G. (1994) *Power and influence: enhancing information services within the organization.* Information Services Management, ed. G. St. Clair. London: Bowker-Saur

St. Clair, G. (1995) Ask the customers. *The One-Person Library*, **11**(9), 1–3

St. Clair, G. (1995) Ask the customers (II). *The One-Person Library*, **11**(10), 25–26

St. Clair, G. (1995) The information audit (part III): you've got the data – what does it mean? *The One-Person Library*, **11**(11), 28–29

St. Clair, G. (1996) Connecting the information audit and strategic management. *InfoManage*, **3**(2), 7

St. Clair, G. (1996) *Entrepreneurial librarianship: the key to effective information services management.* Information Services Management, ed. G. St. Clair. London: Bowker-Saur

St. Clair, G. (1996) The information audit: a powerful management tool for special librarians. *The Specialist*, **19**(2)

St. Clair, G. (1997) Assessing performance levels. *Information World Review*, **126**(June), 26

St. Clair, G. (1997) The information audit I: defining the process. *InfoManage*, **4**(6), 5–6

St. Clair, G. (1997) The information audit: what's involved? *The One-Person Library*, **14**(1), 6–7

St. Clair, G. (1997) The information audit (II): marketing tool. *InfoManage*, **4**(7), 6

St. Clair, G. (1997) The information audit (II): the effective and successful information audit. *The One-Person Library*, **14**(2), 7–8

St. Clair, G. (1997) The information audit (III): identifying the stakeholders. *The One-Person Library*, **14**(3), 5–6

St. Clair, G. (1997) The information audit (III): what's the return on investment? *InfoManage*, **4**(8), 7

St. Clair, G. (1997) Matching information to needs. *Information World Review*, **123**(March), 20

St. Clair, G. (1997) Putting customer care first. *Information World Review*, **129**(October), 27

Stanat, R. (1990) The strategic information audit. In *The Intelligent Corporation*. New York: AMACOM

Strassman, P. (1996) *The economics and politics of information management: an account of an executive seminar.* Available at www.strassmann.com/pubs/econ-polim.html

Strassman, P. (1998) Taking the measure of knowledge assets. *Computerworld*, **32**(14), 74

Swash, G.D. (1997) The information audit. *Journal of Managerial Psychology*, **12**(5), 312–318

The steps to take for conducting an information audit (1997). *The Information Advisor*, **9**(9), S1–S4

Theakston, C. (1998) An information audit of National Westminster Bank UK's Learning and Resources Centres. *International Journal of Information Management*, **18**(5), 371–375

Waddington, P. (1997) Dying for information? A report on the effects of information overload in the UK and worldwide. Paper presented at the *Beyond the Beginning: The Global Digital Library*, London, UK, 16–17 June 1997. Also available at www.anu.edu.au/caul/mirror/global/content/repor~10.htm

Walsh, V. and Greenshields, S. (1998) The value of libraries and library professionals to Australia's top 100 companies: draft report of the study conducted by the Australian Library and Information Association. *Australian Special Libraries*, **31**(3), 59–101

Webb, S. (1994) The information audit. *Information Management Report*, (January), 9–11

Weitzel, J.R. (1987) Strategic information management: targeting information for organizational performance. *Information Management Review*, **3**(1), 9–19

Widdows, R., Hensler, T.A. and Wyncott, M.H. (1991) The focus group interview: a method for assessing users' evaluation of library service. *College & Research Libraries*, **52**(4), 352–359

Widdows, R. (1993) Focus group interviews. In *Encyclopedia of Information Science*, ed. A. Kent, 52 (Supplement 15). New York: Marcel Dekker

Winterman, V., Smith, C. and Abell, A. (1998) Impact of information on decision making in government departments. *Library Management*, **19**(2), 110–132

Worlock, D. (1987) Implementing the information audit. *Aslib Proceedings*, **39**(9), 255–260

Young, V. (1993) Focus on focus groups. *College and Research Libraries News*, **54**(7), 391–394

Zack, M.H. (1999) Developing a knowledge strategy. *California Management Review*, **41**(3), 125–145

Zikmund, W.G. (1997) *Business research methods*, 5th edn. Fort Worth: Harcourt Brace Jovanovich

Zipperer, L. (1998) Librarians in evolving corporate roles. *Information Outlook*, **2**(6), 27–30

Zisman, M. (1999) Making the most of knowledge assets. *InfoWorld*, **21**(5), 33

Index